PHOTOGRAPHY
AS ACTIVISM

Michelle Bogre

PHOTOGRAPHY
AS ACTIVISM
IMAGES FOR SOCIAL CHANGE

AMSTERDAM • BOSTON • HEIDELBERG • LONDON
NEW YORK • OXFORD • PARIS • SAN DIEGO
SAN FRANCISCO • SINGAPORE • SYDNEY • TOKYO
Focal Press is an imprint of Elsevier

Focal Press is an imprint of Elsevier

225 Wyman Street, Waltham, MA 02451
The Boulevard, Langford Lane, Kidlington, Oxford, OX5 1GB, UK

Notices
Knowledge and best practice in this field are constantly changing. As new research and experience broaden our understanding, changes in research methods, professional practices, or medical treatment may become necessary.

Practitioners and researchers must always rely on their own experience and knowledge in evaluating and using any information, methods, compounds, or experiments described herein. In using such information or methods they should be mindful of their own safety and the safety of others, including parties for whom they have a professional responsibility.

To the fullest extent of the law, neither the Publisher nor the authors, contributors, or editors assume any liability for any injury and/or damage to persons or property as a matter of products liability, negligence or otherwise, or from any use or operation of any methods, products, instructions, or ideas contained in the material herein.

Library of Congress Cataloging-in-Publication Data
Application submitted.

British Library Cataloguing-in-Publication Data
A catalogue record for this book is available from the British Library.

ISBN: 978-0-240-81275-5

For information on all Focal Press publications
visit our website at www.elsevierdirect.com

11 12 13 14 5 4 3 2 1

Printed in China

Contents

Acknowledgments

This book owes its existence to the many people who encouraged and supported me. So, in no particular order, I express my deep gratitude to Kyle Garson, the smartest and most able assistant any author could ever have; Jonathan Torgovnik, who became a friend through this process and whose enthusiasm for the book kept me going when I doubted myself; all the photographers, editors, and NGO professionals who gave me their time and their insights; to everyone who worked with me to make sure that I was able to publish as many photographs as possible; Cara St. Hilaire and Stacey Walker at Focal Press, who enthusiastically embraced this project even when I missed deadlines; and finally to my friends and family who will be happy to never again hear the phrase, "I can't, I have to work on my book."

Dedication

This book is dedicated to all activist photographers, past, present, and future.

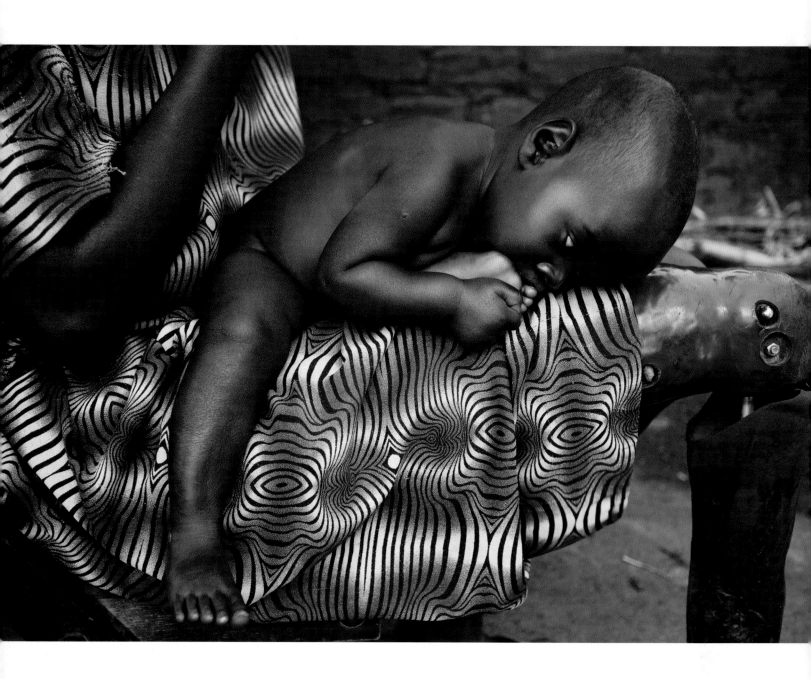

INTRODUCTION

FIGURE 0.1 *Alema Rose, Aler IDP Camp, Uganda, 2006.* © Heather McClintock from Northern Uganda, 2006

There are two things I wanted to do. I wanted to show the things that had
to be corrected. I wanted to show the things that had to be appreciated.

Lewis Wickes Hine

This book aims to examine the complexity of activist photography,
philosophically, historically, and as it is currently practiced. In this
book, the word *activism* is interchangeable with *advocacy*. *Activism,* as
used throughout, does not refer to strident political action, the common
inference in Europe. An activist photograph can be subtle and persuasive,
or it can be confrontational. This book will explore both. Activist
photography is intent and process. It is an act and a filter through which a
photographer perceives the world. It is a passionate voice and a moral
vision. "Sometimes it *is* the responsibility of the photographer to make a
call for action," says award-winning photographer Jonathan Torgovnik,
best known for his project *Intended Consequences*, about the mass rape
of Tutsi women during the Rwanda genocide in 1994 (Figure 0.2).[1]
Torgovnik's own call to action occurred on assignment for *Newsweek*
magazine when he was photographing Tutsi women who had contracted
AIDS as a consequence of being raped by the Hutus in the aftermath of the
Rwanda genocide. Torgovnik realized that the real story was the
complicated relationship that these women had with the children they
bore as a consequence of the rape. He returned to Rwanda to produce a
photo essay on those women and their children, but was so moved by
the stories they told him that when he returned to New York City, he
formed Foundation Rwanda.[2] To date, Foundation Rwanda has raised
more than a million dollars to help pay for the secondary-school education
of these children born of rape. An activist photographer such as
Torgovnik cannot *not* see the world in political terms. He is driven both
by history and the desire to change an inequity, underscored by the
belief that it can be changed.

Why are some photographers driven to change, willingly putting
themselves in difficult and dangerous situations to document the "thing"
that must be corrected? Philosophers have contemplated the question of
activism from the perspective of civil engagement. Some suggest that
activism has ethical undertones, based on John Locke's ideas of the
"fiduciary trust," explained in his *Second Treatise of Government*.
A Lockean citizen—the "citizen trustor"—is endowed with moral acumen
and is obligated to detect breaches in the fiduciary trust. Locke did not
consider this civil engagement to be a choice: "[a]s every man has a power
to punish the crime, to prevent its being committed again, by the right
he has of preserving all mankind and doing all reasonable things he can in
order to that end."[3] In these passages, Locke defined a "crime" as any
violation of natural law. With that definition, maybe we should consider
an activist photographer today as a contemporary version of Locke's
citizen trustor, an engaged citizen with a camera, ever vigilant for those
times when fairness and equity are being violated by the state. Rather
than using the power of the camera to "punish" the crime, an activist
photographer captures it, freezes it, and immortalizes it so it becomes
evidence of the crime, showing the thing that has to be corrected.

Surely today, fairness and equity are being violated to degrees
unimaginable in a supposedly evolved twenty-first-century world. For
example, more than three billion people in the world live on less than
$2.50 a day. More than one billion people lack access to clean water, and
almost three billion lack basic sanitation. In Rwanda in 1994, in just 100
days, Hutus slaughtered 800,000 of their fellow Tutsis and brutally gang
raped thousands of Tutsi women. Today, in the Democratic Republic of
the Congo, the United Nations peacekeeping forces are powerless to stop
the systemic rape of women (in one town, Shabunda, 70 percent of the
women reported being raped).[4] More than 27 million people are modern-
day slaves. More than one million children are exploited by the global
commercial sex trade annually, and more than 800,000 people are
trafficked across international borders every year (Figure 0.3).[5] And these
are just a few examples. In a slight rewrite to the famous quote attributed
to Mary Harris "Mother" Jones—Don't mourn, photograph[6]—these
activist citizen trustors seek out the things that need to be corrected,
and the world needs them to do that.

Noted German philosopher Jürgen Habermas posited that political
morality is redemptive and that ethical activism drives social evolution or
social change. If political morality is redemptive, then perhaps
redemption underlies activism intended to engender social change. While
some critics or cynics would suggest that a degree of self-abnegation

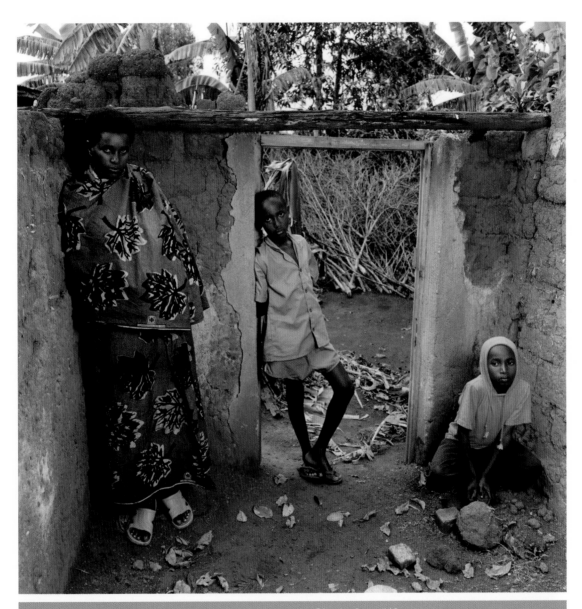

FIGURE 0.2 Jonathan Torgovnik, *Untitled* from *Intended Consequences*. ©Jonathan Torgovnik/ Reportage

FIGURE 0.3 Dana Popa, *Untitled* from *Not Natasha*. Image courtesy of Dana Popa

drives most activist intent, self-abnegation is a pejorative criticism. To the extent that causes, concerns, and issues extend beyond the sphere of one's own life, it's also possible that activists believe that what benefits society also benefits them. So accepting the difficulty and danger inherent in most conflict situations in the quest of the photograph isn't self-sacrificing; it is being an engaged citizen. "It is our responsibility to do something because we live here. It is an ethical issue of conscience," said Larry Towell,[7] a self-proclaimed activist photographer, during a panel discussion on human rights photography at New York University.[8] Towell, who has spent his career focusing on human rights, also noted that he didn't think he'd "changed anything," but that didn't matter to him. He described success in human rights reportage as "being involved in the process of

change" even if he didn't see the result. For him, as others, activism is more about the means than the end. The end is a promise that activists seldom see.

Because photographs work in several registers of ritual and response, employing photography as an activist tool is not a new conceit. Almost from the time it was invented, photography was recognized by both photographers and social activists as a great "activist" tool for people who wanted to expose social injustices. Activists and reformers used the camera as a research tool and as an instrument for social reform, as this book will explore. Some historians think that the first "activist" images were calotypes made in 1840 by the Scots team of David Octavius Hill and Robert Adamson (known generally as Hill and Adamson) in Newhaven, Scotland, a small fishing village outside Edinburgh. Although

Adamson was more interested in pushing the artistic envelope of the calotype,[9] the "candid" documentary portraits he produced of the fisherfolk are now considered to have sparked the idea that photography could be used as a tool for social awareness, if not social change. In 1877, British photographer John Thomson's images were used to illustrate a report, *Street Life in London,* written by social activist Adolphe Smith Headingly (who wrote as Adolphe Smith) to raise awareness among middle-class Britons about the reality of the lives of the urban poor so they would support efforts to improve working-class conditions. Historians credit the report for the construction of an embankment to stop the flooding on the Thames River that periodically would devastate the lives of the poor who lived along its banks.

Although sometimes photographs were not originally made with an activist intent (as with Hill and Adamson), early American photographers actively took photographs to expose social inequities. Photography as activism was more central to the history of American photography in the late nineteenth and early twentieth centuries because of the existing social conditions. Although millions of Europeans migrated to the United States in search of a "better life," the reality they encountered was different: The United States was recovering from post–Civil War economic depressions, leaving the new immigrants underemployed, exploited, living in squalid tenement conditions, or jobless and homeless. Jacob Riis, a carpenter from Denmark who personally experienced these conditions, eventually photographed them with the intent to expose the situation. President Theodore Roosevelt, then police commissioner of New York City, stated that Riis was one of "the most useful citizens in New York."[10] Lewis Hine was a crusader for children's rights. Between 1907 and 1918, while working for the National Child Labor Committee (NCLC), he made more than 5,000 photographs of children working in factories, mines, mills, and canneries. These photographs influenced Congress to pass the Child Labor Law. However, other photographers whose work seems activist do not always think of themselves as activists. Eugene Richards, for example, who has spent his career making photographs that this author and most of his contemporaries would clearly identify as activist, says he is a journalist, or at least that he doesn't think of himself as an activist when he is shooting. Sometimes

photographs that we now consider to be fine art were taken with an activist intent. For example, Ansel Adams' photographs, taken for a book published in 1936, *Sierra Nevada: The John Muir Trail*, and used as evidence when he testified in Congress to help secure National Park protection for Sequoia and Kings Canyon, now can command a six-figure price on the fine art market.[11]

This book also seeks to dissect the difference between activist documentary photography and nonactivist documentary photography because most contemporary activist photography, both single image and multimedia, is of the documentary genre. Maybe activist photography begins at the point that a photographer thinks beyond the photograph, or when the photograph is not the end, rather the means to a solution even if the solution is nebulous. For that activist work that is documentary, this book seeks to affirm the value and relevance of documentary photography, which has been increasingly challenged by photographic critics in the past 15 years. In this digital age, critics question the relevance and veracity of the documentary image because it is so easy to seamlessly manipulate an image and because of the seemingly blurry moral line of editors and photographers.[12] Critics have declared traditional documentary dead many times, or if not dead, passé as a new generation of artists have coopted the genre of "documentary" by discarding process concerns and only emulating its aesthetic with images that are manipulated, staged, and constructed. So if images of horror, pain, and suffering are sold as art, and artists chose the documentary aesthetic with no connection to conscience or compassion, what power and veracity does a true documentary image have?

With the ubiquitous nature of social media as a main source of information, informed by the content posted by every "citizen photojournalist"[13] with a cell phone or a flip camera, even the professionalism of the documentary photographer is under assault. In the last chapter of this book, the reader will discover that documentary photography is not dead. It is vibrant and vital and being practiced by a new generation of very smart and very brave photographers. More than ever before, the world needs professional photographers to record the issues threatening our planet, to be the moral witness of the evil that man still is capable of doing to man.

Endnotes

1. All quotes from Jonathan Torgovnik are from interviews conducted by the author.

2. "Foundation Rwanda," www.foundationrwanda.org (accessed January 20, 2011).

3. John Locke, "Two Treatises on Government," *Laws of Nature and Nature's God, Book II, Chapter 2, The State on Nature.* www.lonang.com/exlibris/locke/loc-202.htm (accessed January 15, 2011).

4. It is impossible to find exact figures of how many women are being violated, but in 2007 Stephen Lewis, former UN Special Envoy for AIDS in Africa, remarked at a press conference in Kenya, "There is not precedent for the insensate brutality of the war on women in Congo. The world has never dealt with such a twisted and blistering phenomenon." Wairragala Wakabi, "Sexual Violence Increasing in Democratic Republic of Congo," *The Lancet* 371, no. 9606 (2008): 15–16. www.thelancet.com/journals/lancet/article/PIIS0140673608600513/fulltext (accessed January 20, 2011).

5. "Human Trafficking Statistics," *Polaris Project.* www.dreamcenter.org/new/images/outreach/RescueProject/stats.pdf (accessed January 20, 2011).

6. The original quote always attributed to Mary Harris Jones, one of America's most prominent labor and community organizers in the twentieth century, is "Don't mourn, organize," spoken after the death of a union organizer.

7. "Magnum Photos," www.magnumphotos.com (accessed January 25, 2011).

8. NYU Panel Discussion, *NYU and Magnum Foundation Discussion on Human Rights,* June 21, 2010. (Attended by author.) Panel summary: www.tisch.nyu.edu/object/NYUAND06082010114823.html.

9. Robert Adamson, a chemist, worked under Hill's direction and was interested in the quality of the light. He usually diffused the deep shadows that direct sunlight produces by bouncing fill light with a concave mirror.

10. Robert Hirsch, *Seizing the Light: A Social History of Photography* (Chicago: McGraw Hill, 2009), 219.

11. "Ansel Adams," *Photography Now.* www.photography-now.net/listings/index.php?option=com_content&task=view&id=361&Itemid=334 (accessed January 24, 2011).

12. In 1982 *National Geographic* magazine photo editors digitally "moved" two pyramids closer together so they would fit onto the magazine's vertical cover. In 1994, *Time* magazine digitally manipulated a mug shot of O. J. Simpson making Simpson's skin much darker (and more menacing) than it was on the unaltered mug shot published by *Newsweek* magazine. In 2006, a freelance news photographer retouched war images from Iraq to increase the size of a plume of smoke.

13. "About Us," *We Media.* www.hypergene.net/wemedia/weblog.php (accessed January 25, 2011).

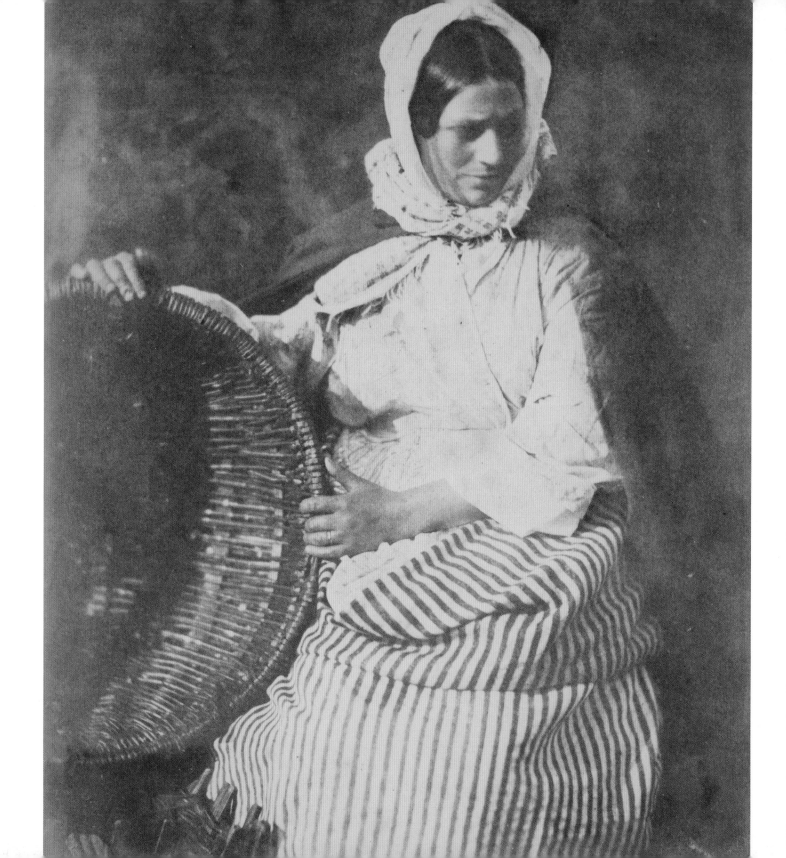

One

ACTIVISM: PRACTICE AND PROCESS

FIGURE 1.0 Robert Adamson, David Octavius Hill, *Mrs. Elizabeth (Johnstone) Hall, New Haven Fishwife (Beauty of New Haven)*, 1843–1846. Salted Paper Print 20.2 x 14.5 cm. Courtesy of George Eastman House, International Museum of Photography and Film

Philosophy and psychology

"The contemplation of things as they are without error without confusion, without substitution or imposture is in itself a nobler thing than a whole harvest of inventions."[1]

Sir Francis Bacon

Since the documentary genre comprises the majority of activist photography, it is important to define *documentary* for the purposes of this book. The definition of *documentary photography* in the twenty-first century is complex, multilayered, and nuanced. It is both process and aesthetic and applies to a broad range of imagery, from traditional, straight reportage-type images to the manipulated faux documentary images that appear on gallery walls. To some degree, all photography is documentary because all photographs document *something*. Each photograph is evidence of something that appeared in front of the camera. Walker Evans qualified the difference between a photographic document and documentary photography: "When you say documentary, you have to have a sophisticated ear to receive that word. It should be documentary style, because documentary is police photography of a scene and a murder ... that's a real document. You see, art is really useless, and a document has use. And therefore, art is never a document, but it can adopt that style. I do it. I'm called a documentary photographer. But that presupposes a quite subtle knowledge of this distinction."[2]

As documentary practice has evolved, and as our critical understanding of how images function has become more sophisticated, Evans' distinction resonates. Even though documentary applies to many types of photography today, the word *documentary* to describe photography dates only to the early to mid-1900s. Most historians credit Scots filmmaker and critic John Grierson with first applying the word *documentary* in 1926 to describe Robert Flaherty's nonfiction film *Moana* about the daily life of a Polynesian youth. Grierson noted that the film presented facts without any fictional overtones,[3] suggesting that authenticity is fundamental to documentary work, that documentary suggests an interest in the actual, not the subjective, and acknowledging that documentary's Latin word root is *doc, doct,* or *docere,* meaning "to teach" or "instruct."[4] Grierson elaborated, describing documentary as "... the selective dramatization of facts in terms of their human consequences,"[5] also setting the stage for the subsequent discussions about documentary and the myth of objectivity. In 1938, photographer Edward Steichen, when reviewing some photographs from the Farm Security Administration's (FSA) Photography Unit, wrote that the photographers produced a series of "... the most remarkable human documents that were ever rendered in pictures" because they were so direct that "they made many a citizen wince," leaving the viewer with a "feeling of a living experience" not soon forgotten.[6] As Grierson did for film, Steichen defined a new genre of photography—documentary—that, although fact based, succeeds best when it informs both the intellect and the emotions. The word *documentary* stuck because it aptly described the type of social reform photography common in America in the 1930s, represented by the early social reform photographers such as Jacob Riis and Lewis W. Hine. Their photographs were rooted in the fact of the thing (poverty, horrific living conditions, child labor), but the photographers knew that they needed to elicit emotion from their viewers because they understood that emotion provokes action.[7] They also understood that for an emotion to be valid the photograph must present and represent actual facts in a vivid and credible manner.[8]

The quest for a definition of *documentary* continued. In 1938, the word made its way into the lexicon of photographic history when Beaumont Newhall identified documentary as a means, not an end—an approach to a photograph, not the photograph itself. Newhall, then head of the Department of Photography at the Museum of Modern Art in New York City, wrote that the documentary photographer is "first and foremost ... a visualizer. He puts into pictures what he knows about, and what he thinks of, the subject before his camera. ... But he will not photograph dispassionately. ... He will put into his camera-studies something of the emotion which he feels toward the problem, for he realizes that this is the most effective way to teach the public he is addressing. After all, is this not the root-meaning of the word 'document' (*docere*, 'to teach')?"[9] In 1972, the Time Life Library of Photography's volume on documentary photography defined *documentary* as "a depiction of the world by a photographer whose intent is to communicate

something of importance — to make a comment—that will be understood by the viewer."[10] In his book *Doing Documentary Work*, psychiatrist Robert Coles riffs more poetically on the documentary genre:

And so it goes then—doing documentary work is a journey, and is a little more, too, a passage across boundaries (disciplines, occupational constraints, definitions, conventions all too influentially closed for traffic), a passage that can become a quest, even a pilgrimage, a movement toward the sacred truth enshrined not only on tablets of stone, but in the living hearts of those others whom we can hear, see and get to understand. Thereby we hope to be confirmed in our own humanity—the creature on this earth whose very nature is to make just that kind of connection with others during the brief stay we are permitted here.[11]

He will put into his camera-studies something of the emotion which he feels toward the problem, for he realizes that this is the most effective way to teach the public he is addressing.

In his essay from *Engaged Observers in Context,* Brett Abbot defines documentary as a term "... used loosely to refer to a wide variety of practices in which the subject matter of a picture is at least as important as its manner of portrayal."[12] He dissects the complexity of the genre, noting that it applies to a "remarkably diverse array of pictures, including landscape and architectural documentation of the nineteenth century ... Western survey photography ... socially engaged work ... portrait projects ... ethnographic studies; street photography; war photography of all periods; mug shots and crime-scene pictures."[13] If we accept Abbot's description, we're back to the notion that a lot of photography is, or can be considered, documentary, keeping in mind Evans' subtle distinction.

Even with this expansive definition, traditional documentary—unvarnished, straight, and unrepentant in its quest for truth—has been under attack for more than a decade by postmodern photographic critics and theorists, most notably Martha Rosler and Allan Sekula. The general assertions that photographs are not simple records, that they are not evidence, and that they can't be objective lead critics to challenge the very nature of documentary work. If, as critics claim, all photographs are suspect, contextual, complex layers of symbols and meanings laden with the photographer's hidden agenda, then how can documentary be truthful and representational? Critics claim that straight photography is boring and passé. Yet in spite of this criticism, documentary photography is thriving, and documentary photographers are still faithful to the notion of a truth, although maybe not *the* truth, and still pledge an allegiance to the idea that photographs can and should be rooted in the moment, not directed, not staged, and not manipulated. Even the sincerity of wanting to effect social change does not shield documentary work from the savages of criticism; rather it evokes another accusation that the documentary photographer who photographs a foreign culture perpetrates a visual form of colonialism. Rosler, in particular, criticized the idea of social documentary as a practice because it was not revolutionary enough: "Documentary photography has become much more comfortable in the company of moralism than wedded to a rhetoric or program of revolutionary politics."[14] In her seminal 1981 essay, *In, Around, and Afterthoughts (On Documentary Photography)*, Rosler claimed that documentary photography doesn't ever "change" anything; rather it simply transfers information about a "group of powerless people" (the subjects; otherwise, they wouldn't be photographed) to a much more powerful group (the elite gallery goers or viewers). "The exposé, the compassion and outrage, of documentary fueled by the dedication to reform has shaded over into combinations of exoticism, tourism, voyeurism, psychologism, and metaphysics, trophy hunting—and careerism.... The liberal documentary assuages any stirrings of conscience in its viewers the way scratching relieves an itch and simultaneously reassures them about their relative

wealth and social position; especially the latter, now that even the veneer of social concern has dropped away from the upwardly mobile and comfortable social sectors."[15]

Only those born into or those from a culture or community can truly understand that culture or community, or so it goes; hence, only the insider has the right to photograph inside that culture. This specious argument ignores the reality that insider truth is not necessarily more accurate than outsider truth. Misrepresentation, intrusion, and exploitation are as likely to occur when an "insider" photographs as when an "outsider" does. In fact, the outsider by the very nature of being an outsider may be more cognizant of the danger of exploitation. "There is an unsigned contract with the subject[s] that I will respect the essence of their experience. I want to be true to the truth of what I have experienced, interacting with the world with a degree of integrity, trying to understand culture and people and how the situation, the conflict, impacts human beings," says Natan Dvir, an Israeli photographer who has won acclaim for his series *Eighteen*, portraits of young Arabs living in Israel.[16] "Although I lived in Israel and photographed it most of my life, I felt I did not really know or understand its large Arab minority, born into an identity crisis. Most individuals I approached expressed great skepticism about my project—'Why would a Jewish person be interested in investigating an Arab person's life?' The initial tension waned down in most cases leading to interesting interaction."[17]

Fresh eyes may see more and tell more because an outsider has no emotional need to show only the positive aspects of a culture or only the politically "correct" side of an issue. Documentary photographers can be visually ruthless and unsympathetic when the situation does not merit sympathy. For example, for more than 10 years, Marcus Bleasdale has been photographing the effects of the brutality inflicted by the Lord's Resistance Army (LRA) on the civilian populations in the Democratic Republic of the Congo (DRC), Central African Republic, and Uganda.[18] The LRA, surely the most ruthless and vicious of Uganda's rebel groups, is most well known for abducting children as "recruits" (they have abducted more than 3,054 children since 2008 according to Human Rights Watch and United Nations documentation)[19] and mutilating those not abducted with a trademarked hacking off of ears, lips, and limbs. "What I've seen there is devastating," says Bleasdale, a member of VII Photo

Agency. "It is extraordinarily important that these people in these forgotten zones have a voice and that the United States fulfills its obligation under the bill that President Obama signed that pledges to provide money and logistical support to finally end the LRA's reign."[20] Bleasdale is a model for the contemporary activist. His work on human rights and conflict has been shown at the United States Senate, the United Nations, and the Ministry of Foreign Affairs in France.

Many other issues and conflicts benefit from an outsider voice, or maybe could be told by only an outsider who sometimes has more access, funding, and the means to distribute the work. It's hard to imagine how Rosler's completely disenfranchised and powerless groups could find the means to transfer information about themselves. Walter Astrada credits being foreign with getting him access for his award-winning photographs depicting the endemic violence against women in India. The project, partly funded by the Alexia Foundation, was exhibited at the 2010 Visa pour l'Image in Perpignan, France. "In India, if you are foreign, it helps because they are very conservative. They would grant me, as an 'other,' access that would not be granted to an Indian photographer," says Astrada, now a member of Reportage by Getty.[21]

Larry Towell, renowned documentary photographer and a member of Magnum Photos, carries a business card that reads simply "Human Being." That is the point, really. As a human being who cares deeply about humanity, Towell, as an outsider, can still bring an insider sensibility. He believes in very long-term photographic projects because he wants to be so familiar with the cultures that he photographs that they cease to be exotic.[22] Beginning in 1986, he traveled to El Salvador as part of a human rights delegation and spent more than 12 years photographing the civil war and the aftermath. He also has spent years photographing in the Middle East, and more recently, Mennonite migrant workers from Mexico who live landless and economically marginalized near his home in Canada. Towell developed such a close "insider" relationship with the Mennonites that they allowed him to travel with them on their annual journeys back to Mexico in the winter.

Activist photographer Susan Meiselas, known for her coverage of the war in Nicaragua and her documentation of human rights issues in Latin America, insisted that her 1981 monograph, *Nicaragua*,

Larry Towell, renowned documentary photographer and a member of Magnum Photos, carries a business card that reads simply "Human Being."

photography that is as applicable to documentary: "Landscape photography can offer us, I think, three verities—geography, autobiography and metaphor. Geography is, if taken alone, sometimes boring, autobiography is frequently trivial, and metaphor can be dubious. But taken together ... the three kinds of information strengthen each other and reinforce what we all work to keep intact—an affection for life."[25]

the result of a two-year project, be published in both Spanish and English because she felt deeply connected to the situation in Nicaragua. In 2004, she returned to Nicaragua with 19 mural-sized images of those original photographs and collaborated with local communities to install the work in public spaces to create a dialogue about collective memory.[23]

They are not precise. They are never unequivocal. A documentary photograph, even a "truthful" one, never really "tells" us anything.

The tenor of postmodern criticism of documentary work has become just snarky because it ignores the fact that documentary photographs are as pure as photography can be. They function as a social lens and can be both a "mirror" and a "window."[24] A documentary photograph makes the random, accidental, and fragmentary details of everyday existence meaningful while preserving the actual details of the scene. It simultaneously hosts an internal dialogue (content, style, the transformation of reality into a two-dimensional representation) and an external dialogue that changes as the time changes. Today, for example, we look at photographs differently than a nineteenth-century viewer would. Although rooted in reality and human attempts at objectivity, documentary photographs are not linear, but then no photographs are. They are not precise. They are never unequivocal. A documentary photograph, even a "truthful" one, never really "tells" us anything. Even though it is rooted in the actual, it suggests and alludes, like poetry and music. However, documentary photography, as a form of representational reality, is as close to truth, albeit poetic truth, as anything other than experience can be (and even experience is mediated by memory). Noted essayist Robert Adams wrote a passage about landscape

That affection for life, passion, a personal urgency that can be quelled only by making images of a certain issue, drive documentary photographers and more so activist photographers who work in a documentary genre. To paraphrase F. Scott Fitzgerald (from his short story "The Rich Boy"), documentary photographers are different from you and me. Psychologists suggest that a person's mental context informs the degree to which that person involves herself or himself in activism or social movements. As humans, our mental context emerges from all the elements in our culture that surround us, that are outside us, often unknown to us, that gradually become part of our personalities and character and transform us into the social beings we become. Who, what, why, and when we care about an issue enough to endure whatever physical hardship it will take to photograph it emerge from the complexity of our lives. Activists, as a group, are more empathetic, maybe, more often moved by what they see. It's harder for them to look away. "[When you're] a journalist, the ground rule is that you don't get involved. You are there to cover the story," says Kristen Ashburn. "I struggle with that because being a human being trumps everything and sometimes I can't just

walk away."[26] Although Ashburn admits to being uncomfortable with the "activist" label, she has repeatedly used her photographs in various ways to raise money to help people or groups she has photographed.[27]

As a group, activist photographers are uniquely comfortable in their own skin, secure enough to work and live in different cultures, places, and social milieus. They have a preternatural ability to relate to and connect to people, a key trait because the subject of a documentary photograph is never the "issue"; it is the person or place impacted by the issue. Genocide is an abstract idea, but it becomes personal through Jonathan Torgovnik's photographs of, and interviews with, Tutsi women who are rape victims and survivors of the Rwandan genocide. The deeply personal stories they tell Torgovnik in the multimedia piece and book *Intended Consequences* occurred only because they trusted him. Activist photographers also are patient, willing to wait for the contact, for the entry into the story, for the perfect photograph. As documentary filmmaker Fred Wiseman says, "If you hang around long enough, you stumble onto sequences that are funnier, more dramatic, and sadder than anything you can find, except in great novels. You're not inventing them. You're just lucky enough to be there when they happen."[28]

Documentary photographers are brash, determined, brave, autonomous, independent, resourceful, and enduringly optimistic despite having seen and experienced the worst face of humankind. "I don't feel fear when I am shooting," says Stephen Dupont, an award-winning Australian photographer for Contact Press Images, who has photographed in some of the world's most dangerous conflict zones, including Afghanistan, where he has been pursuing a long-term project for 15 years, and once literally escaped death.[29] "I know that sometimes I am photographing in a dangerous situation, but I block the fear and allow adrenaline, passion, and excitement to fuel me, or I couldn't do it and some stories just have to be told." For the interviews for his book *Rich and Poor*, if necessary, Jim Goldberg would tell his subjects that what they told him wasn't frank or interesting enough, to provoke the remarkable personal confessions he needed.[30]

One characteristic of activism, I think, is that it is always marked by a lifetime pursuing long-term personal projects, funded any way possible. "Since I pay my own way, I don't cover a story unless I feel strongly connected to it, so it is always personal for me," says Dupont, who admits to having an activist agenda. "If I am not passionate about a story, I won't make good photographs." An activist project might begin as an assignment, as Stephanie Sinclair's project on child marriages did, but it will end months or years later.[31] Although seeking "truth," activist photographers often admit that they are not objective. "Even if we are subjective, we are still trying to uncover the truth. I am a seasoned journalist. I am a professional so I seek honesty, but I am not objective," says Stephen Shames,[32] an award-winning social documentary photographer. He is also founder of L.E.A.D Uganda, a nonprofit organization that supports extraordinary but "forgotten" children in Uganda, such as AIDS orphans or former child soldiers, and molds them into leaders by sending them to the best schools and colleges.[33]

"The difference between documentary and activism is the degree to which it becomes personal," says Torgovnik. "Objectivity is not possible. A photographer always has a point of view." As media producer Brian Storm, president of MediaStorm,[34] an award-winning multimedia production studio, says, "I've long ago crossed that line of being an objective journalist. I'm an advocacy journalist. I make no bones about it. I describe our organization as a purpose-driven organization, not a profit organization."[35]

Activist photographers use the camera to investigate issues and events from social, cultural, and often psychological perspectives. Glenn Ruga, cofounder of socialdocumentary.net, another of the new websites featuring international documentary work, says (describing human rights photography, but applicable to all activism): "Human rights photography is actionable, not representational. In other words, the power of the work is to make change. It's not strictly to represent something out there in the world, but the act of presenting this work and looking at this work itself can make change. . . . Unlike [in] traditional journalism, we . . . encourage a point of view. The work must be fundamentally about the subject, not about the photographer."

Content defines activist photography maybe more than style does, which is not to suggest that all activist images look the same. Aesthetic concerns drive contemporary activist photographers, but not to the degree that the aesthetic overrides the content or the process. "We, as

photographers, aren't important," says Torgovnik. "We are the voice of the story." Activist work is all deeply personal, but marked by intellectual analysis. "I choose to photograph what touches me," says Sinclair. Although her initial impulse is an emotion, she rigorously researches her topics before she shoots, behavior typical of activist photographers. Ask Bleasdale about his Congo images, and he will tell you about the economic situation. Ask Walter Astrada about his photographs for *Undesired: "Missing" Women in India,* and he will cite the statistics of how many female fetuses have been aborted in India because families prefer male children (millions), how many women have been burned or killed because of dowry disputes (7,000 annually), or the cost of a bride from a poor family in West Bengal or Bihar ($561 to $2,360).[36]

An intent to communicate and the photographer's unshakable belief that the photograph has a unique ability to provoke emotion underlie all activist photography because the photograph is so uniquely suited to being able to balance intellectual and sensory understanding. Activists believe that the viewfinder can—or maybe must—be a political instrument. "A single image can make a change," insists Ed Kashi, an award-winning photographer and member of the VII Photo Agency, most well known for his work on the plight of the Kurdish people and the impact the oil industry has had on the Niger Delta region. Kashi tells a story about a letter he received from a woman who saw his photograph of a Nigerian boy carrying a dead goat above his head from his Niger Delta slaughter story (Figure 1.1). The woman was so moved by the photograph that she and her church group located the boy and are now paying fees to send him to school. From a mega perspective, this one boy's schooling is a *de minimis* social change, but for that one boy, it is a profound, transformative mega change that did much more than simply "transfer information," as Rosler suggests is the weakness of documentary images.

Activist photography is marked by a passionate voice and a moral vision. "I need a damn good reason— beyond that it is my work—to make photographs," says Kashi. "I am driven by something much deeper than the image itself."[37] Activists can't separate photography and politics. An activist's "magnetic-truth" north doesn't point north exactly; it points to the wrongs that need to be righted. "I have been working in human rights my whole life, and I don't think that I have changed anything, but that doesn't matter. It is being involved in the process of change that matters," says Towell.[38]

Activist documentary photography does not focus on the familiar, and the content is not memory and identity, as is the conceit of contemporary "fine art" documentary, or documentary mode photography. "Activism is different even than issue-oriented journalism because activism focuses on solutions," says Shames. Noted Swiss documentary photographer Robert Frank said, "Above all, I know that life for a photographer cannot be a matter of indifference."[39] While Frank was not speaking directly to activism, his statement stands. Bleasdale wants his photographs to educate the public and influence public policy. When asked how he handles the emotional fissures that occur when a person spends months or years witnessing horrible events, he says: "What I see has made me angry, and I want to maintain that anger because the photograph itself is not the end. It is only the first step in a process to enforce change. If I can channel my anger, I remain passionate. If I pacify my anger, my job is impossible."[40]

Sebastião Salgado, a self-described activist and one of the most important documentary photographers of the twentieth and twenty-first centuries, describes photography as an ideal expression of activist ideology: "Everything that happens in the world must be shown to the other people

> What I see has made me angry, and I want to maintain that anger because the photograph itself is not the end. It is only the first step in a process to enforce change. If I can channel my anger, I remain passionate. If I pacify my anger, my job is impossible.

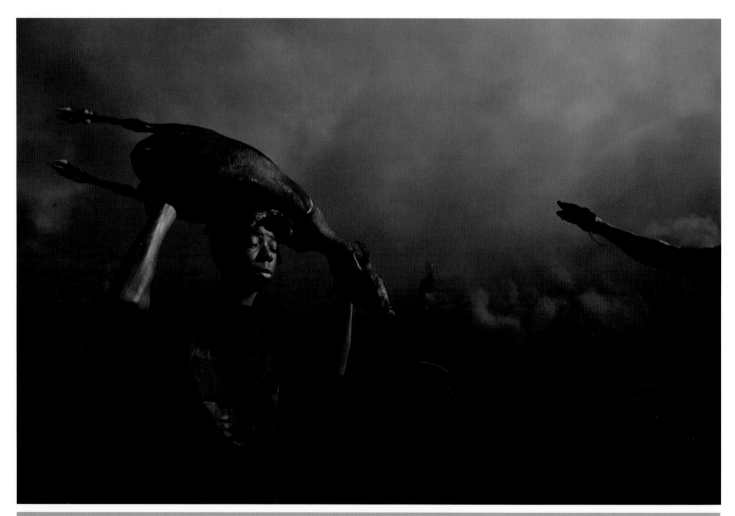

FIGURE 1.1 Ed Kashi, *Untitled* from *Niger Delta Slaughter*, 2006. ©Ed Kashi/VII

around the world ... this is the function of the vector that the documentary photographer must have, to show one person's existence to another. ... The most interesting function of this kind of photography is exactly this: to show and to provoke debate and to see how we can go ahead with our lives. The photographer must participate in this debate."[41]

Activist documentary photography is most essentially the thing itself, as defined by John Szarkowski in the introduction to the catalog of the exhibition *The Photographer's Eye*. "The first thing the photographer learned was that photography dealt with the actual; he had to not only accept this fact, but to treasure it ... he also learned that the factuality of his pictures, no matter how convincing and unarguable, was a different thing than the reality itself. ... It was the photographer's problem to see not simply the reality before him but the still invisible picture, and to make his choices in terms of the latter."[42] Activists seek to illuminate that invisible picture, to amplify that unheard voice, to reveal that untold story. "Liberty lies in the hearts of men and women, when it dies there, no constitution, no court can save it,"[43] This statement, made in 1944 by Judge Learned Hand (to date, the most oft-quoted U.S. judge in history) at a speech commemorating being an American, could describe activist/ advocacy photographers. Activist photographers, particularly those dealing with human rights photography, are always seeking some evidence necessary to maintain, retain, or restore liberty for someone somewhere because they know the truth of Hand's statement.

Finally, it is important to note that all documentary photography is not activism. Many great documentary photographers think their only role is to take the photographs. And activist work is not always documentary photography, even though that is the subject of this book. For example, Alfredo Jaar's extraordinary art pieces depicting the genocides in Rwanda are as powerful as any documentary photographs of that event, but they aren't documentary.[44] Shimon Attie, a photographer and video installation artist whose research focuses on memory, place, and identity, employs photography, video, sound, and text to introduce the history of "marginalized and forgotten communities into the physical landscape of the present."[45] Carlos Motta uses video, installation, and photography to comment on political events and the effect of those events and to suggest alternative ways to read and write those histories.

History: early activism

Even though the term *documentary* was not applied to film or photography until the early 1900s, the idea of using the camera to document places, people, and objects dates to photography's invention. Early photographers realized that rendering reality was the one thing that the camera could do better than any other medium, and grasped its unique potential as an activist tool. One of the first recorded funded "documentary" projects was the Missions Héliographiques, organized in 1851 by the French Commission des Monuments Historiques to develop an archive of French monuments and buildings. The Commission intended to use the photographs of the decaying buildings to raise money to restore them. For this early prototype of the FSA project, the French government hired Gustave Le Grey, Édouard Baldus, Hippolyte Bayard, Henri Le Secq, and Auguste Mestral, among others, and assigned each to photograph the decaying buildings in a specific region. Together, the team made more than 300 images (prints and plates), but most of the images were not published for almost a century.[46] Unfortunately, the project didn't succeed in raising money and most of the buildings were not restored, because ironically the photographers made such beautiful photographs that the buildings didn't look as though they needed repair and the public failed to respond.[47]

Nineteenth-century British archaeologists and adventurers traded their pens and sketchpads for daguerreotypes and calotype paper negatives. Certainly, to them, the camera lens seemed like the perfect scientific tool to produce an objective record. The documentary dilemma was then, and still is, that the lens is attached to a camera controlled by a photographer who is always making subjective judgments that alter the objective reality of the situation. As Lewis Hine is oft quoted, "While photographs may not lie, liars may photograph." Although the early documentary photographers thought they were rendering reality objectively, not intending to lie when they manipulated a scene or even thinking about the subjective/objective dichotomy, contemporary analysis and critical theory suggest they often "lied." The critical analysis about the impact of subjectivity inherent in representational

reality of a supposedly objective photograph would come long after early photographers posed, manipulated, staged, and re-created photographs that viewers long believed were "true" or at least natural.[48] Oblivious to the concerns about subjectivity versus objectivity, these early documentary photographers mastered their medium, and enamored by the camera's ability to record reality, they turned their cameras toward the social conditions that surrounded them. Because most of the early photographers, particularly those in Britain, were affluent amateurs, they were, like their Victorian contemporaries, fascinated by the "working man," a new class being formed by the Industrial Revolution. Whether intentional or not, they made the first "activist" photographs, composing, staging, and manipulating the scenes as needed by the limitations of the photographic technology then: slow lenses and slow recording media that required long exposures.

As with much early photography, our understanding of documentary history exists only from what has survived because many early plates, daguerreotypes, and calotypes have been lost. Among what has survived are the first activist photographs made in Newhaven, Scotland, between 1843 and 1845 by David Octavius Hill and Robert Adamson. Hill, a noted painter, teamed with Adamson, a chemist and one of Scotland's first "professional" portrait photographers, to work with the calotype "paper" process. Adamson realized that the softer form of the calotype's paper negative and its warm sepia to purplish tones had an aesthetic quality lacking in the more detailed daguerreotype. With Hill's artistic eye and Adamson's technical skills, the team enhanced the aesthetic of the calotype portrait with a chiaroscuro lighting effect, made by bouncing light into an outdoor scene with a large concave lens. By suppressing detail and making light the subject, they injected emotion and atmosphere into their images. Their lighting technique enhanced the relationship of the subject to the surrounding space by shifting focus and emphasis to the person and the expression, not on the detail of the background or objects in the photograph that would have been highlighted by the daguerreotype.

The team used this technique to produce a remarkable body of photographs of fisherfolk in Newhaven, an isolated fishing village about a mile and a half from Edinburgh. Although life was difficult in Newhaven, the 130 images produced by Hill and Adamson suggest a tightly knit, interdependent community. Hill and Adamson may have been interested in photographing Newhaven because the rising industrialization in nearby Edinburgh focused attention on the poor living conditions of the urban lower class and they realized the potential of an encroaching poverty imposed by the traditional fishing village way of life. However, unlike their portrait work, these images were not commissioned, another characteristic of activist work: It is most often self-assigned. Photographic historians generally believe that Hill and Adamson thought they could sell albums of the prints to their Edinburgh society clients to raise money to improve boats and fishing tackle to make fishing safer for the fishermen.

In addition to his more typical portraits, although in natural light, Adamson made candid photographs of daily life: fisherman tending their boats or fishing lines on the shore (Figure 1.2), fisher wives selling the catch in the streets, or women gathered in a group to read a letter (Figure 1.3), the content of which was obviously important as evident from their facial expressions. Adamson's images, shot outside in open daylight, were direct and tightly composed, and felt natural, even though the images technically required exposures as long as two minutes. Although the project reinforced existing class distinctions on one hand, it also elevated some of its subjects to the same status as the affluent Edinburgh people who Adamson usually photographed in his studio. Rather than just using generic titles, such as "fisherwoman," Adamson titled some of the Newhaven images by the specific person's name, such as *Mrs. Barbara (Johnstone) Flucker, Opening Oysters* (Figure 1.4) or *Willie Liston Redding the Line*. One image in particular, titled *The Beauty of New Haven* (Figure 1.0), could have been a socialite portrait taken in his studio, but for the dress the "Beauty" wore. Although it is not clear whether they succeeded in raising money, Hill and Adamson's photographs, which went beyond the simply factual, are a study of a community on a scale not repeated until the mid-twentieth century, and they set a standard for what a documentary study could and should be.

Henry Mayhew, a newspaper reporter, expanded the documentary genre when he produced three volumes titled *London Labour and the London Poor* in 1851, illustrated by daguerreotypes he commissioned photographer Richard Beard to take. The daguerreotypes, which unfortunately did not survive, were made into woodcuts for the book.

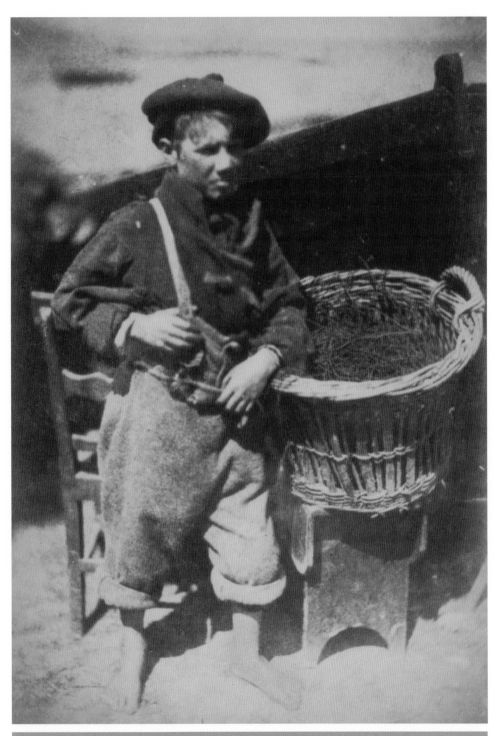

FIGURE 1.2 Robert Adamson, David Octavius Hill, *Newhaven Fisherboy,* ≈1845. Calotype print, 5 ½ x 7⁶/₁₀ in., Library of Congress, Washington, D.C. **Public Domain**

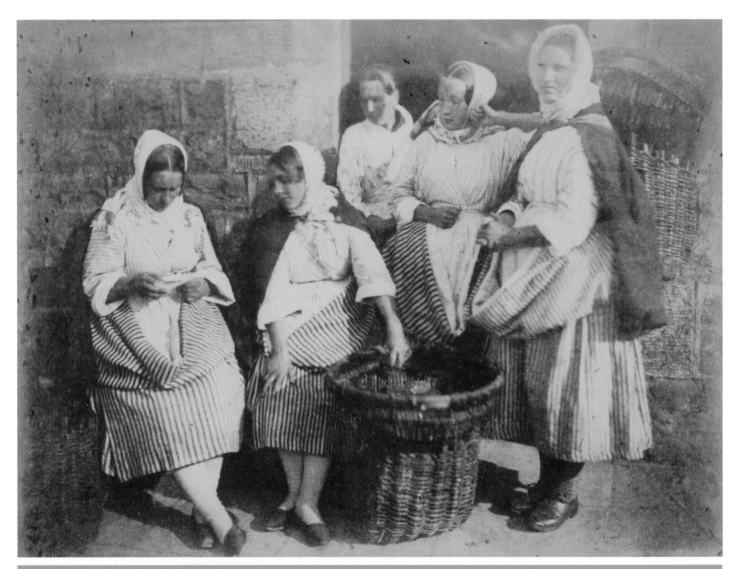

FIGURE 1.3 Robert Adamson, David Octavius Hill, *Newhaven Fisherwomen*, "*The Letter,*" ≈1845. Salted Paper Print, 14.6 x 19.7 cm. **Courtesy of George Eastman House, International Museum of Photography and Film**

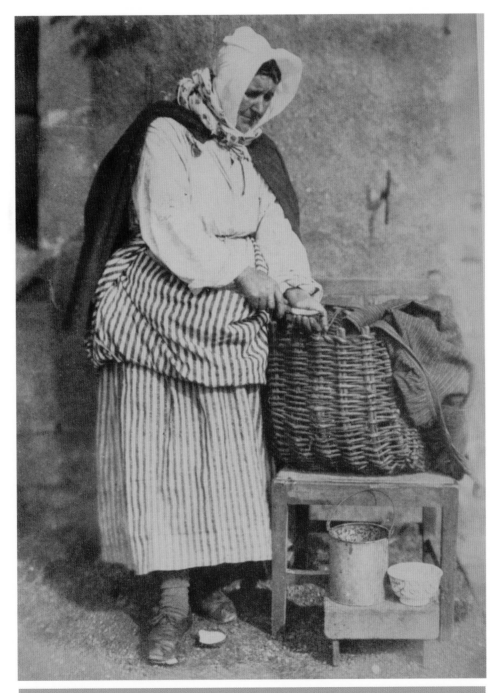

FIGURE 1.4 Robert Adamson, David Octavius Hill, *Mrs. Barbara (Johnstone) Flucker, Opening Oysters*, Salted Paper Print, 20 x 14.6 cm. **Courtesy of George Eastman House, International Museum of Photography and Film**

The woodcuts, which look like sketches, eliminate the backgrounds so the photographs almost look as though they could have been taken in a studio. The book combined the woodcuts with field interviews of London's urban poor, which became a model for the grand tradition of sociological documentation made famous by the epic collaboration between writer James Agee and photographer Walker Evans: *Let Us Now Praise Famous Men*. Continuing in Adamson's and Mayhew's tradition, Scots photographer John Thomson also produced a photographic survey of London's poor, working with writer and social reformer Adolphe Smith (Headingley). Their collaboration, *Street Life In London*, was originally published in 1877 in 12 monthly installments and then later as a book. They acknowledged Mayhew's work, considering theirs to be a sequel and also intending to raise awareness of the working poor. In the report, Smith argued that the "indisputable precision of this report will show real cases of London poverty, without adding or subtracting from the true lives of the poor."[49]

This "true" life came in part from Thomson's belief that the camera should produce an objective document, so, unlike Adamson who used lighting to enhance the aesthetic of the image, Thomson didn't use special lighting techniques. Like Adamson, however, he photographed people in their natural environment. Each image also was accompanied by text describing the living and working conditions of the subject. Although Thomson's photographs were direct and unadorned, they often were intense because the viewer is not shielded from the subject by an aesthetic layer. For example, one of his most powerful images from *Street Life* is called *The Crawlers* and depicts an old woman, sitting on a stoop asleep or almost asleep with her head resting against a wall (Figure 1.5).[50] She's dressed in tattered clothes, but she's holding a baby in her arms, obviously not hers because she is too old. She and the cold, hard-textured wall she uses as a pillow are the focus of the image, and her fatigue and utter poverty are palpable. The focus falls off in the background.

Scottish photographer Thomas Annan continued the tradition. Annan, owner of a photographic business in Glasgow in 1855, was commissioned by the Glasgow City Improvement Trust to document the city's slum areas and squalid living conditions (Figure 1.6), similar to what Jacob Riis would do later in New York City. Unlike Riis, Annan

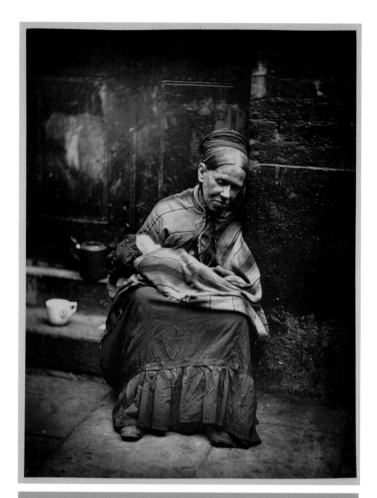

FIGURE 1.5 John Thomson, *The Crawlers*, 1876–1877. Woodburytype, $3^2/_5$ x $4^1/_2$ in. Courtesy of George Eastman House, International Museum of Photography and Film

approached his work almost architecturally; people usually do not appear in his images, or if they do, it is peering though a window or a dark passageway, rendering them small and powerless, reinforcing Annan's message about the sheer squalor of their living conditions. These dark, sad images linger and resonate.

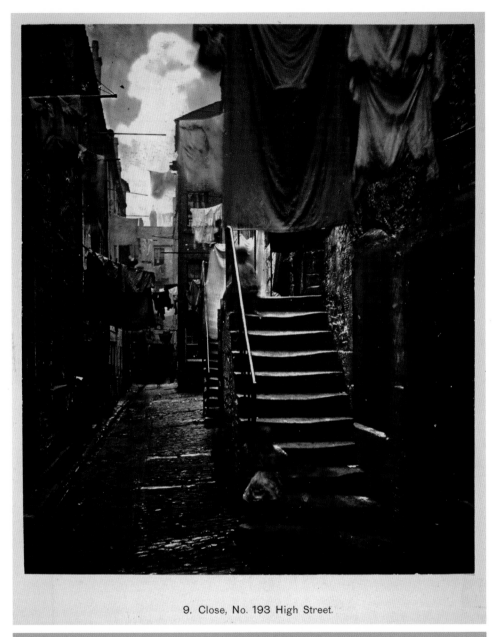

9. Close, No. 193 High Street.

FIGURE 1.6 Thomas Annan, *Close, No. 193 High Street*, 1868. Carbon print 27.3 x 23 cm. Courtesy of George Eastman House, International Museum of Photography and Film

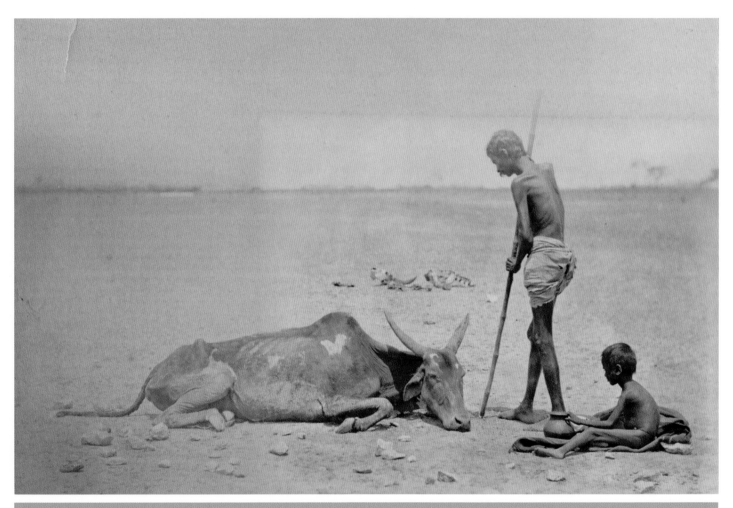

FIGURE 1.7 William Hooper, *The Last of the Herd*, 1876–1878. **Courtesy of The Royal Geographical Society, London**

Other photographers from this era traveled to find images of the same horrible conditions that activist photographs image today. British photographer William Hooper shot the first "famine" photographs in Madras, India, in 1876. Although these images are not as elegant as the ones shot in the Sahel region of Africa in the 1980s by Salgado, Hooper had an artistic eye for space and perspective. One of his photographs, titled *The Last of the Herd*, has a classic composition (Figure 1.7). A cow, starved to nothing but skin and bones with its ribs protruding, is so weak it can't move and lies about midpoint in the frame. The two peaks of its horns frame another cow skeleton lying just behind it, in the upper third of the frame. A man, also reduced to literal skin and bones, stands over the cow, leaning on a staff, and the viewer can feel the man's desperate need to get the cow, probably his only remaining possession, to stand up. The man's starving son, also so weak he can't stand, sits on the ground, almost eye level to the cow. A barren parched desert comprises the rest of the frame. The Victorian upper class had never seen this kind of reality (and a hundred years later, most Americans had the same reaction to Salgado's images from the Sahel), and from the responses of the Victorians, photographers realized the power images had to provoke emotion and compel action.

Anthropologists, scientists, and doctors also realized that the camera was a wonderful tool for scientific studies, often focusing on mentally ill patients. Although most were for scientific study, sometimes the images were used to raise money to benefit the patients. In France, again, individual daguerreotypes of mental patients taken by an unknown photographer were printed as one large piece, to advertise a lottery to benefit the patients.[51]

Although other photographers photographed social conditions, their intents were much different. Dr. Thomas John Barnardo, an evangelical missionary, was the first to use photographs to raise money for charity, although in his case it was his charity, the "Home for Working and Destitute Lads." Between 1874 and 1905, he either produced or commissioned about 55,000 "before" and "after" portraits printed almost as *carte de visites* of the children his home supposedly helped. In the before photographs, the children were always dirty, barefoot, and dressed in tattered clothes. In the after photographs, the children appeared clean, happy, well dressed, and industrious after being rehabilitated by Barnardo.

Although the images were effective in raising money, Barnardo was accused of fabricating the before images by dressing the children in torn clothes he owned, and posing them in decaying environments not representative of their real situations. He was brought to court on "charges of capitalizing on the children by putting them into fictitious settings and altering their appearances to benefit his fundraising operations."[52] Barnardo refused to repent, claiming that he was seeking "generic rather than individual truths about poverty."[53] This idea of generic truth still haunts documentary photographers today. Viewers still want the camera to tell *the* truth when in fact all a photograph can do is tell *a* truth. While not as unvarnished as Barnardo styling his images, every choice a documentary photographer makes (where to stand, what lens to use, where to point the camera, when to push the shutter, what to include in the rectangular or square viewfinder) changes the *individual* truth.[54]

History: early conflict and war photography

"I hope to stay unemployed as a war photographer till the end of my life."[55]

Robert Capa, at the end of World War II

Of all the early genres of photography, war photography has an activist message, intentional or not, because photographs rendered war accessible. For the first time, the civilian viewer saw actual battlefields littered with bodies and armaments, or what death really looks like. It never looks heroic. As imperfect as photography can be, war photography still is viewed as the best witness to war, because despite technological limitations or censorship imposed by a government agency, a photographer can make a photograph only if she or he is physically present. After one experiences war, even if only through a photograph, it is much harder to be gung-ho. The war photographs from Vietnam provoked the antiwar movement, and the Abu Ghraib images in 2004 forever shifted public opinion about the war in Iraq and tainted America's image worldwide.

Even though early war photographers were focused on just physically documenting war, not making activist statements, their

photographs had an antiwar message, as all war photographs do. What acclaimed activist photographer W. Eugene Smith said about his World War II photography rings true for most war photographers: "I wanted to use my photographs to make an indictment against war. . . . I hoped that I could do it so well that it might influence people in the future and deter other wars."[56] As award-winning photographer James Nachtway says of his decision to become a war photographer, "I was driven by an inherent sense that a picture that revealed the true face of war would almost by definition be an antiwar photograph."[57]

Prior to the first war photographs, artists depicted war as symbolic and heroic. The early photographs—daguerreotypes and calotypes—presented a different reality, a reality of raw, horrific detail, which initially publishers did not want to publish for fear of offending viewers. The same debate occurs today: When are war images too gruesome for the general public? As do today's conflict photographers, early war photographers faced philosophical and technical difficulties when they tried to document the experience of war and the causes and realities of conflict. In the twenty-first century, the philosophical dilemma arises, because since 2003, in covering the wars in Iraq and Afghanistan, photographers have to embed in, or attach themselves to, a military unit. To be embedded, photographers sign contracts agreeing not to release photographs unless or until the military approves them. Photographers travel with and depend on the troops, which creates a closeness that poses an inherent conflict of interest. "You try to tailor your story to what you need; however, you try not to get the guys in trouble," says Finbarr O'Reilly, Reuters chief photographer for West and Central Africa and winner of the World Press Photo of the Year in 2006.[58]

When a conflict occurs between what a photographer thinks is an important underreported truth and the military commander labels unacceptable, the military prevails if the photographer ever wants to photograph that war again. What a military deems unacceptable can be odd. When O'Reilly was embedded with a unit in Afghanistan, early one morning he shot a photograph of soldiers, waking up and putting on clean white socks sent by families, not their wet and dirty military-issued socks.[59] This innocuous photograph was banned by the military because white socks aren't military issue and so are "unprofessional."[60] O'Reilly, noted for an activist documentary he coproduced, *The Ghosts of Lomako*, about conservation in the Democratic Republic of the Congo, and a documentary he directed, *The Digital Divide,* about technology in the developing world, acknowledges the potential conflict of interest but says, "Photographers go to places like Afghanistan and get embedded to keep the flow of information coming, and to document major political developments of our time."

Other war photographers, such as freelance photographer Zoriah Miller, who don't adhere to the rules of an embed are removed from the embedded position and sometimes banned from all military facilities throughout the world. Miller's transgression was to photograph dead and injured U.S. soldiers killed on June 26, 2008, by a suicide bomber in Garma, Iraq, in Anbar Province, and post the images on his personal website (Figure 1.8).[61] The images are graphic, but no more so than most images of dead soldiers. Although the U.S. Army's official position is that posting these images created a security risk, it's clear that the army prefers a more sanitized version of war of which bodies of dead or injured soldiers are not dismembered or grotesquely disfigured.

> It's clear that the army prefers a more sanitized version of war of which bodies of dead or injured soldiers are not dismembered or grotesquely disfigured.

Early photographers faced a different philosophical dilemma: how to accurately document conflict with cumbersome equipment that required sensitized materials that had to be prepared and developed on the spot and required long exposures. Although an artist could re-create a scene for maximum effect, photographers were limited to what happened in front of the lens. So if action couldn't happen in front of their lenses, or if it happened too fast for them to

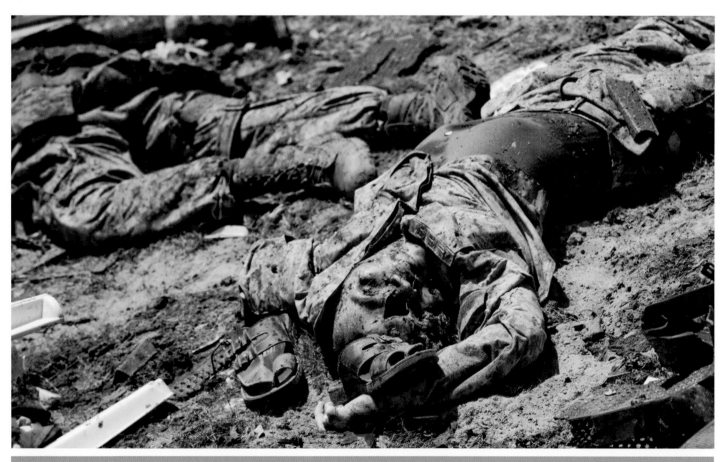

FIGURE 1.8 Zoriah Miller, *Untitled*, June 26, 2008, Garma, Iraq. Zoriah/www.zoriah.com

be able to record it, they resorted to finding or staging events that symbolically replicated what they really had seen. Today, although we accept the manipulated truth of embedded journalism, staging a scene or changing too much in digital postproduction would end a photographer's career.[62]

Roger Fenton, a well-bred Victorian gentleman, became the first serious war photographer. In 1855, the publisher Thomas Agnew & Sons, under auspices of Her Majesty's War Office, hired Fenton to travel to the Crimea to photograph what was then an unpopular war. Fenton traveled with 700 glass plates packed in shockproof boxes. The wet collodion plates had to be prepared in advance and processed immediately, so he equipped his traveling van with five cameras, several boxes of chemicals, a still, basins, and water tanks, one holding distilled water. Fenton so believed in the historical importance of what he was doing that he stayed despite the heat, dust, and general hardship, until cholera forced him back to England. Shortly after arriving in Balaklava, he wrote to his friend William Agnew: "I cannot make up my mind to leave until I have secured pictures of the persons and subjects likely to be historically interesting."[63]

Even with his sense of the historical importance of what he was doing, Fenton did not make classic war photographs; he photographed the war discreetly, producing staged portraits of officers in camp, officers on horseback in full officer regalia, moments of soldiers laughing or eating, waiting in camp, and war accessories. Fenton knew that these quasi propaganda photographs of an idyllic and corpse-free war, which did not represent the experiences he described in letters home, would not offend the Victorian sensibilities of his patron's customers.

He did convey some of war's reality, however, by photographing the aftermath of battle: desolate and barren battlefields (but without dead soldiers). One of his most famous photographs, *The Valley of the Shadow of Death* (Figure 1.9),[64] is a cannonball-strewn landscape of a place where many British troops were killed, and the inspiration for the Alfred Lord Tennyson poem "The Charge of the Light Brigade." When Fenton's photograph was exhibited in 1855, the editor of the *Photographic Journal* in London who thought the show was "the most remarkable and in certain respects the most interesting exhibition of photographs ever opened"

described this image "with its terrible suggestions, not merely those awakened in the memory, but actually brought materially before the eyes, by photographic reproduction of the cannon-balls lying strewd [*sic*] like moraines of a melted glacier through the bottom of the valley."[65] Because Fenton arrived at the battlefield months after the battle, and because he took two images of the scene, one without any cannonballs, photo historians suspect that he and his assistants scattered the all-important cannonballs, which symbolize the dead soldiers, in the foreground (much the same way that Mathew Brady and Alexander Gardner re-created Civil War images).[66] Even if Fenton did move cannonballs, this image, so stark, so palpably real, had a profound impact on viewers because the cannonballs as tokens of the violence imparted the physical sense of war.

Other photographers of the Crimean War, many of whom are unknown, were not as discreet as Fenton. James Robertson, an accomplished British landscape photographer, produced about 60 images far more explicit than Fenton's. Other images of maimed soldiers survived, and although the photographers are unknown, the antiwar sentiment seems obvious. One portrait, titled *Sergeant Dawson, Grenadier Guards, wounded in the Crimean War*, shows Dawson, posed with his daughter, but he can hug her with only one arm, the other arm missing, the sleeve hanging empty. Dawson expresses sadness and resignation; his daughter expresses fear. Some of these unidentified images have been attributed to British photographer John Jabez Edwin Mayall (often identified simply as J. E. Mayall), a British society portrait photographer most well known for making the *carte de visite* chic in England when he published The Royal Album, a group of 14 carte portraits of Queen Victoria, Prince Albert, and other members of the royal family.

The photographs from the Crimean War established the importance of war photography. The viewers who did not look away saw the reality of war as only photography can show it. War is not heroic. Soldiers are tired, hungry, and dirty. Men die. Corpses rot in the field. Munitions destroy the landscape. The wounded and maimed writhe in pain in field "hospitals."

The first comprehensive war coverage occurred during the American Civil War, photographed almost from the early Union defeat at Bull Run to the Confederate surrender at Appomattox, solidifying the

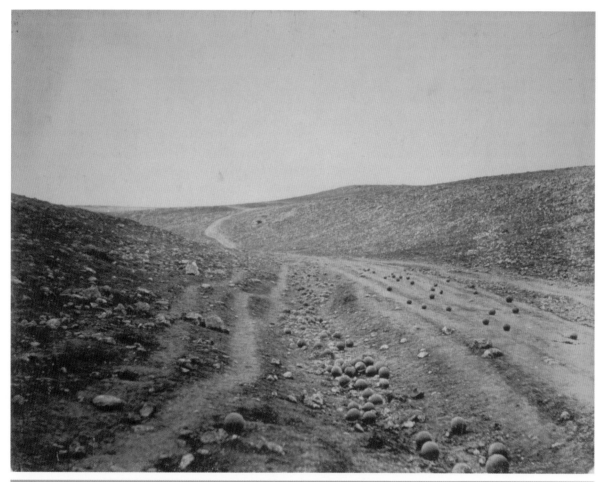

activist value of photographs as "truthful" eyewitness accounts of war. Of course, we now know that many images were manipulated and often re-created long after the actual event for maximum effect and because the cumbersome photographic technology didn't allow much else. Even so, the Civil War photographers exhibited a strong social conscience (the forbearers of contemporary war photographers) because most of them were not being paid. For example, Mathew Brady, the most well known, was a leading New York portrait photographer. When Brady decided to leave his portrait business and photograph the war, he acted without financial backing, much like activists today. He assigned himself the project, in part because he thought the war would be of short duration, but also because he believed in the role of the camera as historian and thought the government would eventually buy all the images. Over the course of the war, Brady invested $100,000 of his own money, a huge sum in those days, to outfit his team of 20 men, many of them former employees of his portrait studio, including Alexander Gardner and Timothy O'Sullivan, both of whom became well known in their own right. Brady outfitted his "war corps" with two wagons of cameras and chemicals. The wet plate process they used required them to plant the camera, focus the lens, coat the plate, expose the plate, and develop the plate while it was still wet. Given the slow and unwieldy process, it's not surprising that they didn't produce "action" photographs. It also explains why photographers directed and staged so many of the Civil War photographs, whether of the aftermath of battle scenes or those "informal" scenes of daily life in the camp.

Brady was the first photographer to cross the "death" threshold in 1862 when he published images of dead soldiers (many of them staged) under his name in his collection titled *The Dead of Antietam*. These photos offended many viewers (and by WWI provoked a blanket ban on any images of dead Americans) because they were vivid and gruesome images of dead soldiers. Brady's penchant for creating, re-creating, or staging "realistic" and graphic imagery proved financially disastrous. The government bought only a few of his images initially because it felt that his images were too "realistic" and bloody to be well received by the civilian viewers and would hamper the reunification efforts. [Not much has changed today as we still debate whether newspapers should publish photographs of dead soldiers from the Iraq and Afghanistan wars as noted during the debate of whether the Associated Press should have distributed the photograph of the dying marine, Lance Corporal Joshua Bernard, taken by AP photographer Julie Jacobson (Figure 1.10).[67]] One particularly graphic image, *Collecting Remains of the Dead at Cold Harbor (Bodies of Confederate Dead Gathered for Burial)* (Figure 1.11),[68] shows in the foreground the gruesome remains of dead soldiers having been dug up for a proper reburial, skulls attached to lifeless bones with the soldier's boots and canteens attached, testifying to how quickly the soldiers had been buried on the scene. Eventually, Congress agreed to pay about $25,000 for some of Brady's collection, but that wasn't enough money to discharge the debt he owed to Anthony and Company, which had supplied him with chemicals throughout the war. Brady never restored his finances and died a pauper.

Although all his photographs bear his name, Brady didn't take all of them. It was just his habit to put his name on the work that his assistants produced. Given this practice, it is ironic that the "Brady" photographs compelled Congress in 1865 to extend copyright protection to photographs.[69] Alexander Gardner objected to Brady putting his name on all photographs, including the ones Gardner took at Antietam (Figure 1.12), and left Brady's team to photograph the war himself, producing some of the war's most well-known images. He published them in 1866, along with some of O'Sullivan's images, in a two-volume set, *Photographic Sketch Book of the War*. Among those published was his infamous *Home of a Rebel Sharpshooter* (Figure 1.13), an image now widely accepted as staged. Historians believe that Gardner dragged the body of a Confederate soldier 40 yards, placed a Springfield musket (not a sniper's rifle) in an artful place (critics claim that Gardner always carried a musket in case he needed a prop), and for maximum effect, turned the soldier's head toward the camera so the viewer would be looking directly into the eyes of the dead soldier, making a strong statement about the tragedy of the violent and untimely deaths of these young men.[70] Staged or not, the photograph takes us back to that moment, to that original moment in time and space, when light reflected from the dead body of the rebel sniper fell on the wet plate. Although today Gardner and Brady would be excoriated for manipulating their "reportage" images, given the time, the equipment they carried, and the

FIGURE 1.10 Julie Jacobson, *Untitled*, August 14, 2009. Associated Press. ©AP Photo/Julie Jacobson

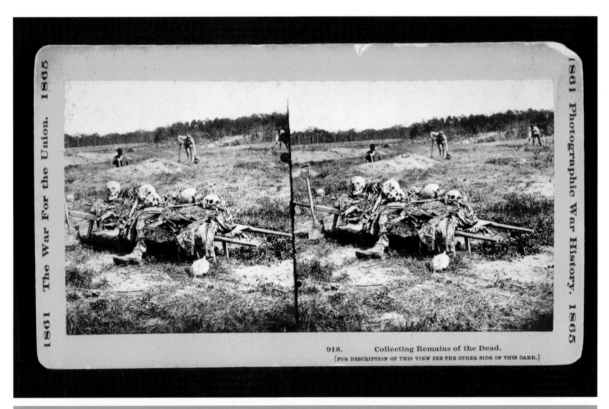

FIGURE 1.11 Mathew Brady (John Reekie), *Collecting Remains of the Dead at Cold Harbor (Bodies of Confederate Dead Gathered for Burial)*, 1865. Glass, wet collodion. Library of Congress, Washington, D.C. **Public Domain**

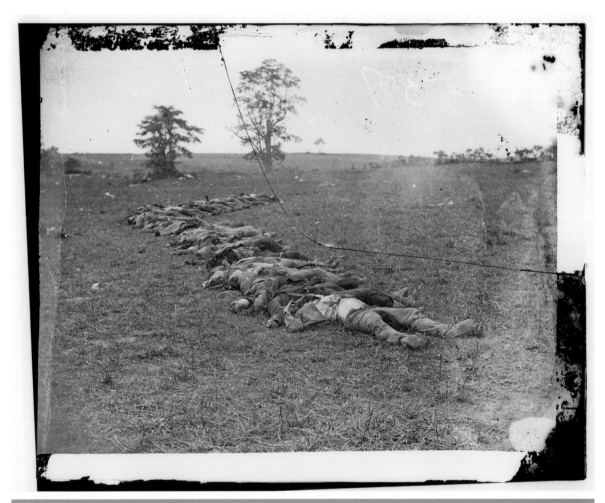

FIGURE 1.12 Alexander Gardner, *Antietam, Md., Bodies of Confederate Dead Gathered for Burial,* 1862. Glass, wet collodion. Library of Congress, Washington, D.C. **Public Domain**

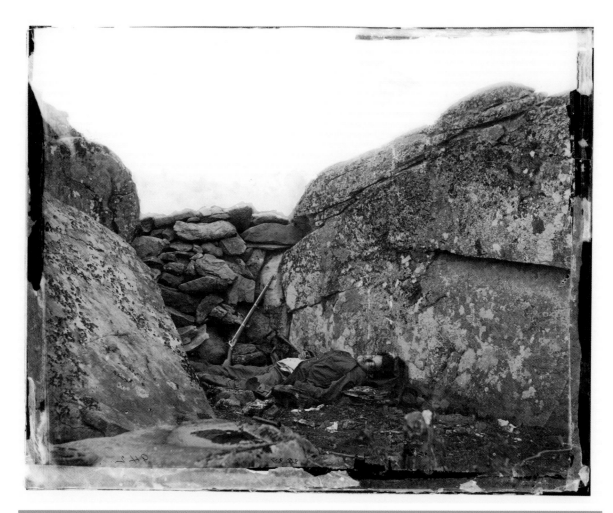

FIGURE 1.13 Alexander Gardner, *Home of a Rebel Sharpshooter*, 1863. Glass, wet collodion. Library of Congress, Washington, D.C. **Public Domain**

manner in which they had to travel, they had no other choice. Despite their differences, neither Brady nor Gardner hid the political activist views evident in their photographs: Both unequivocally supported the Union and hated slavery and the Southern aristocracy. Without these manipulated images, our collective memory of the Civil War would not be as rich, complex, or, some might say, flawed.

Social reform and the progressive era

"The most political decision you make is where you direct people's eyes. In other words, what you show people, day in and day out, is political."
Wim Wenders, The Act of Seeing: Essays and Conversations

As a genre, activist documentary photography was central to the history of American photography in the late nineteenth and early twentieth centuries as immigrants faced a harsh economic reality, the result of post–Civil War economic depressions (the first of which occurred between 1882 and 1887), not the easy, "better" life they imagined. In the same period of social activism and reform termed the Progressive Era (1890s–1920s), Jacob Riis realized that the camera could be a potent tool. In the 1900s, more than 35 percent of the populations of New York and Chicago were foreign born, most living in a squalor that would be unimaginable today. Riis, who had lived in these conditions for several years after immigrating to the United States in 1870, was determined to improve the living conditions for these immigrants through legal reform both for tenement housing and child labor. Originally a police reporter for the *New York Herald,* he realized that photography was even more powerful than words because the camera produced a kind of incontrovertible evidence that exceeded what words alone could do.

In 1887, he picked up a camera, focusing on a particularly toxic part of New York City, Mulberry Bend, one of the worst slums on the East side, housing more than a million people in 37,000 dark and dank tenement buildings. He wanted to challenge the prevailing notion that poor people were responsible for their own poverty. He believed, maybe naively, that if only middle class people knew about, or could actually *see*,

in detail, the horrible living conditions, the vagrant children, the squalid housing, and the disgraceful government housing for the homeless, they would feel morally responsible. His photographs appeared in *How the Other Half Lives: Studies Among the Tenements of New York* (Figures 1.14 and 1.15), a devastating exposé that put Riis in the category of the early "muckrakers." The book included 17 halftone illustrations, accompanied by text, in the tradition of Thomson and Smith with the same sense of realism and scenes of street life, but with the benefits of better photographic technology.

Riis needed access to night shots and low-light situations, so he worked with a handheld box camera, and the first "flash" photography, which although somewhat dangerous[71]—magnesium powder flash cartridges were fired from a revolver and sometimes exploded—penetrated the darkness, revealing details such as dirt, peeling paint, and the sheer nothingness of poverty. Riis' style was unique: He would barge in and shoot the flash cartridges and leave. He wasn't interested in the people's stories as much as the living conditions. Even though he didn't linger, he did need the subjects' cooperation because he had to set up his cameras and ignite his flash powder. He did not idealize or sentimentalize his subjects, but he did understand them; after all, he had been one of them. Because he was more interested in the social problem than the photographic aesthetics, or frankly, the sensibilities of his subjects, Riis' images were not intimate. Yet he produced direct, powerful images of real people living in real poverty. He packed his images with the information that he knew would extract as much emotion as possible from the middle class viewers. For example, *Lodgers in Bayard Street Tenement, Five Cents a Spot* (Figure 1.16) is a photograph of a very crowded room in a tenement, where single males paid five cents for a one-night "spot" to sleep.[72] This image is impeccably composed. A blanket, obviously covering someone, anchors the lower right corner of the frame. Two men, who obviously sleep together in a single bed, sit propped up against a wall, perpendicular to the blanket sleeper. Two other men sleep, not quite perpendicular to them. Above them, two men appear to share the top "bunk" bed. We can't quite see the men who must be occupying the bottom bunk. Possessions tied into a bundle hang from the ceiling in the upper right corner of the frame. Riis crowds the rest of the frame with the men's meager

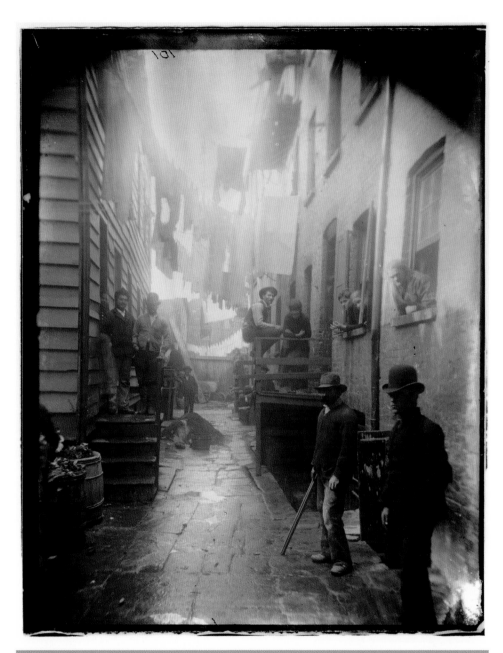

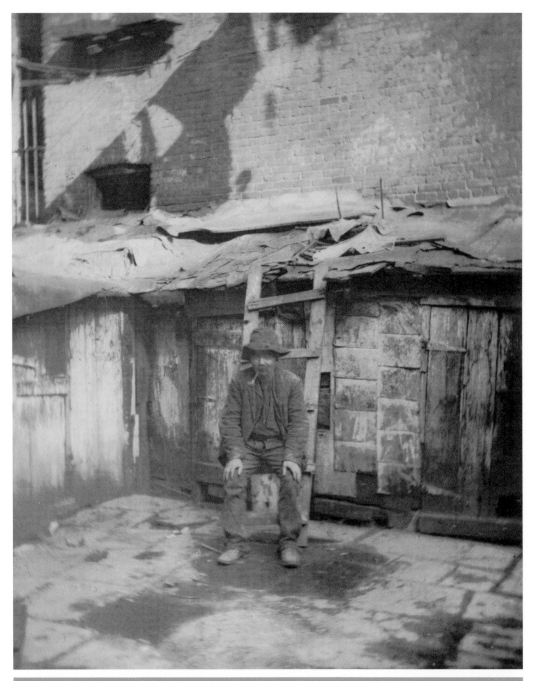

FIGURE 1.15 Jacob Riis, *The Tramp*, ≈1888. Library of Congress, Washington, D.C. **Public Domain**

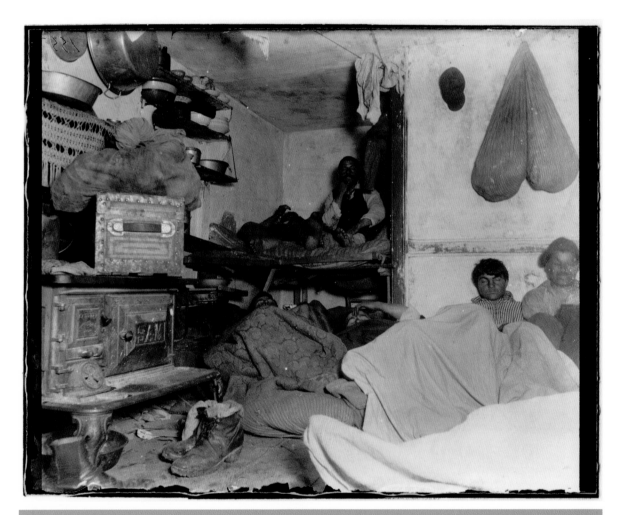

FIGURE 1.16 Jacob Riis, *Lodgers in Bayard Street Tenement, Five Cents a Spot*, 1889. Gelatin silver print, 6³/₁₆ x 3¼ in. Image courtesy of the Museum of the City of New York

possessions, including one pair of boots that anchor the lower left corner of the frame. The image is so claustrophobic that we cringe looking at it.

Like activists today, Riis cared about solving the problem. He could enter some of these places only with the permission of the landlord (no doubt in exchange for some assurance that the landlord would not be prosecuted for running an illegal lodging house). Riis didn't think his job ended with the photograph. He lectured on the need for reform, presenting facts on immigration figures, population density, maternal deaths, police statistics, and solutions for the problem, including laws on occupancy numbers and urban development. His lectures were not dry, linear recitations. He wanted to provoke public outrage. He included lantern slides, music, lights, and at times, sacred singing to manipulatively reach the moral center of the "Christian" audiences.[73] Riis' practice of combining text and imagery, his persistence, his unabashed advocacy for social reform— sending the message that the other half didn't have to live that way, if only society would intervene—became the model for contemporary activist photography. Riis' efforts succeeded. When Theodore Roosevelt became governor of New York, he worked with Riis to institute tenement housing reforms, beginning with the Tenement House Act of 1901.

If Riis' work proved the potency of activist photography to persuade viewers and legislators through graphic, direct imagery of real conditions, Lewis W. Hine, originally a sociologist, expanded the genre with an aesthetic sensibility that Riis lacked. He was as passionate about ending child labor (he likened it to slavery, a past that was still very raw for Americans) as Riis was about enacting housing reform. In the early twentieth century, the American economy, spurred by new inventions, the Industrial Revolution, and almost limitless natural resources, had an insatiable demand for labor. When the number of adult workers proved inadequate, employers turned to children as young as five. With no laws to protect them, child labor thrived. By 1910, more than two million children worked in industrial jobs. "There is work that profits children, and there is work that brings profit only to employers. The object of employing children is not to train them, but to get high profits from their work," Hine said in 1908.[74] He believed so strongly in the cause that he quit his job as a teacher to work full time for the National Child Labor Committee (NCLC), founded in 1904 by progressive reformers. Hine traveled more than 50,000 miles—from Texas to Maine—to document the conditions in which children worked in mills, mines, canneries, fields, and even selling newspapers on the street because he believed that "[p]hotography can light up darkness and expose ignorance."[75] He aimed to produce photographic proof that "no anonymous or signed denials" could challenge.[76] For him, the photograph was persuasive because he said: "In fact, it is often more effective than reality would have been, because, in the picture, the non-essential and conflicting interests have been eliminated. The picture is the language of all nationalities and all ages."

Given the sensitive nature of his work, factory owners seldom invited him to photograph. Rather, he did what all activists do: anything needed to get the photograph. He did not back down in the face of physical threats or attempts at intimidation. He lied, bribed, and tricked his way into places to photograph. Sometimes he pretended to be a fire inspector, an insurance salesman, or an industrial photographer—whatever he needed to do. His photographs are stunning: compelling, direct portraits often with a graphic or almost architectural composition. He worked with a simple view camera and relied only on soft natural light, not the harsh flash that Riis used. Because he studied and taught photography, he understood that portraits of children would be more powerful if he photographed them at their eye level. This point of view forces us to look directly into the children's eyes, catapulting us into their lives, challenging us to consider how the children's health, education, and futures were being sacrificed so the middle class could have less expensive clothing, food, or products.

Hine wanted his photographs to be accurate and truthful and would allow no retouching or manipulation. He carefully recorded facts and details for every photograph because "the average person believes implicitly that the photograph cannot falsify. . . .This unbounded faith in the integrity of the photograph is often rudely shaken, for, while photographs may not lie, liars may photograph. It becomes necessary then, in our revelation of the truth, to see to it that the camera we depend upon contracts no bad habits."[77] By recording exact details, names, places, and times, information he included in his captions, Hine also transformed his anonymous subjects into people. For example, it is a photograph of five-year-old Manuel picking shrimp, not just an unknown child (Figure 1.17). Sometimes he even captioned the images by using the child's name, as with *Ora Fugate, 10 years old, worming tobacco* (Figure 1.18). Ora is dressed like a boy in bib overalls

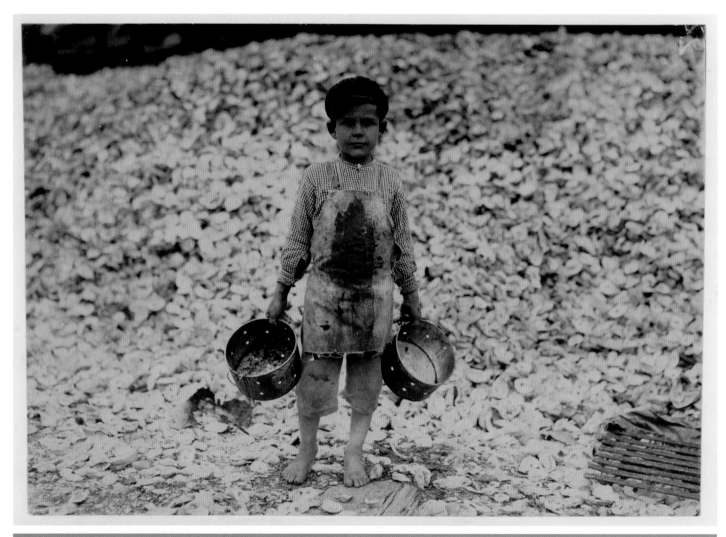

FIGURE 1.17 Lewis Hine, *Manuel, the young shrimp picker, five years old, and a mountain of child-labor oyster shells behind him*, 1911. Library of Congress, Washington, D.C.
Public Domain

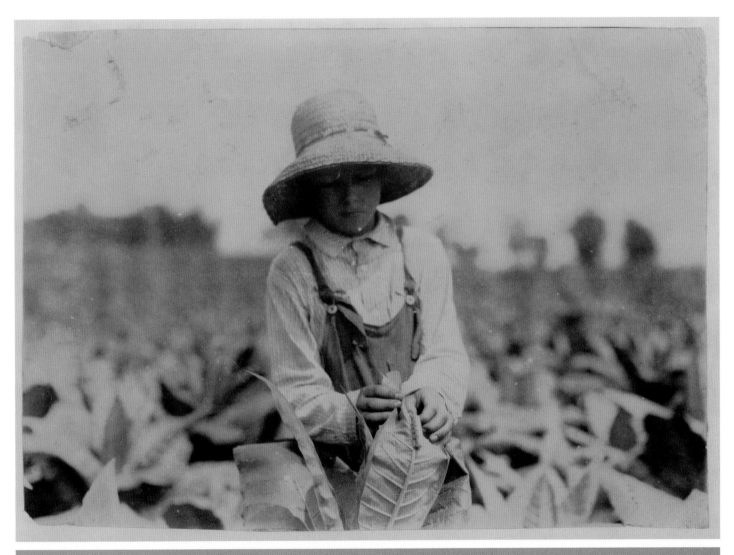

FIGURE 1.18 Lewis Hine, *Ora Fugate, 10 years old, worming tobacco*, 1916. Library of Congress, Washington, D.C. **Public Domain**

> This unbounded faith in the integrity of the photography is often rudely shaken, for, while photographs may not lie, liars may photograph. It becomes necessary then, in our revelation of the truth, to see to it that the camera we depend upon contracts no bad habits.

so big they fall off her thin body. She wears long sleeves and a hat in an image that feels so hot and dusty that we can taste the dust.

Hine immortalized six-year-old Warren Frakes, a field worker in Comanche County, Oklahoma, whose "Mother said he picked 41 pounds yesterday,"[78] and 12-year-old Addie Card, an "anemic" mill worker (Figure 1.19). Addie, an amazingly beautiful child, stands in front of a spinning machine, dressed in an old, filthy, tattered dress, with one pocket so full of something that it pulls her dress off her shoulder. She leans on the spinner, but her thin arm protrudes at such at an odd angle that it looks as if it might have been broken and not set properly. She wears no shoes, and her feet are dirty and greasy. Bathed in soft natural light, she gazes directly at the camera with an expression that seems to be asking "How can you allow this?" evoking the compassion of all but the most cold and unsympathetic. The photograph became an iconic symbol of the evils of child labor, even appearing on a postage stamp in 1988, but not just because of Hine's technical skill, but because Hine's caption named Addie, a detail that helped freelance journalist Joe Manning locate her family and some other descendents of the children Hine photographed.[79] (Addie Card never broke the chains of poverty and died in public housing.)

Hine pioneered the current activist practice of combining objective fact with subjective emotion, the model for what Cornell Capa would term the "concerned photographer." Hine, like Riis, believed that if only people could see for themselves how horrible the working conditions were, they would pressure legislators to change the laws. In a prescient speech predicting the idea of compassion fatigue so common today, Hine beseeched his listeners: "Perhaps you are weary of child labor pictures. Well, so are the rest of us, but we propose to make you and the whole country so sick and tired of the whole business that when the time for action comes, child-labor pictures will be records of the past."[80] He defined a good photograph as "a reproduction of impressions made upon the photographer which he desires to repeat to others."[81] His "impressions" were so powerful that by 1916 Congress—maybe with the urging of the citizenry—passed the Keating–Owens Act that established child labor law standards about age, hours worked, and the need for documentary proof of age. By 1920, fewer than one million children were working in the mills, mines, and factories.

This idea that if only the middle class knew of social inequities they would *do* something, or that images could nudge the moral true north of middle class people, underscored socially oriented documentary photography in America in the 1930s and 1940s.

Farm Security Administration (FSA)

> "The good photograph is not the object, the consequences of the photograph are the objects."
>
> Dorothea Lange

The best documentary photographers pay very close attention to everything that is happening in the lives of the people they are getting to know. No more so than the photographers who were hired by Roy Stryker, who headed the Farm Security Administration (FSA). Over a six-year period, they produced more than 270,000 images. Today this is still one of the greatest collections of photographs ever assembled in America, and one that has had an enduring legacy for the documentary genre. While Riis and Hine proved that photographs could effect change, their images, per se, were not innovative because of technical limitations, and their approach to their subjects was very sociological: They classified people

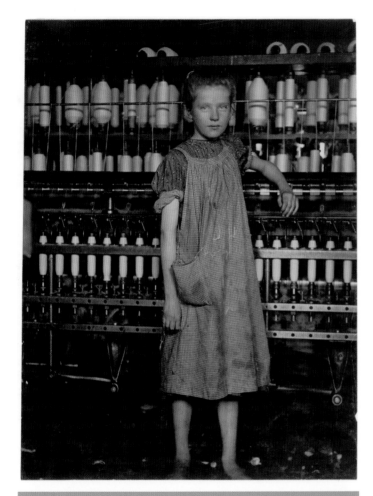

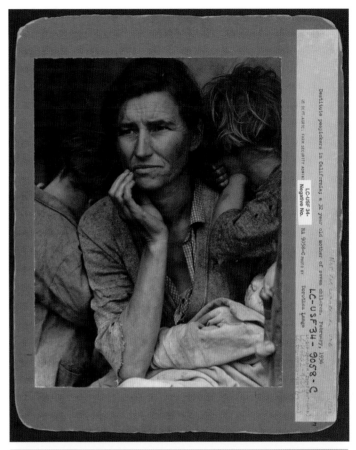

by socioeconomic class, job, or ethnicity. The work produced by the FSA photographers profoundly changed the notion of what documentary work can or should be because it was both emotionally persuasive and rooted in reality.

The FSA, originally created as the Resettlement Administration (RA) in 1935, was formed as part of President Franklin Delano Roosevelt's efforts to fight the depression. Renamed the FSA in 1937, the RA's purpose was to help move farmers and other poor rural Americans, devastated by the economic and environmental realities of the 1930s, into more economically viable work. The visionary Roy Stryker headed one of the RA/FSA departments titled basically "Historical Section— Photographic." Although the images produced have become iconic, such as Dorothea Lange's *Migrant Mother* (Figure 1.20), and part of our

collective memory, originally they were intended as propaganda: photographic evidence of the good work being done by the RA/FSA to enlist support from urban America for expenditures for Roosevelt's New Deal programs. Like Riis, Hine, and contemporary activists, Stryker believed that if urban Americans could see the desperate situation of rural Americans, they would support Roosevelt's programs. He employed about 20 photographers who worked with him off and on until 1942. He sent them out on scheduled assignments, sometimes with shooting scripts, and he alone decided what images would be distributed to the public. Stryker exerted such control that he is credited with creating the FSA-style documentary.

He wanted to "introduce Americans to Americans" through images that were dramatic, empathetic, and positive.[82] He instructed his photographers to make images that did not demonize the rural poor, rather presenting them as working hard to rectify their situations. Although it is easy to question the objectivity inherent in a Stryker assignment, for the most part, it was true of most of the people photographed and less clichéd than the photographs taken of the poor at this time. In the tradition of Hine, Stryker emphasized that his photographers shoot from normal eye level to create equality between viewer and subject. It's both a testament to Stryker and to his photographers that they and their images have become the standard for the potential of great documentary photography. Walker Evans (who was fired in 1937 because he could not follow Stryker's rules), Dorothea Lange, Carl Mydans, Arthur Rothstein, Ben Shahn, Russell Lee, Gordon Parks, and the lesser known Esther Bubley all became successful photographers post FSA. Also the images shaped our cultural understanding of the Depression, of poverty, and of the need for government intervention.

Lange produced the most iconic FSA image, *Migrant Mother*. Rothstein produced the second most iconic, *Farmer and sons walking in the face of a dust storm, Cimarron County, 1936* (Figure 1.21), and the first controversy about a faked photograph when he "created" a photograph by picking up a steer skull he found and moving it so it would be positioned to be side lit. The skull and the resulting lit shadow fill the lower half of the frame, surrounded by barren parched earth (Figure 1.22). The photograph itself is not problematic and moving the skull to create a better composition didn't change the truth, but the trouble started when

an editor captioned it "Skull of a drought-stricken steer" and nationally syndicated the photograph. It quickly became a symbol for the drought and the need for government intervention. Critics of the New Deal policies latched onto a newspaper article that the photo was a "fake" (How do we know that the steer died because of the drought?) to discredit Rothstein and to cast the RA/FSA program as Roosevelt's propaganda arm. Ironically, this image was no more faked than many of Lange's images. However, the specter of something being labeled fake and then discredited haunts all activist documentary work. Some photographers, like Bleasdale or Eugene Richards, refuse to manipulate anything. "If I miss a moment, I miss it," says Richards. "I never go back to re-create it, but I do think about the photos I missed."[83]

Lange, originally a society portrait photographer like Robert Adamson, left that lucrative job to focus on what she called "the forgotten man." Some of her earlier socially driven work has been credited with forcing the government to set up sanitary camps for migrant workers. Her image of the *Migrant Mother*, a woman named Florence Thompson, is, even today, the quintessential image of the Depression and has been reproduced more than any other photograph. It also was somewhat manipulated. Lange deliberately chose a close-up composition to exclude four of Thompson's seven children so middle class viewers wouldn't be outraged at her large family. Thompson sits, looking out of the frame, lost in thought, with her hand idly cupping her chin, a commonplace gesture, cradling in her other arm a baby who appears about to suckle at her breast. Two other children hide their faces, defeated, yet they cling to their mother for comfort. Thompson's expression is one of worry yet strength, vulnerability yet determination. Her worry for her children is every mother's worry. Yet *she* does not seem defeated. We believe she will survive (and she does although she never really escapes her poverty). The image, a powerful symbol of class distinctions, became iconic because it evokes sympathy and empathy from the viewer. *Migrant Mother* is every mother, and our collective impulse is to help. It is the same impulse that compelled readers of *Stern* magazine to donate $150,000 to Foundation Rwanda when the magazine first published Torgovnik's portraits, or to donate millions of dollars to Donna Ferrato's Domestic Abuse Agency (DAA).

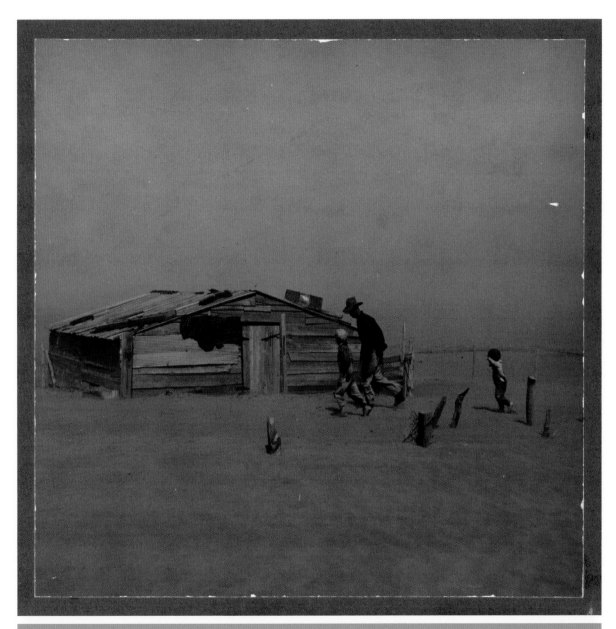

FIGURE 1.21 Arthur Rothstein, *Farmer and sons walking in the face of a dust storm. Cimarron County, Oklahoma*, 1936. Silver gelatin print, 8 x 10 in., Library of Congress, Washington, D.C. **Public Domain**

FIGURE 1.22 Arthur Rothstein, *The bleached skull of a steer on the dry sun-baked earth of the South Dakota Badlands*, 1936. Nitrate negative, 2 ¼ x 2 ¼ in., Library of Congress, Washington, D.C. **Public Domain**

and so she helped me. There was a sort of equality about it.... I knew I had recorded the essence of my assignment."[84] These two very different versions of a moment between photographer and subject highlight the very delicate balance that exists in all documentary work, and more so in activist work.

Evans, the only photographer to shoot FSA images with an 8 x 10 camera, made images that were understated, unadorned, and methodically documentary, tricking the viewers into believing that this is exactly what they would have seen had they been there. Of course, the simplicity was misleading because these images, with no patina of sentimentality, revealed the literal and metaphorical decay, how long-term poverty sucks determination out of even the most determined. In 1936, Evans collaborated with his friend, the writer James Agee, on an article about three tenant cotton farmers in Alabama for *Fortune* magazine. They spent a month on site, not so much working together as working in parallel. Evans' images, neither sentimental nor exploitive and with no background distractions or fancy composition, reveal the essence of the people and of the place, preserving the beginnings of the fading of a regional American culture—in true portrait fashion. Although the magazine rejected the original piece, the team expanded the story, eventually publishing it as *Let Us Now Praise Famous Men*. This seminal piece of how images and text work together and how a photographer and writer can work as mutually independent coequal authors remains the standard for activist work. And as is sadly often the case with much activist work—people want to be able to look away—the book sold only 600 copies in the first year.

It is proof that if a documentary photograph evokes emotion, it can compel action.

This photograph became so famous that it overshadowed Lange's subsequent projects about desperate social conditions, including a very sympathetic series on Japanese Americans interned by the American government in camps in post–Pearl Harbor hysteria. Yet, it also became controversial when Florence Thompson was located many years later. She was still poor and very bitter that she had never received any money from the famous photograph. She felt betrayed by Lange because she said that Lange had promised her the photograph would not be published. Lange's own version is quite different: "I did not ask her name or history. ...She ... seemed to know my pictures might help her,

The FSA-style work is being replicated today, but not funded by the government. A group of photographers inspired by the FSA has created a nonprofit cooperative, Facing Change, Documenting America (FCDA). Founded in 2009 by photographic greats David Burnett, Brenda Ann Kenneally, Anthony Suau, and Danny Wilcox Frazier, among others, and equally well-known writers, FCDA has as its mission to "cover and publish under-reported aspects of America's most urgent issues and distribute work through an innovative online platform while highlighting the efforts of individuals and organizations working to [effect] positive change."[85] In December 2010, the site received more than 3,600,000 hits.

Endnotes

1. "Stanley Wells & the Anti-Stratfordians," www.sirbacon.org/wells.htm (accessed January 4, 2011).

2. Robert Coles, *Doing Documentary Work* (New York: Oxford University Press, 1997), 145; Leslie Katz, "Interview with Walker Evans," *Art in America* (March/April 1971): 85, 87.

3. William Stott, *Documentary Expression and Thirties America* (Oxford and New York: Oxford University Press, 1976), 9.

4. "doceo," en.wiktionary.org/wiki/doceo#Latin (accessed January 3, 2011).

5. Brett Abbott, *Engaged Observers: Documentary Photography Since the Sixties* (Los Angeles, CA: J. Paul Getty Museum, 2010), 48.

6. Stott, *Documentary Expression,* 11; see footnote 8.

7. Beaumont Newhall, *The History of Photography* (Garden City, New York: Museum of Modern Art, distributed by Doubleday, 1964), 142.

8. Stott, *Documentary Expression,* 14.

9. Milton Meltzer, *Dorothea Lange: A Photographer's Life* (Syracuse, NY: Syracuse University Press, 1999), 161.

10. Martin Mann, *Documentary Photography: Time Life Library of Photography* (New York: Time Life Books, 1972), 12.

11. Coles, *Doing Documentary Work,* 145.

12. Abbott, *Engaged Observers,* 9.

13. Ibid, 9.

14. Martha Rosler, "In, Around and Afterthoughts (on Documentary Photography)," originally published in Richard Bolton, ed., *The Context of Meaning* (Boston: The MIT Press, 1992). Full text can be found at web. pdx.edu/~vcc/Seminar/Rosler_photo.pdf (accessed January 4, 2011).

15. Ibid.

16. Unless otherwise noted, all quotes by Natan Dvir are from interviews conducted by the author.

17. Geoffrey Hiller, "Natan Dvir," *Verve Photo: The New Breed of Documentary Photographers* (blog), June 14, 2010. vervephoto. wordpress.com/2010/06/14/natan-dvir/ (accessed January 7, 2011).

18. www.marcusbleasdale.com (accessed December 29, 2010).

19. "Congo/Central African Republic: LRA Victims Appeal to Obama," *Human Rights Watch,* November 11, 2010. www.hrw.org/en/news/2010/ 11/10/congocentral-african-republic-lra-victims-appeal-obama (accessed January 4, 2011).

20. *Lord's Resistance Army Disarmament and Northern Uganda Recovery Act of 2009.* 1067, 111th Cong., 2nd Sess.: This bill is intended to "support stabilization and lasting peace in northern Uganda and areas affected by the Lord's Resistance Army through development of a regional strategy to support multilateral efforts to successfully protect civilians and eliminate the threat posed by the Lord's Resistance Army and to authorize funds for humanitarian relief and reconstruction, reconciliation, and transitional justice, and for other purposes." accessed January 4, 2011; Full text can be found at http://www.opencongress.org/bill/111-s1067/ text.

21. To see a multimedia piece on *Undesired,* go to www.mediastorm.com.

22. Abott, *Engaged Observers,* 174.

23. Susan Meiselas' work in Nicaragua can be seen at www.susanmeiselas. com/nicaragua/.

24. John Szarkowski, *Mirrors and Windows: American Photography since 1960* (New York: Museum of Modern Art, 1984). In the introduction, Szarkowski coined the terms *mirrors* and *windows* to explain a change he perceived in documentary photography beginning in the 1960s. There were the more traditional documentary photographs, the "windows" that showed the viewer the reality with an end to change it, and the newer "mirror," which aimed not so much to reform the world, but to understand it through the photographer's own sensibility.

25. Robert Adams, *Beauty in Photography: Essays in Defense of Traditional Values* (New York: Aperture, 1981), 14.

26. Unless otherwise noted, all quotes from Kristen Ashburn come from phone and email interviews conduced by the author in April 2011. Ashburn's work can be seen at www.kristenashburn.com.

27. Ashburn is profiled in the appendix of this book.

28. Bill Scott, *Pensées* (blog), March 16, 2007. billstott.blogspot.com/2007/03/penses.html (accessed January 5, 2011).

29. Dupont's awards include a Robert Capa Gold Medal citation from the Overseas Press Club of America; a Bayeux War Correspondent's Prize; and first places in the World Press Photo, Pictures of the Year International, and the Australian Walkleys and Leica/CCP Documentary Award. In 2007, he was awarded the W. Eugene Smith Grant for Humanistic Photography for his ongoing project on Afghanistan. All quotes come from an interview conducted by the author on September 3, 2010, at the Visa pour l'Image Festival in Perpignan, France.

30. "Jim Goldberg: 'Rich and Poor,'" *American Suburb X.* www.americansuburbx.com/2009/03/jim-goldberg-rich-and-poor.html (accessed January 2, 2011).

31. Stephanie Sinclair's work can be seen at www.stephaniesinclair.com.

32. All quotes from Stephen Shames are from interviews conducted by the author. .

33. www.stephenshames.com/bio/ (accessed January 9, 2011).

34. MediaStorm's website: www.mediastorm.org.

35. Panel Transcript for Neiman Foundation for Journalism at Harvard, *Visual Storytelling about the Human Condition.* www.nieman.harvard.edu/reportsitem.aspx?id=101973 (accessed December 29, 2011).

36. Interviews with Walter Astrada conducted by the author in New York City in 2010.

37. Ed Kashi (Panel Member), NYU Panel Discussion, *NYU and Magnum Foundation Discussion on Human Rights,* June 21, 2010. (Attended by author.) Panel Summary: www.tisch.nyu.edu/object/NYUAND06082010114823.html.

38. Ibid., Larry Towell (Panel Member), NYU Panel Discussion, *NYU and Magnum Foundation Discussion on Human Rights,* June 21, 2010.

39. "Photography Quotes—Robert Frank," www.photoquotes.com/showquotes.aspx?id=68&name=Frank, Robert. Modified August 26, 2010 (accessed January 5, 2011).

40. All quotes from Marcus Bleasdale come from an interview conducted by the author. London, England, March 23, 2010.

41. Ken Light, *Witness in Our Time* (Washington, DC, and New York: Smithsonian Books, 2000), 111.

42. John Szarkowski, *The Photographer's Eye* (New York: Museum of Modern Art, 2007), 3.

43. Learned Hand, *The Spirit of Liberty Speech*, "I Am an American Day" ceremony, New York, May 21, 1944. quotationsbook.com/quote/44410/ (accessed January 2, 2011).

44. *The Rwanda Project,* 1994–2000. www.alfredojaar.net (accessed December 20, 2010).

45. Museum of Contemporary Photography, "Profile of Shimon Attie," www.mocp.org/collections/permanent/attie_shimon.php (accessed January 3, 2011).

46. The J. Paul Getty Museum, "Profile of Gustave Le Gray," www.getty.edu/art/gettyguide/artMakerDetails?maker=1913 (accessed December 20, 2010).

47. Naomi Rosenblum, "Documentation: Landscape and Architecture," in Walton Rawls and Nancy Grubb, eds., *A World History of Photography,* 3rd ed. (New York: Abbeville Press Publishers, 1997), 100.

48. For example, Alexander Gardner's famous Civil War photograph of a rebel sharpshooter lying dead in Devil's Den in Gettysburg was staged. The body had been moved and repositioned for the photograph. For an excellent analysis of other staged Civil War photographs, see William A. Frassanito, *Gettysburg: A Journey in Time* (New York: Charles Scribner's Sons, 1975). This book is not going to concern itself with that debate for those photographs from that time period.

49. Brigitte Govigon, ed. *Abrams Encyclopedia of Photography* (New York: Henry N. Abrams, 2004), 80.

50. *Crawlers* was a term used to describe old women so destroyed by poverty that they were too feeble to even beg. They would often watch other women's children, and when they had enough money to buy tea leaves, they would "crawl" on their hands and knees to the nearest pub to get hot water. Robert Hirsch, *Seizing the Light: A Social History of Photography,* 2nd ed. (New York: McGraw Hill, 2009), 121; Mary Warner

Marien, *Photography: A Cultural History*, 3rd ed. (Upper Saddle River, NJ: Prentice Hall, 2011), 150.

51. Marien, *Photography: A Cultural History*, 37.

52. Hirsch, *Seizing the Light*, 105.

53. Rosenblum, "Documentation: Landscape and Architecture," 352.

54. On November 23, 2010, the author attended a panel discussion titled "Does the Camera Ever Lie?" sponsored by Amnesty International at its Human Rights Action Centre in London, and as surprising as it seems in 2010, the question of whether the documentary photographers on the panel told "the truth" with their photographs took up most of the Q &A session.

55. *Great Themes: Life Library of Photography* (Alexandria, VA: Time Life Books, 1987), 212.

56. Susan D. Moeller, *Shooting War: Photography and the American Experience of Combat* (New York: Basic Books, Inc. 1989), 11, citing W. Eugene Smith, quoted in George Santayana, "The Photograph and the Mental Image," in Vickie Goldberg, ed., *Photography in Print: Writings from 1816 to the Present* (New York, 1981), 261–262.

57. James Nachtwey, "James Nachtwey Searing Photos of War" (speech at Nachtwey's Acceptance Ceremony for the TED Prize 2007), March 2007. Video of Speech: www.ted.com/talks/james_nachtwey_s_searing_pictures_of_war.html (accessed December 23, 2010).

58. Finbarr O'Reilly's work can be seen at www.finbarroreilly.com.

59. Rosenblum, "Documentation: Landscape and Architecture," 352.

60. O'Reilly commented that even showing the photograph at the Amnesty event probably violated the military ban.

61. Michael Kamber and Tim Arango, "4,000 U.S. Deaths, and a Handful of Images," *New York Times,* July 26, 2008, p.1. www.nytimes.com/2008/07/26/world/middleeast/26censor.html?_r=2&pagewanted=all (accessed January 15, 2011).

62. Brian Walski, a staff photographer for the *Los Angeles Times*, was fired on April 1, 2003, for combining two photographs taken moments apart in order to improve the composition. The *Chicago Tribune* and the *Hartford Courant* both published the photograph in a prominent space on March 31, 2003. Walski admitted the manipulation. He offered no excuses and apologized to his colleagues. To his friend and fellow *Times* photographer Don Bartletti, he said "I f—ed up, and now no one will touch me. I went from the front line for the greatest newspaper in the world and now I have nothing. No cameras, no car, nothing." www.poynter.org/how-tos/newsgathering-storytelling/9289/l-a-times-photographer-fired-over-altered-image/ (accessed February 25, 2011). Reuters fired a top photo editor and severed its 10-year relationship with Lebanese freelance photographer Adnan Hajj when it discovered that he had been digitally altering images, including one taken during the 2006 Israel–Lebanon conflict, in which he had compiled two photographs to show three flares being dropped by a plane, not one. "Reuters has zero tolerance for any doctoring of pictures and constantly reminds its photographers . . . of this strict and unalterable policy." www.msnbc.msn.com/id/13165165/ns/world_news-mideast/n_africa/ (accessed February 25, 2011).

63. Gail Buckland, *Recording Reality: Early Documentary Photography*, (Greenwich, CT: New York Graphic Society, 1974), 59, from Helmut Gernsheim and Alison Gernsheim, *Roger Fenton: Photographer of the Crimean War: His Photographs and Letters from Crimea* (London: Ayer Co. Pub., 1954), 75.

64. Collection at the Victoria and Albert Museum, London.

65. Marien, *Photography: A Cultural History*, 101.

66. Marien, *Photography: A Cultural History*, 101, from Ulrich Keller, *The Ultimate Spectacle: A Visual History of the Crimean War* (London: Gordon and Breach, 2001), 136.

67. Defense Secretary Robert Gates accused the AP of a "lack of compassion and common sense" because it distributed the image to American newspapers.

68. In the collection of the Library of Congress, negative number B8184-10396.

69. Many historians take for granted that Congress acted in reaction to Brady's fame and popularity, but an analysis of the legislative history does not confirm this.

70. William Frassanto, *Gettysburg: A Journey in Time* (New York: Scribner's Sons, 1974). More than 623,000 soldiers died in the Civil War, with an additional 400,000 injured and maimed, more than in all other American wars combined, including Vietnam and the Iraq war.

71. Riis' flash sometimes did start fires, ignite his own clothes, and once almost blinded him.

72. In the Jacob Riis Collection, Museum of the City of New York. www.museumsyndicate.com/item.php?item=42910.

73. Hirsch, *Seizing the Light*, 220.

74. Russell Freedman, *Kids at Work: Lewis Hine and the Crusade Against Child Labor* (New York: Clarion Books, 1994), 21.

75. Marilyn Esperante Figueredo, "The Exposure of Ignorance: Child Labor in America," *Cigar City Magazine History* (blog), accessed February 4, 2011: www.cigarcitymagazine.com/history/item/the-exposure-of-ignorance.

76. Curatorial Intern, "Documentary Photographers with Social Concerns," *New Britain Museum of American Art: Where Art Meets Life* (blog), February 23, 2010. nbmaa.wordpress.com/2010/02/23/documentary-photographers-with-social-concerns/ (accessed January 2, 2011).

77. Lewis Hine, "Social Photography, How the Camera May Help in the Social Uplift." Proceedings from *National Conference of Charities and Corrections* (June 1990) tigger.uic.edu/depts/hist/hull-maxwell/vicinity/nws1/documents/hine-socialphotography.PDF (accessed January 2, 2011).

78. A collection of Hine's images can be seen at www.historyplace.com/unitedstates/childlabor/.

79. Manning began the search for Addie Card at the request of novelist Elizabeth Winthrop, who, inspired by the photograph, was writing a novel, *Counting on Grace*. This search led to the Lewis Hine Project. Manning located her family, as recorded in "Addie Card: The Search for an Anemic Little Spinner," *Mornings on Maple Street*. www.morningsonmaplestreet.com/addiesearch3.html (accessed January 3, 2011).

80. Hine, *Social Photography*, 4.

81. "Teaching with Documents: Photographs of Lewis Hine: Documentation of Child Labor," *National Archives*. www.archives.gov/education/lessons/hine-photos/ (accessed January 5, 2011).

82. Hirsch, *Seizing the Light*, 39.

83. All quotes from Eugene Richards are from an interview conducted by the author in Richard's Brooklyn home on September 11, 2010.

84. "Dorothea Lange's 'Migrant Mother' Photographs in the Farm Security Administration Collection: An Overview," *Prints and Photographs Reading Room—Library of Congress*. www.loc.gov/rr/print/list/128_migm.html (accessed January 5, 2011).

85. More information about FCDA can be found at facingchange.org (accessed January 7, 2011).

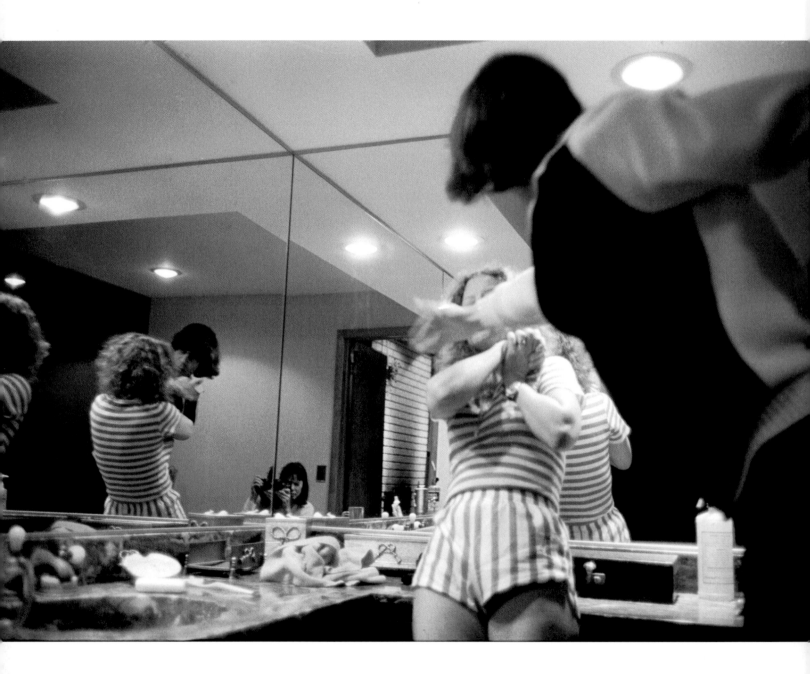

Two

MOMENTS IN TIME

FIGURE 2.0 Donna Ferrato, *Scenes from a marriage: Garth & Lisa, 1982*, Saddle River, New Jersey. ©Donna Ferrato

Modern history

"How a photographer wraps that rectangular frame around a moment in time can be powerful, or it can be a moment wasted."[1]

Donna Ferrato

The successes of Riis, Hine, and the Farm Security Administration (FSA) photographers described in Chapter 1 firmly established the fact that photographs were, and continue to be the most effective method of communicating a verifiable truth about social injustice while evoking an emotional response from the viewer. That emotional response provokes action(s), putting pressure on those with the power to do something. Photography retained its activist status throughout the late 1930s and 1940s because the photograph had no competition. In World War II, news organizations and publications geared up to cover the war, providing support and precious print space for the newer generation of photographers. For example, *Life* magazine sent photographers to the frontlines and even ran a photo school to train army photographers.[2] W. Eugene Smith, one of the great social documentary photographers of the twentieth century, started his career as a war photographer for *Life*. His desire to get close enough to the action to "take what voice I have and give it to those who don't have one at all" resulted in his being wounded.[3] Although Smith made that statement about his war photography, it defined his career and his signature style.

Photography's power waned somewhat in the 1950s and 1960s as television journalism supplemented the still photograph. Television news was more immediate; its moving image and sound intrigued viewers. Throughout the mid-twentieth century, the amount of activist work produced fluctuated, but it never ceased. There have always been and there always will be activist photographers who care enough about covering the stories that need to be told that they will push for commissions, or they will self-fund projects. Activist documentary photography peaked again in the 1960s and 1970s, the heyday of both *Life* and *Look* magazines. Photographers imaged the great social movements, upheavals, and issues (for example, civil rights, the Vietnam War, and drug addiction) in America, and then traveled to photograph the injustices and social inequities around the world, just as their Victorian counterparts did in the 1800s.

Advocacy photography almost disappeared in the Reagan era as the limitations of print media forced magazines to close, television viewing increased, and the *greed is good* culture emerged. Americans did not want visual reminders of social inequities. The practice reemerged in the mid-1990s as the Reagan influence declined and the global community burgeoned, supported by technology and the Internet. When there were only a few magazines, there were far fewer working photographers. The new Web platforms and sites that appeared in the late 1990s and that have propagated in the twenty-first century have supplanted television news and challenged print media, but they also have created new distribution models and opportunities for photographers to publish work. With more distribution opportunities, more documentary photographers make images today, as evidenced at the Visa pour l'Image in Perpignan, France. The thousands of documentary and activist photographs projected in the evening presentations testify to the dedication of the photographers who are not deterred in spite of growing up in a world without magazine assignments and generous expense accounts. "No one has a gun to my head," says Walter Astrada. "It's not easy making a living as a documentary photographer, but we find ways of getting funding for our projects."[4]

W. Eugene Smith

As Astrada notes, contemporary photographers do not have the magazine assignments or flush expense accounts that their predecessors relied on for long-term projects. W. Eugene Smith, who worked for *Life* when WWII ended, is credited with creating the quintessential activist photographic essay, but he did so initially with magazine support. Smith merged his life with that of his subjects—producing dramatic and intimate photographs, not the more distanced photographs produced by the FSA photographers. Because *Life* magazine paid him, he could spend months working on stories, living with or near his subjects. He worked on domestic stories, such as *Country Doctor*, an essay on a small country doctor; and *Nurse Midwife*, the story of Maude Callen, a black midwife working in a poor community in the rural South. Even though *Nurse Midwife* was specifically a story about Callen, Smith believed it made a strong statement about racism because it showed "a remarkable woman doing a remarkable job in an impossible situation."[6] *Life* readers apparently agreed because they donated enough money to build Callen a clinic in South Carolina.

Back at the magazine, Smith wanted to be as involved with the editing as he was with his subjects. The editors didn't always welcome his involvement, and he regularly fought with them about how the photographs should be sequenced. This concern about how images are used typifies activists today. Marcus Bleasdale carefully crafts his captions and insists that the captions cannot be edited. For online media pieces, photographers can work directly with producers and editors, giving them the kind of control that Smith craved.

Smith quit *Life* magazine in 1955 over editing disagreements and joined the Magnum Agency. In the 1970s, he produced the classic activist piece on the Japanese fishing village, Minimata. Minimata residents were being poisoned by the industrial mercury and other heavy metals discharged into the Minimata Bay by the Chisso factory. Smith and his wife, Aileen, lived in Minimata from 1971 to 1973, intent on covering the whole story, including the pollution, the resulting birth deformities, and the victims' quest for justice and monetary compensation from Chisso. Smith so immersed himself in the story that he received a severe beating from Chisso employees at a factory where he and Aileen had traveled with a group of patients to record a meeting the group expected to have with company officials. Instead of company officials, about 100 men showed up and attacked them, leaving Smith with permanent impaired vision in his left eye.

Smith made his most famous photograph during this project: *Tomoko Uemura in Her Bath*. The photograph is stunningly beautiful and reminiscent of Michelangelo's Pieta: A mother cradles her deformed naked daughter in a traditional Japanese bathing chamber lit by a single shaft of light that illuminates only the mother and daughter.[7] It is also a fabricated photograph, although that information did not surface for many years. Tomoko's mother, Ryoka, collaborated with Smith on this photograph because she wanted the world to know about the terrible effects of what, through Smith's activist involvement, has come to be known as *Minimata disease*. She suggested that Smith photograph her bathing her daughter. Smith scouted the available light and selected the time of day that would give him the perfect shaft of light he wanted to illuminate Ryoka and Tomoko. It was the ideal collaboration: Ryoka would make her statement to the world, and Smith would get that one symbolic photograph he knew he needed to be the catalyst to provoke thought and action from *Life* readers. First published in *Life* magazine in 1972, the photograph was so beautiful and poignant that it raised the world profile of the problem in Minimata.

Smith is often quoted as saying, "What use is having a great depth of field, if there is not adequate depth of feeling."[8] Smith might be called the prototypical activist: dedicated, persistent, and willing to suffer whatever necessary—even a beating—to get the story. However, his almost careless manipulation of photographs, both setting them up and using obtrusive lighting and heavily manipulated prints to convey the right feeling, distinguishes him from activists today. He would do whatever he needed to produce that "adequate depth of feeling," but today in our post-Photoshop world, which calls into question the veracity of a photograph or an event, even the slightest manipulation is unacceptable.

Smith's unique style, blending journalist authenticity with the subjectivity of art, spawned contemporary activist documentary photography, which by the late twentieth century had become what it is today: a hybrid blend of photojournalism, art photography, and documentary that moves seamlessly between the editorial, online, and gallery worlds.

"Photo is a small voice, at best, but sometimes—just sometimes—one photograph or a group of them can lure our senses into awareness."[5]

W. Eugene Smith

Photographer Portfolio

Mary Ellen Mark

Activist documentary experienced another surge in the late 1970s and 1980s when *Life* was revived again, and women and minority photographers entered the profession. Mary Ellen Mark, who credits Smith as an influence, was originally trained as an artist, and that influence is evident in her images. She continued in Smith's tradition of in-depth and personal photographs with an understated patina of politic and social message. Mark says she became a photographer because she cared about people. She was drawn to the people at the edges of culture— heroin addicts, prostitutes, mental patients, and runaways. Mark pioneered funding methods commonly used today. She was the first to seek funding from nonprofit groups for projects that would be published in print, but she also exhibited in museums. Early in her career, she infiltrated the film still business and supported herself and her projects with money from shooting film stills, which allowed her to spend months or years on her projects. She is most well known for her book *Ward 81*, which contains photographs of women in a mental hospital in Oregon; *Falkland Road: Prostitutes of Bombay*, where she befriended and almost lived with the prostitutes in the brothels on this notorious street; and *Streetwise*, which first appeared as a magazine article, then a book, and then as an Oscar-nominated documentary film on teenage runaways in Seattle, Washington.

Mark, like Eugene Richards (profiled in Chapter 3), does not venerate or belittle her often disenfranchised and poor subjects. For example, her images in *Streetwise* are compassionate yet direct and unflinching, suggesting that these teenage runaways are, like all of us, good, bad, strong, and weak. Human nature is complex, and social constructs are convoluted. The project started as an assignment for *Life* magazine in 1983. Mark returned to Seattle in 1988 and with her husband, Martin Bell, made a documentary film. Mark remained in touch with one 14-year-old prostitute, Tiny. Among the most well known of this series is a portrait of Tiny, whom Mark continued to photograph into adulthood, staring at the camera, arms crossed, eyes impassive yet defiant, blowing a bubble with her gum. She is dressed for Halloween as a French hooker, although without the caption, it would not be obvious that her attire was a Halloween costume. However, although this image is almost iconic, Mark's other images of Tiny are even more nuanced. For example, in *Tiny, Seattle, Washington* (Figure 2.1), Mark photographed Tiny at a carnival, ferociously clutching a stuffed animal horse with an expression of such sadness and loneliness that we see her as the vulnerable child she is. Although the facts of Tiny's adult life might not evoke compassion, Mark's images do, because the images acknowledge the humanity of people who, like Tiny, live on the edges of society and often at the edges of their own lives. Mark forces the viewer to confront the helplessness and vulnerability underscoring Tiny's life, and through that confrontation, mitigate the snap judgment it is so easy to make about someone who by age 35 has nine kids by almost as many men.

Many of Mark's projects became self-financed even if they began as assignments. *Ward 81* was her first major self-financed project and was groundbreaking for her career. Mark worked as the still photographer on Milos Forman's film *One Flew Over the Cuckoo's Nest*, filmed in a real mental hospital in Oregon. She met the hospital director and eventually convinced him to allow her and writer Karen Folger Jacobs to spend 36 days living in the women's security ward photographing and interviewing the patients. This project defined Mark's style: photographing people who are not famous, people who are not newsworthy, people who have had some type of bad break (mental illness, poverty, addiction, abuse, and so on). She seeks to reveal some universal truth about people through the specifics of the lives of those

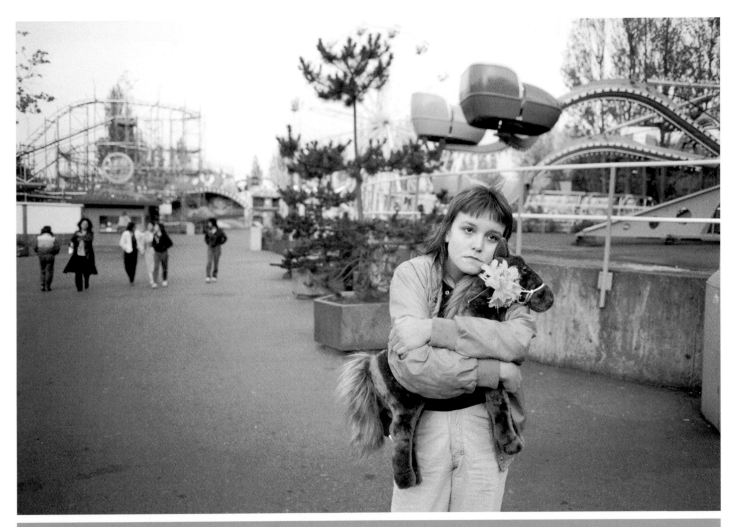

FIGURE 2.1 Mary Ellen Mark, *Tiny, Seattle, Washington*, 1983. Image courtesy of Mary Ellen Mark

she photographs. "I like feeling that I'm able to be a voice for those people who aren't famous, the people that don't have the great opportunities," says Mark."[10] She has an ability to connect quickly and deeply to her subjects, a trait most evident in her *Falkland Road* work. Mark was most interested in photographing the prostitutes who sat in street-level "cages," very small rooms with metal bars. Initially, the subjects were not willing to be photographed. Mark persisted and made friends with street prostitutes, then transvestites, then the madams who ran the brothels, and finally through all of them, the "cage" prostitutes themselves. Not only did they finally let her photograph them, but also they protected her from police and dangerous customers.[11] Although she usually shot in black and white, she chose color for these images because she thought the choice made aesthetic sense, noting that the difficulty in color is to "have it be not just a colorful picture but really be a picture about something."[12]

"No, I don't think you're ever an objective observer. By making a frame you're being selective, then you edit the pictures you want published and you're being selective again. You develop a point of view that you want to express. You try to go into a situation with an open mind, but then you form an opinion, and you express it in your photographs."[9]

Mary Ellen Mark

Susan Meiselas

Susan Meiselas, a member of Magnum since 1976, is most well known for covering the insurrection in Nicaragua, and documenting human rights issues in Latin America. She was the first to break from the tradition of the photographer–writer team when she produced both the images and text for her seminal book, *Nicaragua, June 1978–July 1979,* originally published in 1981 (Figure 2.2). The book combines history, social science, and photography, a common approach for Meiselas. The project was sparked by an article she saw in the *New York Times* (also a commonality among activists) about the assassination of Pedro Joaquin Chamorro Cardenal, editor of the newspaper *La Prensa* and Nicaragua's most outspoken opposition leader. After five months of delay from the writer she was going to work with, Meiselas realized she didn't need him. She left for Nicaragua alone, even though she didn't speak Spanish, didn't have contacts, and didn't even have a place to stay. "It sounds nuts, but it's true," she says.[14]

Meiselas spent two years photographing life under the waning years of dictator Anastasio Somoza and the subsequent successful Sandinista revolution that left 50,000 dead and one-fifth of the population homeless. Although the images had been published in magazines and newspapers, Meiselas wanted to contextualize the experience, and the resulting book, *Nicaragua*, has almost acquired a cult status because it was the first book about the kind of small-scale internal wars that began in the 1970s and continue today, and the first to focus on the revolutionary movement, speaking on behalf of the revolutionaries. In publishing the book, she shed any semblance of objectivity. She writes on the title page, "This book was made so that we remember."[15]

As did Mark, Meiselas switched to color for her work in Nicaragua, because what she was seeing—the people, the clothes, the houses—felt as though it should be in color.[16] Her choice of color for photographs that included war and death also was controversial at the time. Critics accused her of aesthetisizing violence (Figure 2.3), an accusation that continues to be leveled at activists, most notably Sebastião Salgado, although he was criticized for making aesthetically beautiful black-and-white images of famine victims. Meiselas cemented her activist role with her subsequent work in El Salvador where her photographs of the uncovered graves of four murdered American nuns garnered Congressional attention and prompted U.S. congressional investigations into America's role in that war and complicity in aiding the right-wing death squads.

As with many activists, Meiselas' own involvement with issues is complicated and often continues after the story is over. "Knowing when to pick it up and put it down is what it's all about," says Meiselas. "There is a world out there and the world within and you have to somehow move between the two and navigate very complex and contradictory sets of feelings. It is . . . sensitized and desensitized. It is a powerful relationship to manage."[17] Twelve years after she left Nicaragua,

> "There is a world out there and the world within and you have to somehow move between the two and navigate very complex and contradictory sets of feelings. It is . . . sensitized and desensitized. It is a powerful relationship to manage."[17]

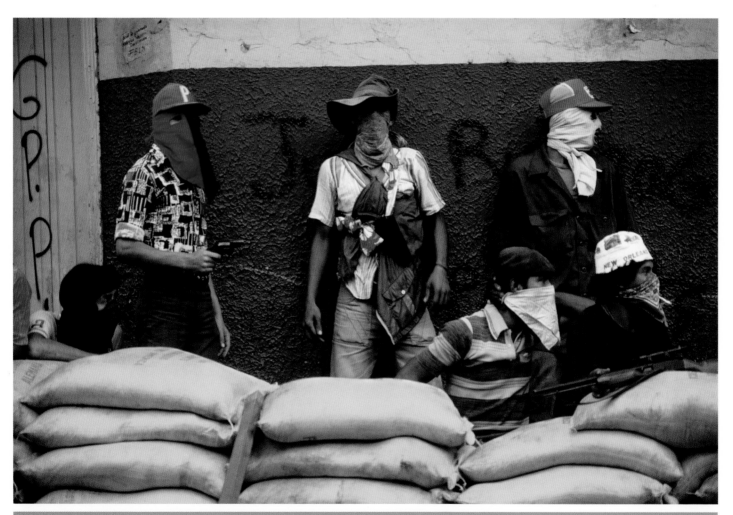

FIGURE 2.2 Susan Meiselas, *Muchachos await counterattack by the National Guard*, Matagalpa, 1978. Image courtesy of Susan Meiselas/Magnum Photos

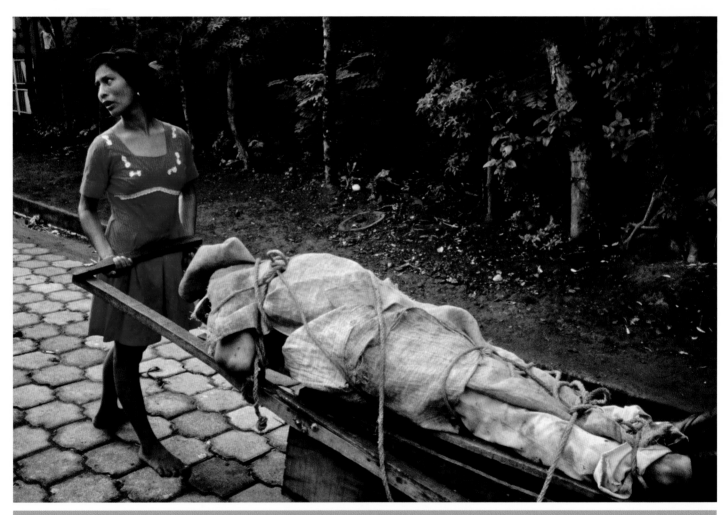

FIGURE 2.3 Susan Meiselas, *Monimbo woman carrying her dead husband home to be buried in their backyard,* Monimbo, 1979. **Image courtesy of Susan Meiselas/Magnum Photos**

wondering what had happened to the people she photographed, she returned to find and interview them. She produced two films, *Pictures from a Revolution*, based on that journey to find the subjects, and *Reframing History*, about her project of making mural-sized prints of the images and hanging them in public places at or near the sites where they were originally taken. "I am still fascinated by that schism between the aesthetic object—the frame versus the lives that come forth from behind the photograph I seek the feeling that comes from the connection. I think that the moment of engagement is ultimately what sustains me as a photographer."[18] Meiselas most recently completed a multiyear project on the Dani, an indigenous tribe in West Papuan Highlands. Her book *Encounters with the Dani* explores how they interact with outsiders.[19]

"So the problem for the photographer remains: how to create images and a sequence that's sustaining and engaging, but asks people to wait, to not think they know, but to be suspended and uncertain along with those pictured whose lives are unpredictable and unraveling."[13]

Susan Meiselas

Donna Ferrato

"Activism goes beyond the photographs," says Donna Ferrato, an award-winning New York–based activist photographer. "And that's the problem that some editors or photo directors have with the idea of activism because it makes them uneasy when photographers become so engaged with an issue that they want to use their life, their voice to bring attention to something that needs to be changed." If anyone has done that, it's Ferrato, who turned one assignment in 1981 into a life's work to bring attention to the previously invisible issue of domestic violence. The photographic project, published as the book *Living with the Enemy* by Aperture in 1991, began when Ferrato was on assignment for Japanese *Playboy* magazine. She was doing a story on a successful couple with five children living in a mansion in Westchester, New York, who epitomized the American success story. To show how the couple's social life meshed with their family life, Ferrato spent almost a year off and on at the couple's house. On the surface, the pair, Lisa and Garth, had the perfect life. But Ferrato sensed underlying tension that erupted one night when Garth viciously beat Lisa. Ferrato heard shouts and things breaking and grabbed her camera (Figure 2.0):

When I first saw Garth hit Lisa, I couldn't believe my eyes. Instinctively I took a picture. But when he went to hit her again, I grabbed his arm and pleaded with him to stop. He hardly noticed my presence, nor did he seem to care that anyone was watching. This surprised me at the time. Now I know that when a man is determined to beat his wife, he will do it in front of the children, the neighbors, even the police. Garth's response to my plea was, "I know my own strength and I'm not going to hurt her—I'm only going to teach her a lesson."[20]

That moment was pivotal for Ferrato, who spent the next 15 years photographing domestic violence. "Even though we have to pay our bills, [activists don't] want to jump to a new story when an assignment is over," says Ferrato. "We want to be effective in deeper ways, and I don't see a problem with that. Why shouldn't we want to understand the issues we plunge ourselves into? We're seeing it all; and the deeper we go, the smarter we get; so we don't want to get diluted. We want to think about how to use our pictures in a new way, for the benefit of the people we photograph."

Ferrato surely did go deep into this subject. Like all great activists, she has a unique ability to inculcate herself into a situation or culture, even in situations as secretive as this. She lived with families, spent more than 6,000 hours riding with police, and visited and often lived in battered women's shelters and maximum-security prisons to create this extraordinary photographic essay on one of the most complex human relationships—that between a batterer and the wife who can't or won't leave. Ferrato's unique understanding of this relationship is evident in her photographs. It is all about power, she says—who has it and who doesn't. "A photographer has to know what's going on in a situation and really direct the action by how [she frames] the picture," Ferrato says. "I don't mean that a photographer literally directs, but if you're paying attention, you can see who has the power by body language or expression." Ferrato's antenna for that was finely tuned during this project. For her, one photograph of a boy, Ernie, and his sister, Brianna, is definitive (Figure 2.4). She explains:

Ernie is only eight years old, but he has already started hitting his sister, so he's become just like his father who is in prison for trying to kill his mother. Hitting women is the only way that Ernie knows how to behave as a male. His sister, Brianna, already lived in fear of her brother because she never knew when his temper would be raining down on her. She didn't like to go crying to her mother. She would just take it, because that's what she saw her mother do when she was being

beaten up. In this one picture, Ernie is tending to a fire in the backyard, waving a stick around, which could seem normal, but Brianna was afraid, so she was standing behind him with her hands folded, submissive, like a perfect little Geisha girl. For me, this says it all. This one picture shows what is in store for this boy and girl as they grow up. A photographer has to be thinking all the time what a scene means to the story and how to use the photographic frame to best represent those moments.

Ferrato's activism didn't end with the photographs. She committed herself to raising awareness about this previously hidden subject by forming a nonprofit organization, Domestic Abuse Awareness, Inc. (DAA), and using her images to raise money for women's shelters. "I had lived in so many domestic violence shelters that I knew how depressing some of them were," she explains. "I wanted to help them raise money so they could continue to do their good work and so people would understand why the shelters are so important if we are ever going to solve this problem." Her nonprofit organization has hosted more than 400 exhibitions worldwide and raised millions of dollars. Although DAA still exists, Ferrato is not as actively involved. "I was really happy with the work we did in the '90s, but eventually I realized it was time to move on. I needed some balance in my life. I wanted to do stories about good relationships, about love."

Today Ferrato's long-term project focuses on her Tribeca neighborhood (Figure 2.5). She is shooting differently she says, but with the same intensity and passion, making photographs that are artistic and almost conceptual. She is less interested in pure content and more interested in the liberation of being an artist, of being playful and conceptual. "It's so much fun to go out at night and feel the energy of 100 years of history, to feel the essence of Tribeca," she says. "When it's finished, I think it will be one of the more beautiful bodies of work I've ever done."

Like the work of Lewis Hine, Ferrato's work has helped change laws,[21] and she was honored in 2008 by a New York City proclamation of "Donna Ferrato Appreciation Day" for "her service as an example of advocacy and activism and for being a citizen the city is proud to call one of its own."[22]

"When people let you into their lives to photograph and what you see is hardcore, how can you not want to help them? Photographers should not be afraid to get their hands dirty. We have to stop thinking like dilettante photographers—you know, the 'my job is just to take the pictures'—I don't buy it when you are photographing in tough complex situations."

Donna Ferrato

FIGURE 2.4 Donna Ferrato, *Ernie & Brianna: Children Who Witness Violence*, Vermont, 1995. ©Donna Ferrato

FIGURE 2.5 Donna Ferrato, *10013, Franklin Street, Tribeca, NYC, 2008.* ©Donna Ferrato

British Activism: Chris Killip and Paul Graham

While American photographers were working in a traditional documentary genre, others were beginning to work in a more contemporary aesthetic. British photographer Chris Killip used gritty large-format black-and-white images to tell the story of an industrial society in decline. For these images, published as a book, *In Flagrante*,[23] Killip chose the point of view of the working labor class in Northeast England devastated by the deindustrialization policies started in the 1970s but carried out by British Prime Minister Margaret Thatcher in the 1980s. The images are raw and without sentiment of people in circumstances unimaginably bleak. The images show how people, at the fringe of their own lives like many of Mark's subjects, cope: They pick up and sell coal washed on shore by the tides that flow over coal seams in the sea; others chronically unemployed because the industry is gone do nothing but drink tea and smoke cigarettes or pass out on the street after an afternoon or evening of trying to obliterate the reality of their lives by drinking too much; and teenagers sniff glue. Although Killip is not sentimental, he is angry, another characteristic he shares with current-day activists, and that anger pops off the page.

Paul Graham continues a focus on the aftermath of Conservative British politics in his book titled *Beyond Caring*, published in 1986, a study of the British social welfare system. Rather than produce intimate up-close photos, he made experiential images of people stuck in the mind-numbing wait emblematic of bureaucracy—sitting; waiting in dank, dark rooms; waiting for anyone to care, for anyone to help them navigate through the system. Unlike Smith, Mark, and Killip, Graham is a voyeur in these images, mostly taken on the sly. Graham's activist work is more contemporary, more fine art than documentary, because he chooses topics that are harder to visualize, such as his New Europe project, in which he used a poetic flow of images to highlight the tension between the shadow of history and the rising super state in Europe.

Stephen Shames

Stephen Shames consciously shifted to advocacy journalism well before his contemporaries. He spent his career creating award-winning essays on social issues, including two seminal projects on child poverty in America. "I think the shift between being a photojournalist and being an activist photographer occurs when you realize that with social issues, photographs transcend who you are," says Shames. "If we are interested in effecting change, we need to think of our photos as a starting point, not a final destination. I got tired of taking pictures of hopeless situations and hoping someone else would figure out the right way to help." Now in his 60s, Shames has traded his camera for a role as the founder and executive director of L.E.A.D Uganda,[25] a nonprofit organization that locates forgotten children in Uganda who show the potential to become entrepreneurs and innovators. For this work, Shames was named a 2010 Purpose Prize Fellow, a designation given to Americans over 60 who have made "an extraordinary impact in their encore career."[26]

L.E.A.D Uganda, which calls itself an "educational leadership program," intends that these forgotten children will become the leaders in their own country. "We need to think about what will change the world," says Shames. "We stay with the children over time, but our goal is to give them all the skills they need to grow up and become self-reliant adults and to send them to the best boarding schools [where the elite in Uganda send their children] so they will become Uganda's next generation of leaders and make real changes in their country." Without L.E.A.D Uganda, these former child soldiers, refugees, abused street kids, and HIV/AIDS orphans would continue to be forgotten. The L.E.A.D Uganda model is not the typical orphanage model; its staff make an effort to find the children's relatives and reintegrate them into their kinship groups because Shames believes that the family culture is a "vital part of the healing process" so necessary for these severely traumatized children.

"One of the problems with orphanages is that you take the kid[s] to the orphanage, and that's where they stay," says Shames. "We realized that if we wanted our kids to be leaders, they couldn't be leaders of the orphanage; they had to be leaders of the community."

Shames' transformation from award-winning crusading photojournalist to crusading social activist is the model for contemporary activism,[27] although unlike others profiled later who have active practices, Shames now uses his camera mostly to promote L.E.A.D Uganda. "One of the reasons I strayed from journalism is that I feel that journalism has certain prejudices toward the negative or toward the sensational," he explains. "When I was a practicing journalist, I always tried to look at what was normal, maybe, or extraordinary, but not sensational. I got tired of the negativity. I think journalism tries to 'unheal' us. And I wanted to heal society." Certainly, Shames' extraordinary career has focused both on issues and solutions. "I've always wanted to right the world," says Shames, whose empathy is palpable. "Eventually, just photographing solutions wasn't enough, so I created my own solutions."

Shames, who started shooting for Newsweek, the New York Times, and the Associated Press while a student at Berkeley in 1968, pioneered the current model of working with foundations, advocacy organizations, NGOs and nonprofits, the media, and museums to fund his personal projects. He has authored four monographs on poverty and civil rights: Outside the Dream: Child Poverty in America (Aperture, 1991); Pursuing the Dream: What Helps Children and Their Families Succeed (Aperture, 1997); The Black Panthers (Aperture, 2009); and Transforming Lives: Turning Uganda's Forgotten Children into Leaders (Star Bright Books, 2010). Shames says, "What interested me was always outside mainstream journalism. I guess I was part of the movement of subjective journalism. I would live with the people I photographed. I didn't pretend to be objective."

Shames made his first major documentary project as the official photographer for the Black Panthers, and in typical "subjective journalistic" fashion, he spent a lot of time with them. Of that time, Shames says: "Bobby [Seale] taught me a lot. He taught me how to organize. He taught me 'black.' He taught me how to use media."[28] Shames learned these lessons well and has applied them to his work in Uganda, which began as a magazine assignment to do a story on AIDS orphans. On his first shoot, Shames became interested in a story on families that were now headed by children because the siblings were intent on remaining together. He found one family of five orphans, headed by a 12-year-old girl who was caring for an 11-month-old baby named Sarah. Shames formed a special relationship with Sarah, who now calls him "Dad" (Figure 2.6). When he went back to photograph the siblings in 2003, they told him that "they had prayed every day that he would come back." It was his epiphany: "I just knew that I didn't want to exploit people anymore." So he decided that he had to pay for school for these five children to give them a chance in life. "I knew that when I did that I would be destroying my story," he says.

That "destruction" became L.E.A.D Uganda, which now has "found" more than 100 children. Although Shames may not be carrying his camera around as much anymore, his passion for effecting social change is more intense, and L.E.A.D Uganda is the culmination of everything he learned as a photojournalist. "I had been involved in children's issues for over 40 years, first as a photojournalist, now as an advocate," says Shames. "Always at the top of my mind is: How do you help those who are most at risk? What I learned documenting child poverty and researching poverty alleviation for The Ford Foundation; what I found out as an activist in the U.S. and Uganda is this: The best way to help children is to help their families and communities in a sustainable way. That is why L.E.A.D Uganda systematically gives children the advanced skills needed to help their communities."

"I've always wanted my photographs to be a voice for the oppressed, a voice for the people who didn't have a voice."[24]

Stephen Shames

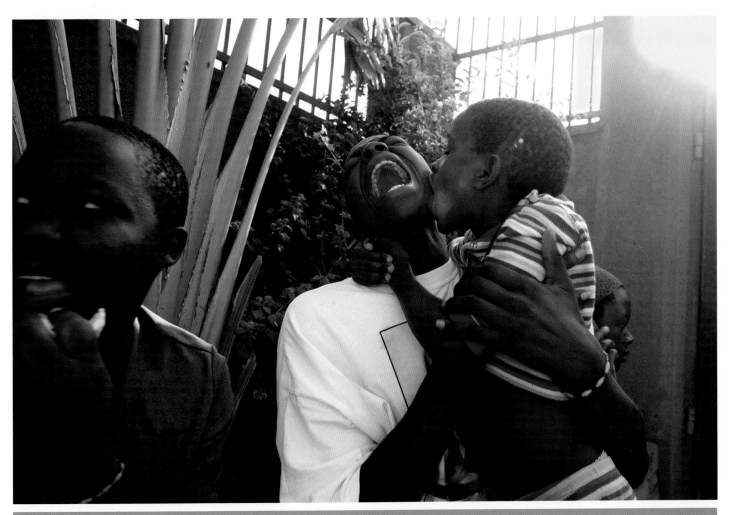

FIGURE 2.6 Stephen Shames, *Sarah Bites* from L.E.A.D Uganda. Six-year-old L.E.A.D Uganda student Sarah playfully bites Michael on the cheek at L.E.A.D Uganda's office in Kampala, Uganda. Sarah was 11 months old when Steve met her while photographing her mom's funeral. Shames formed a special relationship with Sarah, who now calls him "Dad." ©2005, Stephen Shames/Polaris

Sebastião Salgado

Sebastião Salgado, a self-taught photographer, is one of the most well-known and controversial activist photographers of the twentieth and twenty-first centuries. Salgado, who unabashedly calls himself an activist, originally worked as an economist in his native Brazil. With a 40-year career traveling to more than 100 countries to photograph the common man, the worker, and the most powerless and disenfranchised—peasants, children, migrants, and refugees—he is the rightful heir to the Riis and Hine model of social advocacy photography.[30] He admits he is not objective: "Photography for me is the most subjective thing that exists in this world."[31] He works largely self-assigned, self-scheduled, and sometimes self-funded, although he was once on contract to *Life* magazine and was among the first photographers to fund a project (his book, *Workers)* by securing commitments from magazines to serialize the story as he finished sections of it.

Salgado first gained recognition and notoriety with images from the famine in northern Africa, a trip funded by Médecins Sans Frontières (MSF; or in English, Doctors Without Borders), who asked him to photograph their work on famine relief. He spent 15 months photographing in the Sudan, Ethiopia, Chad, and Mali. One stark image, *The Drought in Mali* (1985) (Figure 2.7), shows a boy on the right side of the frame, barely holding himself up with a walking stick, naked and as gaunt as the parched tree mirroring his stance in the middle left half of the frame. The image is symbolic of both Salgado's style and of the criticism that bombards his work. The boy stands upright with an almost defiant look, gazing into the distance. He is starving, but he is not pathetic. Salgado's choice of angle, light, lens, and film (always black and white) gives the boy a certain grace and does not turn him into the passive victim that viewers want to see. The image is not gritty or ugly and does not dehumanize the boy, thus making his suffering more palpable. Salgado never reduces any of the people he photographs into types or issues because, in part, he sees himself as an insider.

You have a very different way of looking at the world when you come from the south to the north. I come from this world, and I have a different understanding of the poor side of this world. I look at the poor without pity because I know that they are only poor materially. They are rich in culture and tradition. It's different than the poverty in America. The ghetto is poor materially and spiritually. This is what I was trying to get people to understand. This world is not a poor world in a spiritual sense. It is possible to construct a very human dignity in society, even the hunger. I never wanted to give a conscience to anyone. These pictures were to give a basis of reflection and discussion. To see that the men who lived in South America, Africa, and Asia are the same men who live here (the developed Western world). We are the same. When you save those people, you are saving yourselves.[32]

Salgado believes that a photographer should "have the strongest relation with a person, to go inside the intensity of a person" because "the strength of a picture depends on the relationship you have with the person being photographed because there is a moment when the subject gives you the picture."[33] Due to his sophisticated visual vocabulary, his images pulsate between the literal and the poetic, creating a story within a story. He shot the image of the starving boy in black and white, with luminous natural light (Salgado never uses a flash because it creates an artificial look). It is an exquisitely composed cinematic image, a style that garnered the most intense criticism that his images are too beautiful, too sentimental,

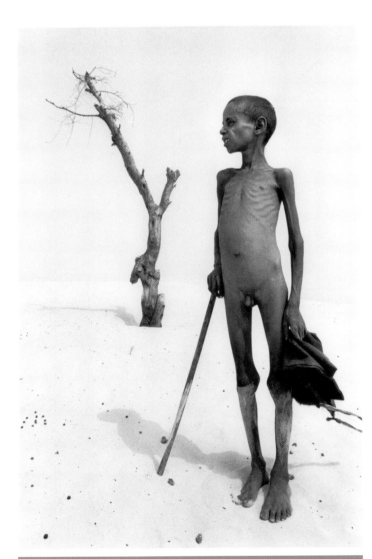

FIGURE 2.7 Sebastião Salgado, *The Drought in Mali* (1985). Image courtesy of Sebastião Salgado/Contact Press

"To aestheticize tragedy is the fastest way to anesthetize the feelings of those who are witnessing it,"

and as such, exploitive. "To aestheticize tragedy is the fastest way to anesthetize the feelings of those who are witnessing it," wrote the critic Ingrid Sichy in a 1991 piece in the *New Yorker* magazine.[34] Other noted critics vehemently defend him. "Salgado's images begin at compassion and lead from there to further recognitions. One of the first of these further recognitions is that starvation does *not* obliterate human dignity," wrote David Levi Strauss of the Sahel photographs.[35] Other critics complained that his photographs are too political and his politics too obvious; Salgado did (and does not) hide the fact that he is fearlessly political and highly critical of the rich Western countries' responses (or lack of response) to the poverty, famine, and disease in Africa. And the West's response to his photographs? Editors deemed them too disturbing for American viewers and would not publish them in American magazines. European audiences were more receptive, and the images were finally first published as a book, *L'Homme en Détresse,* in 1986. Salgado donated the book's proceeds to MSF.

Salgado believes that photography can help humanity make progress and equalize the great economic disparity, because photographs can show to one group what's happening to the other, showing one person's existence to another. He believes that photographs and photographers should provoke debate, both the function and responsibility of activism. "I hope that the person who visits my exhibitions, and the person who comes out, are not quite the same," says Salgado. "I believe that the average person can help a lot,

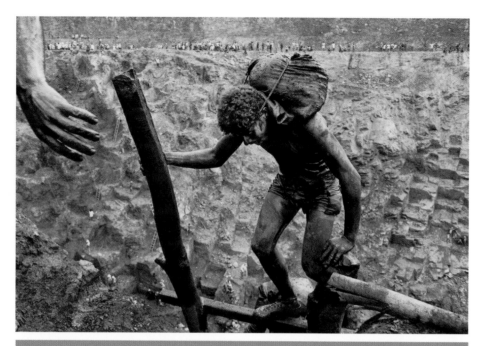

FIGURE 2.8 Sebastião Salgado, *Gold mine at Serra Pelada*, Para, Brazil, 1986. **Image courtesy of Sebastião Salgado/Contact Press**

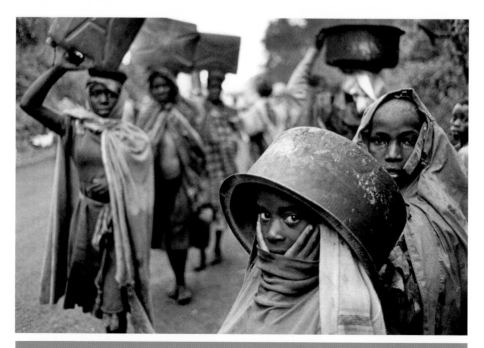

FIGURE 2.9 Sebastião Salgado, *Water supplies are far away from the Rwandan refugee camps*, Goma, Zaire, 1994. **Image courtesy of Sebastião Salgado/Contact Press**

not by giving material goods but by participating, by being part of the discussion, by being truly concerned about what is going on in the world."[36]

Salgado's other projects, in addition to containing a rich photographic legacy, detail the failings of humankind during the twentieth century. In *A Certain Grace,* he documents the life of landless peasants in Latin America. *Workers* is the photographic legacy of the last manual labor being done as the Industrial Age ends, and one particular image, an overview of the Serra Pelada gold mine in Brazil, published in the *New York Times Magazine,* solidified his reputation in the United States. The iconic image taken in 1986 depicts the movements of the gold miners, or diggers, up and down the 1300-foot sheer cliff that leads to the open-top mine. Mud covered, hunched over, with heavy sacks of gold on their backs, the 50,000 plus men, paid about 20 cents a day, move like a colony of ants (Figure 2.8). *Migrations*, photographed in more than 35 countries over the course of six years, documents one of the largest population upheavals in current times as refugees in Africa, Asia, and Latin America fled the aftermath of war, ethnic cleansing, and famine (Figure 2.9). *The Children*, a group of 83 direct, simple, vertical portraits taken in part to get street children to leave him alone while he was working on *Migrations*, references the unadorned direct-level imagery of Lewis Hine, and as in Hine's images, the children here seem to be asking "How can you let this happen to us?"

Salgado's latest project, *Genesis,* is different. It's a project of personal and photographic rebirth. He is photographing the last untouched places on the planet, both to create awareness about the need to protect these places but also to heal him. After having witnessed a lifetime of humanmade suffering, Salgado says, "I was injured in my heart and my spirit." Although these are his first landscape photographs, true to his own politics, he is also photographing communities that still live as their ancestors did. And true to his activist roots, Salgado and his wife, Léila, have created the Instituto Terra, a nature reserve transformed from a cattle ranch once owned by Salgado's father but now devoted to promoting reforestation, conservation, and environmental education.

Love him or hate him, think he's the most exploitive or the greatest documentary photographer of the twentieth century, there isn't an activist photographer working today who has not been influenced by Salgado's unique blend of passion and politics, of his insisting that people not be reduced to issues, and by the way his images mix the eye of an artist with the mind of an economist and the soul of a journalist. He works in what David Levi Strauss calls "the realm of collective subjectivities," and he has and continues to breathe "new life into the documentary tradition."[37] In the end, Salgado says, "I hope that my pictures can add in some way to construct a different society."

"I don't want anyone to appreciate the light or the palette of tones. I want my pictures to inform, to provoke discussion—and to raise money."[29]

Sebastião Salgado

Endnotes

1. Unless otherwise noted, all quotes from Donna Ferrato come from a phone interview conducted by the author on April 1, 2011.

2. Robert Hirsch, citing Paul Hill and Thomas Cooper, "W. Eugene Smith," *Dialogue with Photography* (New York: Farrar, Straus and Giroux, 1979), 280.

3. Hirsch, 282.

4. Interviews with Walter Astrada conducted by the author in New York City in 2010.

5. John G. Morris, *Get the Picture: A Personal History of Photojournalism* (Chicago: University of Chicago Press, 2002), 279.

6. www.pbs.org/wnet/americanmasters/episodes/w-eugene-smith/about-w-eugene-smith/707/ (accessed June 9, 2011).

7. This photo is no longer available for publication at the request of Tomoko Uemura's family.

8. "W. Eugene Smith," *Photo Quotes,* www.photoquotes.com/ShowQuotes.aspx?id=53&name=Smith,W.%20Eugene (accessed February 10, 2011).

9. www.maryellenmark.com/text/magazines/asmp%20bulletin/913L-000-002.html (accessed April 1, 2011).

10. Marianne Fulton, *Mary Ellen Mark, 25 Years* (Boston: Little Brown and Company, 1992), 26.

11. Andrew Long, "Mary Ellen Mark," *Salon.com,* March 28, 2000. www.salon.com/people/bc/2000/03/28/mark (accessed February 11, 2011).

12. Fulton, *Mary Ellen Mark, 25 Years,* 5.

13. www.photoquotes.com/showquotes.aspx?id=479&name=Meiselas, Susan (accessed April 2, 2011).

14. *Nicaragua: Thirty Years Later, a Conversation Between Susan Meiselas and Kristen Lubben, Associate Curator,* International Center of Photography, December 6, 2007.

15. Susan Meiselas, *Nicaragua* (New York: Aperture, 2008).

16. Ibid., Lubben. *Nicaragua: Thirty Years, a Conversation.*

17. centerforcomm, *Susan Meiseles Job Tip—Center for Communication Presents—Photojournalism: Power of the Image,* January 14, 2011. www.you.tube.com/watch?v=Gzt9SyDoDJw (accessed February 10, 2011).

18. Ibid., centerforcomm.

19. Work from *Dani* can be seen on Meiselas' website: www.susanmeiselas.com/dani/dani.html (accessed February 10, 2011).

20. Donna Ferrato, *Living with the Enemy* (New York: Aperture, 1991), 162.

21. Based on an exhibition of Ferrato's images, in 1998 Governor Paul Patton declared October as Domestic Violence Awareness month in Kentucky, New York State also declared October to be Domestic Violence Awareness month, and several other states have increased the penalties for men convicted of domestic violence.

22. Svetlana Bachevanova, "FotoWitness: Donna Ferrato," *PhotoEvidence: Documenting Social Justice.* www.fotoevidence.com/interview-donna-ferrato (accessed March 25, 2011).

23. *In Flagrante*, originally published in London by Secker & Warburg in 1988 is currently out of print. A version has been reissued by Errata Editions: *In Flagrante* (New York: Errata Editions, 2009).

24. Unless otherwise noted, all quotes from Stephen Shames come from several interviews conducted by the author in New York City in 2010.

25. "L.E.A.D Uganda," www.leaduganda.org (accessed March 25, 2011).

26. "Encore Careers Purpose Prize," www.encore.org/prize (accessed March 25, 2011).

27. Shames' awards include the Kodak Crystal Eagle for Impact in Photojournalism, the Luis Valtuña Humanitarian, World Hunger Year, Leica Medal of Excellence, World Press, and the Robert F. Kennedy Journalism Foundation, among others. www.stephenshames.com/bio/ (accessed March 25, 2011).

28. "Stephen Shames: The Black Panthers," *Miss Rosen* (blog), Miss Rosen, missrosen.wordpress.com/2010/05/25/stephen-shames-the-black-panthers/ (accessed March 25, 2011).

29. "Photo Quotes," www.photoquotes.com/showquotes.aspx?
id=496&name=Salgado,Sebastiao (accessed April 2, 2011).

30. Sebastião Salgado, "Amazonas Images," www.amazonasimages.com/
(accessed February 11, 2011).

31. Interview with author in New York City in 1991.

32. Ibid.

33. Ibid.

34. Ingrid Sichy, "Good Intentions," *New Yorker* (September 9,
1991), 92.

35. David Levi Strauss, "Epiphany of the Other," in Diana Stoll, ed. *Between
the Eyes: Essays on Photography and Politics* (New York: Aperture,
2005), 48.

36. "Biography: Sebastião Salgado," *Unicef.Org.* www.unicef.org/salgado/
bio.htm (accessed February 11, 2011).

37. Strauss, "Epiphany of the Other," 48.

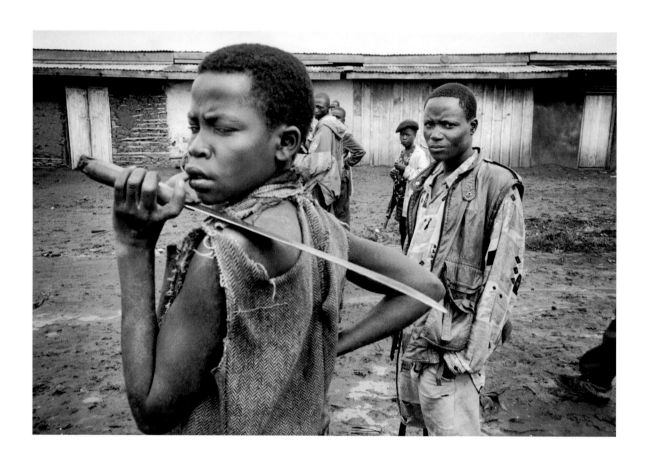

CONSTRUCTING A
BETTER WORLD

FIGURE 3.0 Marcus Bleasdale, *Child Soldiers, Congo*. Child soldiers of the Union des Patriotes Congolais wait for their orders in Bule, Ituri District, Democratic Republic of the Congo, DRC, in December 2007. The DRC contains one of the highest numbers of child soldiers in the world. Many are abducted or recruited by force, and often compelled to follow orders under threat of death. ©**Marcus Bleasdale/VII**

Salgado's desire to construct a different society also compels contemporary activist photographers to seek out the underreported story, the story that just has to be told, the social inequity that has to be redressed. Some continue in the black-and-white tradition; others question the limitations of a single image on a printed page in today's media-saturated world where viewers are bombarded daily by images of the most dreadful scenes and events and respond with a compassion fatigue. Some activists experiment with new media platforms or new storytelling formats. They do this, questioning whether an image can be legitimate if it appears only on a computer screen. Some believe that the photograph is only the beginning, only the means to a solution. They routinely partner with nongovernmental organizations (NGOs) and nonprofit organizations for funding without compromising their photographic integrity. They create foundations to support the subjects they photograph. They use their photographs for fund-raising to aid groups working on the issues that were the subjects of their photographs. They work with activist civilian groups. They post their images on the many new websites devoted to showing social documentary work, or they create their own sites, as award-winning Mexican photographer Pedro Meyer did with ZoneZero®, founded in 1994 as an online site to explore the transformation from analog to digital.[1] Now that digital is entrenched, ZoneZero's goals have changed and include providing "a platform for intelligent photography. That is, photography that offers sensible, informed insight of what is happening in our world."[2]

The profiles that follow highlight a few photographers who are providing informed insight and who are continuing in this tradition of thinking that the photograph is only the beginning. This section is not an exhaustive, complete, or definitive survey of activist photographers today. It is not a statement that these are the best or the only ones, although all the photographers profiled make extraordinary photographs. The photographers were not interviewed with an eye to political, gender, or diversity correctness. They are simply a few of the many photographers working in an activist way today—making great images and going beyond those images to try to find a solution.

The photograph is only the beginning.

Eugene Richards

Eugene Richards is one of the most admired photojournalists working today. He photographs at the fringe of social issues, concerns, and inequities, photographing the harsh realities of his subjects' lives without censoring his images or sentimentalizing the situations. As unvarnished as his photographs are, they are also intensely personal and they pulsate with passion. Although the impact of his work is activist, Richards staunchly denies that label. He is a reporter, he says. Richards started his career as a health advocate for Volunteers in Service to America (VISTA) in eastern Arkansas in 1968. He says he was "kicked out of (VISTA) for being a little too active." He stayed in Arkansas and with other VISTA workers started a newspaper, *Many Voices,* reporting on black political action and the Ku Klux Klan. It was, he says, the start of his career. Some of those photographs were published in his first monograph, *Few Comforts or Surprises: The Arkansas Delta.* Richards' work has been published in 16 books and more than 40 solo shows. He has won almost every award that a photographer can win, including a Guggenheim Fellowship and the Robert F. Kennedy Lifetime Achievement Award. He now lives in Brooklyn, where we met to talk about his most recent book, *War Is Personal* (Many Voices Press, Brooklyn, 2010), a collection of 15 stories, told in photographs and text, of soldiers who returned from the Iraq War. Richards describes the book on his website as "a study of lives in upheaval, a chronicle of greatly differing experiences and perceptions of what it means to go to war, to fight, to wait, to mourn, to remember, to live on when those that you love are gone."[3]

Eugene Richards, Brooklyn, New York, September 11, 2010

MB: In one interview I heard about your book, *War Is Personal*, you described yourself as an antiwar activist. Would you talk about your role as a photojournalist and antiwar activist?

ER: If I did describe myself as an antiwar activist, it was in reference to the Vietnam War. But when I hear it repeated back, I think it was the wrong statement to make about this body of work, because if you make a statement that you're against something, then it clouds your objectiveness. I tried hard to balance this book. I didn't choose people based on their political beliefs. Many of the people I photographed were very much in favor of the war, at least when they went in there. And some of the people still are because it's hard to say that something was wrong when you've lost your limbs or your whole being, or you've lost your child. My God, you're a parent and you've lost your son and you're going to say that it's for nothing? So I think I did this project, to be honest, because I felt like I wasn't doing a damn thing about the war and—it's very true that I was just, as obviously you were ... I'm not alone—just distressed to pieces by that war, appalled by the way it happened.

> "[A] study of lives in upheaval, a chronicle of greatly differing experiences and perceptions of what it means to go to war, to fight, to wait, to mourn, to remember, to live on when those that you love are gone."

MB: Or even that it happened at all.

ER: Yes, that it happened. You know, I was in Budapest on September 11 working as a volunteer for a project on the plight of the mentally disabled (Figure 3.1)—so when I came back home, I had a lot of assignments to go down to Ground Zero, but deeply depressed, I turned them down. At that time, my son, Sam, was 13 years old, and I just saw the whole world changing for him and for us—you know, boom! I said to myself, we're in truly, enormously deep shit that's not going to go away in my lifetime. I knew that covering the destruction at Ground Zero was not only what this was about. It was not only a horrendous crime scene; it was about this enormous loss of American innocence. On September 20, my wife, Janine, and I did go down to the area of Ground Zero and began a project that I now think of as an elegy to those who lost their lives.

MB: How did the *War Is Personal* project originate then?

ER: Thinking back, it began outside of the 2004 Republican convention. Sam and Janine got arrested; I didn't because I was a journalist with a press pass. I photographed the antiwar demonstrations going on. When I got home, even though I'm not a poet, I wrote a poem about the war, how it was a threat to our basic beliefs and our children, and called it "War Is Personal." Then I tried to get assignments to go to Iraq, without any success. Maybe it's because I had less experience overseas than other people had, or maybe there's a little bit of ageism involved, or maybe it's my in-your-face style of photography. And I didn't have the money to go myself. Whatever it was, I finally got tired of listening to myself bitching and moaning about the images I was seeing, or, more correctly, the images I was not seeing. That's how the project began. I knew I could at least try to take a look at people coming home from the Iraq war, even though as an idea this wasn't anything new. The only difference, I feel, is that—because I don't trust pictures and I haven't trusted them in a very long time—I knew that the photographs alone wouldn't be enough, that I had to include the soldiers' words. Language became the primary element in the book, and the photographs happened as the language developed.

> It just isn't enough to show us that people are hungry or living in shit—a lot of people are living in shit. We want to know "Who caused that? Where are they going? What is the future?"

MB: Why don't you trust photographs?

ER: At Visa pour l'Image in Perpignan, the audience was aching for *context*. We wanted to know, you know, what was the difference between the lives of the people who were starving in the Philippines versus the ones starving in India. It just isn't enough to show us that people are hungry or living in shit—a lot of people are living in shit. We want to know "Who caused that? Where are they going? What is the future?" It's the tendency today to sentimentalize the poor or to make them monumental. My experience with the very poor is just the opposite of monumental: Poverty reduces you because it takes away all your opportunities. The poor aren't grand figures. They are reduced. That's what poverty does. So, when I see images that glorify poverty, I am suspicious. When I see photographs of violence that are grand moments—the explosion, the classic moment of death—I am distrustful. Violence isn't grand. Violence when it really happens is very small, ugly. That's what makes it disturbing. The soldiers say all of a sudden there's a "pop" and your friend's dead. There's no music, there's no nothing. So I distrust photographs that monumentalize these moments. And I really don't always blame journalists because we want to make a significant statement, and want to be remembered for what we do, but as a result, sometimes our visual reportage is, if not dishonest, misleading.

> Violence when it really happens is very small, ugly.

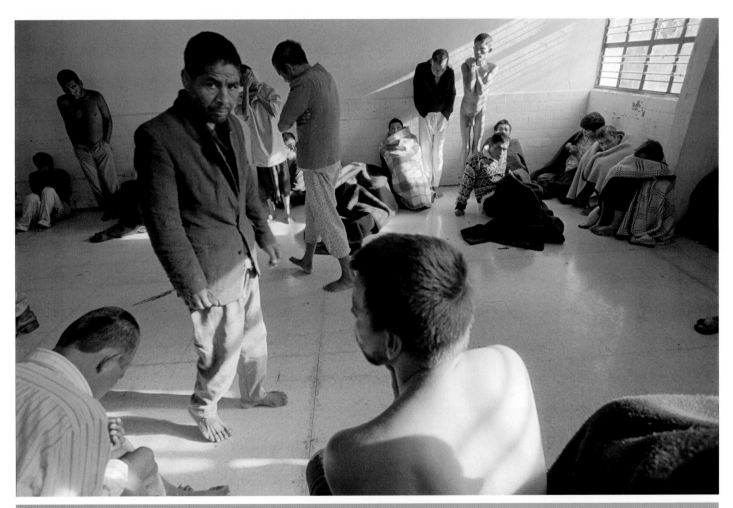

FIGURE 3.1 Eugene Richards, *Untitled* from *Procession of Them—The Plight of the Mentally Disabled.* ©Eugene Richards/Getty Images

MB: Your photographs are much more nuanced than what you're describing here.

ER: I hope so. Well, I don't think they're necessarily more nuanced than anybody else's. I grew up with films more than still photography, and in films, life isn't frozen. I don't want to make the final or definitive image because I know that something different happened before and that life goes on afterwards. So I prefer to photograph what I think of as fragments or fragmentary scenes. You know, people want pictures to be total and final statements, but they're not.

MB: Where does the criticism of your work come from, or who are the critics?

ER: Well, all journalists are criticized; and that's not necessarily a bad thing, though there is a whole lot of hard-core media bashing going on now. That said, the publication of *Cocaine True, Cocaine Blue* did unleash a massive amount.

MB: Really? Those images are extraordinary.

ER: The *New York Times* published an article about the drug crisis, and they used some images from the book, including a sort of infamous one, of a young woman who was a prostitute, preparing to have oral sex with a man, while her baby clings to her back.[4] A group from Harlem picketed the *Times,* but they weren't picketing the article, per se, more the fact that when an article was finally done on the black community, it was negative. The *New York Times* article also saw fit to point out that these images were made by a white photographer. Once these ideas were tossed out there, it was igniting a firestorm. Al Sharpton, whom I've never met, labeled me a bigot. TV cameras came to my house. The media attention and criticism were amazing, considering that at the time it was just a photo book and photo books usually don't get that much attention. A planned exhibit at ICP [International Center for Photography] was almost canceled, then on opening night we had a bodyguard, which was ridiculous. There were all kinds of accusations: that I had paid people, that I used drugs myself, that I gave people needles. That part was true. I did give out clean syringes. I was sitting with a group of young women, covered with sores, and they're passing shared needles around. What would you do? I had some clean needles with me, so I passed them out. I sometimes gave people food, but I never paid anyone. People criticized the representation of black people. They asked me, "Didn't you see these as black people?" First, they weren't all black. I photographed addicts who were Hispanic and white. When you're photographing in that world, you don't see the color of the addict's skin. You just see a sad, beautiful, little girl who sells herself for $2 on the street. You see mothers grieving for their dead children. You see young drug boys carrying automatic weapons. You just see the horrible waste of lives. Eventually, the protests died down and I got work again, but it made me question how far you can go if you are a social critic of any kind. Where will you be stopped? What are the lines that are politically correct? You can't be too angry or too direct. All I wanted to do was photograph how drugs were devastating the inner cities. How else would I do that if I didn't photograph hard-core drug users?

MB: Do you feel that society just doesn't want to see the things you photograph?

ER: Sometimes, even when I don't expect it. Even my book *Exploding into Life*, which was the story of my first wife Dorothea's [Lynch] losing battle with breast cancer, was often criticized. Dorothea was a journalist, and when she was diagnosed with breast cancer, she kept a diary and she wanted me to photograph her. I didn't want to take the pictures. I wanted to get someone else to photograph, but she insisted that I do it. So I did, but I had a very hard time making those photographs. When the book was published, right away the criticism came from some in the medical community. People questioned how I could show breast scars, but even that wasn't my choice. It was her choice to be so honest and revealing. In the end, the Boston Women's Health Collective wouldn't carry the book in their bookstore because the "editor" was male. How f—ing outrageous can you be? Dorothea was gone by that time.

MB: Cancer is ugly, but I think your images are very loving and personal (Figure 3.2). It's a different kind of book for you.

ER: It was a kind of activism which I didn't realize until I read an article some years ago that appeared in *Elle* magazine about the books that have influenced women. Women said this book was ahead of its time and

FIGURE 3.2 Eugene Richards, *Untitled* from *Exploding into Life.*
©Eugene Richards/Getty Images

inspired them to look at themselves. I found that most of the people who bought that book were cancer patients.

MB: Does your early career as a social worker inform your work as an activist?

ER: First off, I learned not to be too sanctimonious when I protested the war in Vietnam and others went. Later, I was a VISTA volunteer and helped found a social service organization in the Arkansas delta, so I came to know what real poverty was and how difficult it was to eliminate such conditions. Then later yet, as I began to photograph, I learned that it takes a real long time to get people to trust you, to let you into their homes, which is where I prefer to photograph.

MB: You photograph at the fringes of culture. How do you gain people's trust?

ER: It takes patience and sometimes luck. The first person I met when working on *War Is Personal* was Tomas Young, who'd been shot in the spine on his fourth day in Iraq. He'd agreed to meet me because he was very much against the war. But when I'd go to his house, he wouldn't see

me. And I grew discouraged, for I didn't really understand the nature of his illness. It usually took him three hours to take all of his medication and to get dressed. Then, ironically, on the day his wife let me in to see him, Tomas accidentally overdosed on his pain medications. We did the interview and I made some photographs, but I was later concerned about that set of pictures. I called him after I got home and aware that he was a proud guy, I said to him, you know, you really look like shit in these pictures. And he said, "So what?" I thought he might be angry with me for the pictures. But he said, "So what?" and I caught the inflection of his voice, and he said, "Well, they're true, aren't they?" And I said, "Yeah." And he said, "Okay, that's it."

MB: What would you have done if he had asked you not to use the photographs?

ER: I wasn't working for someone else, but for myself, so I wouldn't have used them. Now that happened twice with this book. First Tomas, then with Mike Harmon, who'd been a combat medic in Iraq. In his interview he had talked about his drug use, how he had no self-confidence, that he thought he was the ugliest thing alive and wanted to commit suicide. He lives here in Brooklyn, and Janine and I were worried about him. I read him his interview. Then aware that he wanted to go to law school, I asked him if he wanted me to pull the article. He said, no, go ahead. A while later, he was in a political science class when his professor, who had seen one of my photographs of Mike, said, "We have a celebrity in the class." And after the class, this beautiful girl came up to him and told him she had hated him because he'd been so aggressive in the classroom. But now she understood. Today, they live together in Brooklyn, and Mike, who will be graduating from college in the spring, still plans to be a lawyer. Have to tell you, this is one of the few times I know for certain one of my photographs made a difference.

MB: One of my favorite photographs is the one with the mother lifting her son who has lost half his brain (Figure 3.3). It's heartbreaking.

ER: I couldn't get permission from the VA hospital to photograph, but Nellie, Jose's mom, had invited me, so I just hung out with her. I didn't photograph that much because I had to be very quiet. I didn't want to

FIGURE 3.3 Eugene Richards, *Untitled* from *War Is Personal*. ©Eugene Richards/Getty Images

embarrass her or get her in trouble with the hospital. I kept seeing her lift her son up, but couldn't get the photograph. Every once in a while, she'd go to him because he'd need to be turned or changed. He was a big man— she's a little teeny woman, and she'd lift him in one motion, but the picture would be out of focus with it so dark in that room. But eventually I got it.

MB: Do the missed moments haunt you?

ER: They don't haunt me. I don't dream about the photographs I miss, but I am a professional, working in real situations, situations that happen only once, and I don't have a right to fail. I know that some photographers set things up, but I don't (Figure 3.4). You can always tell. Pictures are seldom perfect. You know, like, no matter what people are doing, they're thinking. There's a consciousness in their eyes. If there isn't, they're posing. I don't tell people to move or to do something again.

MB: Was it hard to get this book published?

ER: The *War Is Personal* project began with a short series of picture essays in the *Nation* magazine. Later, when the book was finished, I tried six publishers. Finally, I self-published the book. What made this possible is that we presold something like a third of the books in advance to Visa pour l'Image in Perpignan, Getty Images, and the Nation Institute. I still remember Jean-François [Leroy], Visa's director, calling when we were at the end of our rope, offering to help, because he just loved *War Is Personal*. But without everyone's help, there wouldn't have been a book.

MB: Is the struggle to get published frustrating for you, because you know that projects that really should be done are projects that people don't want to see?

ER: That's actually the best question I've been asked in a long time because people usually ask me if I get depressed by the work itself. I don't. Taking the photographs doesn't depress me. But fighting so hard to get the work published takes a toll on me, and I have to be careful not to take it out emotionally on my family. But even if I get angry or upset, I keep working because I don't want to get stuck in that hole of being beaten down and becoming bitter. We [Eugene and wife Janine] keep working and hoping that the work will make a difference, though that only rarely happens.

MB: Social change is slow.

ER: It is slow. We photojournalists put out books about the world as we see it and hope that someone will take them and use them to organize around a social cause or use them politically. Change does happen, even if photography plays but a very, very small part in this. I once lived where segregation was very much alive, and now, in America, we have a black man in the White House. Although we haven't achieved equality, women's positions have been improved. When I was photographing Dorothea, the doctors would talk to me about her cancer, seldom to her. Doctors would tell the husbands of very sick women about the seriousness of their condition, but not the women themselves. So, things *have* changed in this country. I don't know if I have been a part of the process. I know I've been a witness to history, and maybe that's enough.

MB: I would call you an *activist,* but you use the word *journalist.* What is the distinction between being a journalist and an activist?

ER: To me, being an activist is a choice. But I am not comfortable with calling myself an activist. I've just been in a position to make photographs that reflect the sometimes appalling things that I've seen. And I don't always, at first, understand the significance of what I'm seeing. For example, I was on assignment for a magazine story about public psychiatric institutions in Mexico. The conditions encountered were just dreadful, and so I wondered whether institutions in other countries were as bad off as this. It was then that I volunteered to do a book project on the plight of the mentally disabled around the world. Does that make me an activist? In this case, yes. But in other cases, if I have advocacy or a political point of view in mind, it will adversely affect my photographs and the people I do stories on. *War Is Personal* has been called an antiwar book, but I didn't set out to make an expressly antiwar book, but rather I wanted to do a book that spoke in the voices of others about the consequences of war. I personally feel that war is appalling, hateful, and pornographic, but I am a reporter. Maybe I'm kidding myself, but I want to believe that I am a reporter first, and if I take on the advocate's position, I will miss some truth.

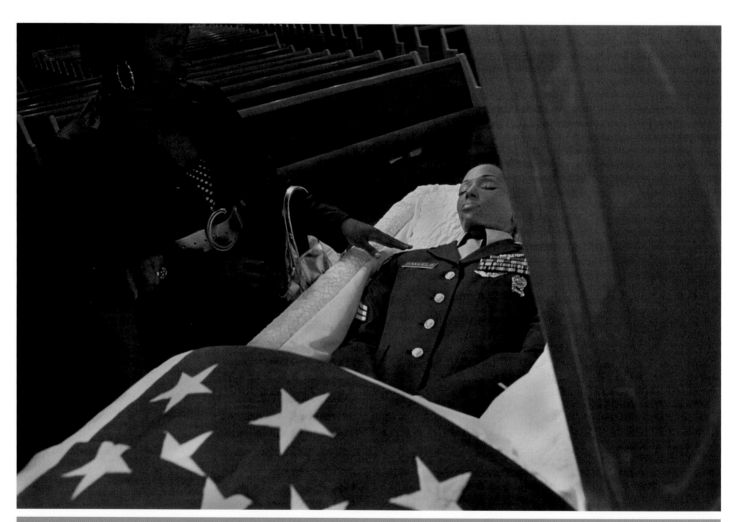

FIGURE 3.4 Eugene Richards, *Untitled* from *War Is Personal*. © Eugene Richards/Getty Images

Photographer Portfolio

Marcus Bleasdale

Marcus Bleasdale, a member of VII Photo, is almost notorious for leaving the very lucrative investment banking job he had when he was 27 years old. It's rumored he was making more than 500,000 GBP a year. His epiphany occurred in 1998 when a fellow trader's response to the day's story about the uncovering of the mass graves in the Balkans was to worry about the impact on the value of the American dollar and German mark. "That repulsed me," says Bleasdale. He swapped derivatives for cameras and after a few years earned the reputation as one of the world's leading documentary photographers. An outspoken advocacy photographer, he often exhibits his work in venues linked to policy makers, such as the U.S. Senate, the United Nations, the Federal Building in New York City, the Holocaust Museum in Los Angeles, the Nobel Peace Center in Oslo, and at the Houses of Parliament in the United Kingdom. He's won many key awards and published two books— *One Hundred Years of Darkness* (2002) and *The Rape of a Nation* (2009)—based on his multiyear work photographing in the very worst and most dangerous conflict areas in Africa: Congo, DRC, and Uganda. Typical of Bleasdale's unique form of activism is a project he helps fund in Eastern Congo. Bleasdale met a nun, Sister Immaculate, who was taking care of 30 children either orphaned or abandoned by families broken apart by the conflict between the Hema and Lendu tribes.[5] The St. Kizito orphanage was in very bad condition, and Bleasdale was so moved by Sister Immaculate and the children's needs that he left her some money to buy medicine and food. When he returned to London, he spoke to a few friends, raised a few thousand dollars, and sent it to Sister Immaculate. When the orphanage needed more money, he turned to the friends from his previous life. "I called my old banking friends," says Bleasdale. "Everyone criticizes bankers, but I think they're wonderful when they send me $10,000, $30,000, or $50,000 donations. They have been very

generous, particularly around bonus time." The ultimate goal is for the orphanage to be self-funding and self-supportive, so the orphanage has partnered with local farmers to farm the orphanage land and share the proceeds with the orphanage. "We now have 134 kids, 6 camels, 10 goats, and I don't know how many chickens," he says. Here, Bleasdale talks about advocacy photography, working with NGOs, how to use photography to effect change, and the future of the business.

Marcus Bleasdale, November 23, 2010, London

I approach photography as an *activist,* or I prefer *advocate.* I am this person who works with advocacy, but I'm not a politician; I'm not a journalist. I don't use a pen. The camera is my tool. I use it to educate, inform, and influence policy. That's how I approach photography. I have a background in economics and finance, so I always try to come at a story, maybe not consciously, but I always come at a story with economics in mind. I work frequently with conflict, or the effects of conflict on the population. I always analyze that conflict: Why does it occur? Why is it there? What are the main sources of this conflict? Who are the main perpetrators, and what are they interested in? And fundamentally, the answer to all of these questions comes down to one thing: There's always an economic basis for the conflict. Or there's always an economic solution to the conflict, and I'm a great advocate of the idea that conflict can be solved if we can find the economic solution. It's always about money, and people's involvement in that conflict can only be influenced if you start influencing them financially and encouraging them financially. I think the majority of all the major conflicts in the last 200 years are

fundamentally economically based. I think that it is the most effective activist approach to try and put economic pressure to effect change.

For example, in 2005, I had a very effective collaboration between Open Society Institute (OSI) in the U.S., and Human Rights Watch. For years, I had been photographing the impact of the gold mining and trade in the eastern part of Democratic Republic of the Congo (DRC) (Figure 3.0). Human Rights Watch released a report called "The Curse of Gold" about a particular conflict in the Ituri and Haut-Uélé provinces in Congo over the gold mines and access to gold there. There were principally two rebel groups that were fighting for the access to the very high gold deposit areas. While the rebels are fighting, in the background you obviously have people who were buying that gold, and we found out that one of the main companies buying that gold [was] a Swiss company called Metalor Technologies. They were buying about a hundred million dollars of gold every year from Ugandan gold dealers. Uganda doesn't have any deposits of gold, so the gold obviously was coming from the DRC. So, we [Human Rights Watch] approached Metalor Technologies with the report that included my photographs, and we asked them, "Will you stop doing this because you are funding and fueling the conflict in this region of the DRC?" They refused, continuously, even after several requests by Human Rights Watch. So we had an exhibition in the lobby of the Union Bank of Switzerland (UBS), in Geneva. The fact that UBS agreed to let us mount an exhibit was unusual for a corporation, and I think that the UBS curator there had some tough questions to respond to after the opening evening, but UBS had been bold by pulling out of their investments in the DRC in 1998, I think. So they were already the good guys in the conflict, or at least not so much the bad guys. Anyway, we invited journalists, the investors of Metalor Technologies, and their shareholders, and of course, we invited executives of Metalor. The exhibit had the effect of affecting them financially, because their investors were unhappy in the way they were funding, or sourcing, their revenues. The journalists were unhappy, and their shareholders were unhappy, so several days later they pulled out and issued an apology. And the $100 million of funding that had been purchasing weapons and uniforms for the rebel commanders just dried up overnight.

This approach was so successful that we repeated it in Toronto at the BCG space where all the mining companies are based, including AngloGold Ashanti, one of the main stakeholders in gold mines in Eastern Congo. They are listed on several stock exchanges, but they were implicated by Human Rights Watch in aiding some of the rebel groups with equipment and turning a blind eye to human rights abuses on their terrain in order to maintain a status quo, so they could still have access to their gold mining areas. When we opened in the BCG space, we invited bankers, traders, and financiers in the mining areas to come have a look—to visually comprehend—the effects their investments have on the populations if they don't go through with the correct due diligence. So we've used this body of work on an advocacy level throughout the U.S. and Europe.

The exhibit in Toronto didn't have the direct effect as it had on Metalor, but we weren't aiming to stop a specific company. This was simply an advocacy statement, "This is what can happen, if you don't behave correctly." During the exhibition, Human Rights Watch had several heavy meetings with AngloGold, and it was an ongoing process, and now AngloGold—especially in Eastern Congo—has changed their working practices, and invested in local schools and hospitals. And now the community has set up a committee that includes the town's mayor, the village chief, government representatives, Global Witness (I think), and Human Rights Watch to monitor AngloGold Ashanti's activities and to hold them accountable. Now the local population can have a voice and say, "You're abusing us in this way," or "You're overstepping the line, in this way." Mining is essential. We aren't trying to stop mining, because the local economy depends on it; we just want the mining companies to be a little smarter about how they mine or who they are supporting when they buy gold or diamonds so no one is abused in that process and the money is not funding rebel groups. So, people have to start behaving in a different way and become accountable for their actions.

This project is still going on. We exhibited some of it at the U.S. Senate in 2009, and we had meetings with Senators Russ Feingold and Sam Brownback, who were part of a special committee to draw up policy. We invited two or three Congolese people, and both Global Witness and the Enough Project were there. So we were in this committee where the senators had a visual understanding of the effects of this conflict on the

population, what the resources can do—what the mining of these resources can do in places like DRC. We walked the senators through the exhibition first, explaining what happened; and shockingly, they were unaware of quite a lot of the issues. Well, I'm a great advocate of Senator Brownback and Senator Feingold,[6] but they needed that visual push: They needed to see children forced to work in mines; they needed to know that a seven-year-old is forced to carry a gun. I want my photographs to be rattling around in their psyche when they make policy decisions.[7]

Human Rights Watch is one of my favorite organizations to work with. The people are great: They're hugely intelligent about what it is they're trying to do and very targeted, and, you know, I think working for them is a joy; working *with* them is a joy. I work the same whether I am working for them or working for other media outlets, but it feels a lot better to be working for the end goal that Human Rights Watch has. It is the process. Why are we photographers? What do we do this for? Why did we pick this camera up? And everyone's response to that question is very, very different. My response to that is I pick this camera up because I want to, in some form, influence and make change, encourage change, and educate people about what needs to be changed. That process of encouraging change, of changing policy, educating a population, is more acute when you work with an organization like Human Rights Watch. You can see that their goals are my goals, and yes, it's kind of an honor to work with them. We've just done a huge project (we just finished, actually, this weekend): a two-and-a-half-month project on the Lord's Resistance Army (LRA), which started in Northern Uganda and then went to the border of Southern Sudan and Central African Republic and then Eastern Congo.

The LRA is run by a guy called Joseph Kony. In May [2010], the U.S. government passed a law called the Lord's Resistance Army Disarmament and Northern Uganda Recovery Act that commits the U.S. to having a significant role in capturing, eradicating, and stopping the LRA from committing the atrocities (Figure 3.5) that they're currently committing in Eastern and Central Africa.[8] So, I've just done this two-and-a-half-month project collectively with Human Rights Watch, partly funded by Human Rights Watch, and partly funded by the Pulitzer Center on Crisis Reporting, documenting the effects of the Lord's Resistance

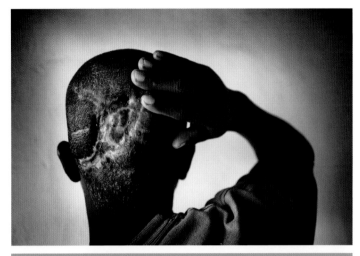

FIGURE 3.5 Marcus Bleasdale, *Lord's Resistance Army, Congo.* Masua Abaneru, 22, and father of three children, revealing his scars, is seen in northeastern Democratic Republic of the Congo on August 18, 2010. Abaneru was abducted by the Lord's Resistance Army (LRA) and used as a porter. When he became too tired to continue, he was taken into the bush, and the LRA commanders forced the children to hit him with sticks until [they thought] he was dead. He woke up several days later and crawled to find help. He was found by some people coming to the village to bury the dead after they heard of the attack. He has not been able to work for over one year due to the attack. ©**Marcus Bleasdale/VII**

Army on these countries: Southern Sudan, Uganda, Central African Republic, and the Congo. The LRA operates in very remote regions, which is why they are successful. There is no one to hold them accountable when they go into a village and abduct 300 children. The boys will be forced to become soldiers, and the girls will become "wives" for the LRA commanders. This project cost tens of thousands of dollars because of the logistics of flying into these very remote areas. We had to hire planes and motorbikes and essentially take everything with us, even generators, and a support team to take us in there. Logistically, it's quite a complicated operation. We conducted 92 interviews over a period of two and a half months with different children and other parts of that society who had been affected by the LRA. We produced a video and a multimedia piece, which is now online with Human Rights Watch and the Pulitzer

Center,[9] but it will also be shown to the White House in this policy decision meeting where, you know, Human Rights Watch will be sitting with military leaders and political leaders trying to formulate a plan that will be effective to eradicate the LRA. So, what we did, we created a bunch of messages from the people that had been affected, and it was a very personal message to President Obama: "Mr. Obama—President Obama, this is what I want you to do," you know, from an 8-year-old child who had been abducted or from a 14-year-old girl who'd been forced to marry Joseph Kony or from an old lady who lost her three grandchildren.

Now, that could never run in other media outlets because it's very obviously a piece of advocacy. I've been working on the LRA for 10 years now, so hopefully with Human Rights Watch and journalists who I've been working with as well and myself, we have a base of knowledge to maybe encourage, or guide, policy on this particular issue. I even made a three-minute video with a personal appeal talking about what I've seen, my thoughts, and my understanding of the situation. This piece is ongoing. We have months of advocacy ahead of us to use the images, film, and the testimony we've taken to educate people and influence policy. I'm currently looking for more funding to enable us to do distribution that work[s] better.

The reason that we had to do this project this way is that we couldn't fund this in the traditional channels. Other major media outlets do not have a budget; Human Rights Watch can't fund it fully, so that's why we had to cofund it with the Pulitzer Center on Crisis Reporting. And so, it's interesting that even though they can't fund it, some media outlets won't run the photographs because it was funded by the nonprofit organizations. With all the dubiously funded and inverted commerce journalism that we see in this world—you know we have media moguls like Murdoch who we're happy to work for and call that journalism—why is this kind of funding suspect? Why is something that's been funded by a human rights organization that has all of our interests at heart questionable as journalism in its truest form? The embodiment of that organization is to defend human rights; that's all they want to do! To me, it's humanity against . . . what?

The media world is broken right now. The funding tools don't exist anymore. No one has the ability to effectively report on the issue in the way that, for example, back in the day, people reported on the first and second world wars. Now we're embedding photographers with the military in Afghanistan, so no one's telling the story of the Afghani people. No one is telling the story of the people on the ground. They're just telling the story of what it's like for the American soldiers in there. I don't think that's journalism, unfortunately. I don't see the difference between [my] working for an organization like Human Rights Watch, and a media organization sending a photographer in to embed with the U.S. Marines. Where's the difference? My images aren't censored by the military. No one filters what I shoot with Human Rights Watch. I shoot what I want. I present what I want. The end message is the message that I want to present. It's me in front of a camera talking to you, saying this is what should happen. You don't have that freedom if you're embedded; your images are censored by the military, but mainstream media will run the photographs.

I have an extreme amount of empathy for the people who have suffered in DRC, and that makes me angry. What I see made me angry and I want it to stop. I do get involved with the people, and that might be a valid criticism of my style of photography, but that also happens to photographers and journalists who are embedded with the U.S. military, because when you embed with a group of soldiers, you can't help but become friends. It's inevitable that you start to feel like you are part of that group because you are living in the same conditions, being shot at, bombed, in the same way as the soldiers you are embedded with. You start to feel as if you are part of the same team, but you're not. You don't want to get your friends in trouble, and you don't have control of what images are released. That's not true journalism, either. It makes me angry that the same people who won't publish images funded by human rights organizations will publish images from a photographer who was embedded. I got into a heated argument at dinner with a friend who just spent six weeks embedded with Marines. He admits that he was drawn in and says that he became friends with the soldiers, but I couldn't quite get him to articulate what effect that had on his journalism. Yes, he put his camera down sometimes. I put my camera down sometimes too. I mean, if a child gets shot and there's someone there who's better qualified to help the child, I'll carry on shooting; that's my job. I'm there to document, I'm there to tell people what's happening. But if there's no

one there to help, I make a photograph—it takes a sixtieth of a second—but I also pick up the child and make sure they get to the hospital. For God's sake, of course, you do. So humanity is going to happen anywhere. How, after six weeks of living with soldiers, does that really affect your ability to tell a story? No one has answered that about being embedded.

I know I can sound angry, but the things I see make me angry, and I want to maintain that anger. The photograph is only the start. Some photographers think that the photograph is the end product, but for me, it's not. It's the first step in the process of trying to enforce change. So if you try, in some way, to pacify the anger you feel when you take the photograph, I think, for me at least, that makes my job a little bit more difficult. I need to stay angry, you know? I want to be just as angry now over what I've seen over the last two and a half months in Congo as I was the first day I started the job, so I will be just as passionate about getting the problem solved as I was five years ago when I made the photograph. That anger stays, and it's important; I don't want it to go, you know? I think it's a channeled anger, though; you know, I am not lashing out at people all the time. I have blown up at a few people in the past over these issues, but I know that doesn't necessarily achieve very much, so I try to be very articulate in the way I express my anger, because if I can articulate my point and in some way communicate to these people about the issue that I am passionate about it, then I can be more effective in making the case for change. That said, you know, when people say, "No, we can't publish the work," or "No, it doesn't work here," well, then I can't always contain the anger.

Fortunately, with the tools we have today to disseminate the work, we don't *need* traditional media outlets all the time. I told my niece and my nephew that I know they're not going to read the *New York Times, Newsweek,* or *Time* magazines, so if they're going to see this piece, it's because it will be on Facebook or some other way of being linked to the Internet because that's what they use everyday. I am on Facebook primarily for work—for this exact thing—so when we publish something on Human Rights Watch, I make sure that the 1,000 people I know on Facebook see it and engage with it and make it viral as they forward it on, and on and on. . . . So everything I produce gets a Facebook tab and a Twitter tab, and everything gets tweeted. Social media is a powerful tool when used properly. You can almost instantly have thousands or tens of thousands of people seeing and responding.[10]

Social media is another way to raise money. Today you just have to be involved with every funding body, with every NGO, with every newspaper and magazine. It's not a single platform as it used to be in the '50s and '60s and '70s, where you went off to a particular place and you recorded what you saw, and you published 15 pages in *Life* magazine, and they paid you $30,000, and you bought a house in New York. That's how it used to work. That doesn't happen anymore. Today, funding is multiplatform. I have to be in touch with the Pulitzer Center on Crisis Reporting. I have to be in touch with Human Rights Watch. I have to be trying to distribute work through *Newsweek, New York Times Magazine, Le Monde,* and the *Daily Telegraph Magazine.* You know, I have to be in touch with these people and have a multiplatform financial solution; otherwise, I wouldn't be able to continue doing these projects. Human Rights Watch and the Pulitzer Center didn't pay me to do the job in Congo; they paid the expenses. So now I need to place the work in order to live. So, we sold it to the *Telegraph Magazine* here in London, *Newsweek* in the U.S., and we partnered with PBS to do a documentary and we released several viral multimedia pieces. That's how the profession works today.

I'm also shooting a lot of video and taking a lot of sound. As I mentioned, we have collaboration with PBS *Need to Know,* so we're going to be doing a 20-minute piece for them. VII [the VII Photo agency] also has a relationship with Canon. So I can do a 5-minute documentary on the "issue," talking about why I'm in the middle of Congo taking these pictures, what I'm thinking about when I'm taking these pictures, why I am taking a picture of the abandoned school (Figure 3.6). I will talk about how the children have been

> I know I can sound angry, but the things I see make me angry, and I want to maintain that anger.

FIGURE 3.6 Marcus Bleasdale, *Lord's Resistance Army, Congo*. An abandoned school on the outskirts of Ango, Bas-Uele province, Democratic Republic of the Congo, on August 11, 2010. People have fled due to recent activity and abductions and killings by the Lord's Resistance Army. ©**Marcus Bleasdale/VII**

abducted or fled this area, and now that no one's going to school, no one's getting an education, and that's really going to affect the future of this area. If people aren't receiving an education, there's no basis for keeping governments in check in the future. So I'm shooting this with a Canon camera talking about the issue. That's what people want to see and hear. But then Canon will use that in their piece. Maybe this is selling out, maybe it isn't, but I need to work; I need to earn money so I can continue photographing new projects. I did a job for Human Rights Watch, I did a job for the Pulitzer Center for Crisis Reporting, I did a job for *Newsweek*, I did a job for PBS, and I did a job for Canon, and I didn't get paid a cent. But at some point, that will all come back in terms of earnings and revenue for me, so I can go and do the next job.

One of my recent paying jobs was to cover the fashion shows, oddly, for *New York Magazine.* The editor, Jody Quon—I think she is now with *W*—takes a photographer who's never been in the fashion world and knows nothing of fashion and puts them in that world. It's very funny actually. On the Monday I had a meeting with her, and she said, "Wednesday, you're going to meet with Marc Jacobs. It's very important." I said, "Who's that? Is that the writer?" And she fell off her chair laughing, saying, "Have we got the right guy?!" I had no idea who Marc Jacobs is. I had no idea who that woman is who they did *The Devil Wears Prada* movie about. Although it turned out fine in the end, it was a very odd experience. I came straight from Congo where I had been doing another job for Human Rights Watch documenting the reactions of the local population on the opening of the Lubanga trial (Thomas Lubanga, former rebel leader from Congo) in the International Criminal Court. So I came from there to the New York fashion shows, and after spending one day backstage, I thought I'd made a huge mistake. I called my wife and said, "I know I can't walk off this job, but that's what I feel I want to do right now." Compared to where I'd been, this was just so completely frivolous. And it got worse for three or four days. I didn't understand it at all, and I didn't get involved in it. I just criticized it. And the images I made then reflect that. I found that the whole thing was very lonely (Figure 3.7). So the images were quite sad. I felt that the girls—the women—who work in that industry were lonely, but now I think maybe that was a reflection of my own state of mind too (Figure 3.8). I didn't see much real beauty.

There was a funny moment, though. I was on the phone with Sister Immaculate, from the orphanage in Congo that some friends and I help support, because she was on a raft with some cows she had just bought in Uganda. I am on the phone with her trying to negotiate a tax so we can ship the cows across the lake, and all these really skinny models are prancing around in front or me, and I'm thinking that I should call MSF and set up a feeding station backstage because I've never seen so much malnutrition in a developed country. It was a bit surreal. The models are photogenic, but it wasn't an attractive place, and they weren't an attractive bunch of people. So the images from New York, and also from Milan, are quite lonely, but then by the time I got to Paris, I'd started to actually get used to it and enjoyed bits of it. It became like going to Cirque du Soleil five times a day. There was so much celebration, and it was just so outrageous and so over the top that you just have to marvel at the creation of these shows. And I did. I was in a warehouse in the middle of Paris at John Galliano's show, and it's snowing real snow. How do they do that? John Galliano's theme was Latvian brides. Latvian virgin brides. Where do they get these ideas? I have no idea. Anyway, he had created this snowstorm in the middle of this warehouse, and you could only marvel at it; you could only just sit there and go, "Wow! That's amazing." And I did, and I finally enjoyed it—I enjoyed coming home at the end of it too and going back to work on the projects that I care about.

Every year the Nobel committee asks a photographer to take portraits of the winner. This year it was actually quite difficult to get access to the Chinese winner, so I've been documenting what China is like right now to give a background to the environment in which this Peace Prize was awarded. I am looking at human rights abuses, looking at the role of law, looking at the Internet and how that's affecting the Chinese population. So that's ongoing, and I'm doing some other Internet-based projects trying to look at work in a very different way. Again, having my niece and my nephew in mind, I'm talking with a gaming company that's based here in London to put together a game, where children, or adults, will take the role of a child in Eastern Congo and become a child soldier. They'll be abducted or forced to work in the mines, but it will be educational, so you will be able to take the role of either a journalist or a photographer or an aid worker working in these areas trying to negotiate

FIGURE 3.7 Marcus Bleasdale, *Fashion Week*. Front of House at the Hermes show, Autumn/Winter 2009 collection, during Fashion Week in Paris, France, on March 11, 2009. ©**Marcus Bleasdale/VII**

So people will either be paying for the game, access for the game, or advertising within the game. And some of the funding goes to Human Rights Watch or MSF. How much is Farmville worth now? I think Farmville was just sold for $400 million? So, imagine us in three years. Imagine if we had some sort of platform where kids engage in real topics and learn about real issues and the basis of that will then go to fund more research in the field or more hospitals or more doctors or whatever. I could see creating these funding games for other countries too. Haiti can then have a similar funding-related game so kids can actively take part in entertaining themselves, but also learning about what's happening in these areas. I don't see any downside to this.

FIGURE 3.8 Marcus Bleasdale, *Fashion Week*. A model is seen backstage at the Dolce & Gabbana show, Autumn/Winter 2009 collection, during Fashion Week in Milan, Italy, on March 2, 2009. © Marcus Bleasdale/VII

the release of these children. But you only advance by learning, not by killing people like you do in *Tomb Raider*. Here you get points when you learn about cassiterite or tantalum, and how that's used in computers and phones, but also how it is affecting the people in Congo. You can rent a 4 x 4, but only if you've scored enough points through the knowledge that you've gained about how people are suffering because of insecurity in that whole region. It might be like Farmville, but here you will be engaging in real issues, not some vacuous freaking farming: "My pig is going to die." I think it's a great way for kids to be entertained and to learn.

I can also see an interactive model where we could embed multimedia pieces about Human Rights Watch or MSF, so if you hit on a certain thing in the game, you get a multimedia piece from Human Rights Watch or these kids talking about their life in Congo or an appeal from a doctor in East Congo—these will be real people, with real appeals, with real issues, connecting with all of the people playing the game.

Tom Stoddart

Tom Stoddart, who is represented by and works closely with Getty Images, has been making remarkable humanistic photographs and winning awards for 40 years. During his long career, which began in a local newspaper in the Northeast of England when he was 17, he has been seriously injured (by an explosion in Bosnia) and witnessed many of the important events of the twentieth and twenty-first centuries. He was on the ground in Lebanon, in Sarajevo, and in Iraq when Saddam Hussein was deposed. He saw the Berlin Wall fall, Nelson Mandela elected, and Americans shell shocked by 9/11. He has seen famine, death, genocide and its aftermath, and the HIV/AIDS pandemic in Africa where 9,000 people die every day. Through all of that, he remains true to himself; he's modest and kind and remarkably enthusiastic about documentary photography. The title of his book, *iWITNESS*, maybe describes it all. The "i" is lowercase because Stoddart hates pomposity. He is more interested in witnessing than being part of the story, and his humanity permeates his photographs. We almost feel his presence, imagining him with his Leicas, running alongside a scene, or crouching, to create that perfect composition. And we know with certainty that he does not want us to feel pity for the people he photographs; he wants us to be angry that the situations exist. Although he spent the past year shooting advertising, topping off his bank account and taking time off from man's follies, he wants nothing more than to get back in the field and find that next great story. Here, Stoddart talks about his career, the state of photography today, and what makes a photograph great.

Tom Stoddart, November 24, 2010, London

MB: Do you think of your work in the context of activism?

TS: Generally, I think photography has always been essential for change. I recently had lunch with Don McCullin, and as usual with photographers—especially old photographers—we had a trip down memory lane. Inevitably, our conversation turned to Vietnam. Don was in Vietnam with Philip Jones Griffiths and Larry Burrows. Their pictures were obviously used to inform people about the horrors of war, and eventually those people became active and helped hasten the end of the war. I think things have changed immensely these days. Think about the reaction from the Abu Ghraib photographs that undoubtedly forced Donald Rumsfeld to come out and admit what was going on. I don't think photography's changed; it's still an incredibly powerful medium. But today there are so many pictures being taken that the activism is coming from different sources, not just professional photographers. That's not to say the role of photojournalism is diminished at all. I think in many ways it's more important now for photojournalists to go to places and bring back photo essays and stories, but the activism doesn't come just from professional photographers.

MB: Who is doing the activism? Citizen journalists?

TS: Yes, I'm very skeptical about citizen journalism—I mean, what does it mean? Does it mean someone stumbles on a road accident and sends in a photo to their local paper or puts it on YouTube? Or is it something else? I saw an incredible statistic the other day (but I can't remember where I saw it) about how many photographs are made. It was either that there are more photographs taken every day or every week than there are bricks in the world. Whichever, it is a phenomenal amount of imagery produced today. I don't think very much of it is activism. Yesterday we went to the World Press exhibition at Royal Festival Hall. When you go from one horror scene to the next horror scene, and every one of those photographs is winning an award, it becomes repetitive, and I don't know if the typical viewer can look at all of that. I've been a fan of the World Press forever and ever, but I do think that there is this slight thing that, unless it's war, and unless it's horror, it has no value.

MB: I've read some criticism that the venue was inappropriate because families with children go there. What do you think?

TS: These pictures should be seen, so where they're being shown is appropriate. It's free and it's public. It's not enough to put them up in a sweet little gallery where people have to pay to go in. Places like The Photographer's Gallery are so art-based, and so irrelevant in some ways. The work there usually says, "Look at me, me the photographer," rather than "Look at this," which is what photojournalism does. And you hardly ever get a reportage or photojournalism in The Photographer's Gallery because the Arts Council funds it. So you could say, if the so-called place where photojournalism should be seen is not exhibiting it, then it has to go elsewhere, and even if that is a public space, you have the choice of walking away with your kids.

MB: What is the state of photography today? Is photojournalism under pressure to be "art"?

TS: This is a great time to be a photographer or a fan of photography, even with all this doom and gloom about the death of documentary. Photographers have had it good for a very long time. We have been very well paid, whereas writers and poets and artists rarely get paid for their work, and still there are thousands of people writing. Poets are writing wonderful stuff with no guarantee of being paid or being published, and yet photojournalists are up in arms, you know, saying "They don't understand us; they don't understand how important we are," etc. Photojournalism is very important, but we have to understand that times have changed, and we have to deliver the message in a very different way. We have to be better at it and understand that we need to be authors, that we need to tell the stories properly in the age we live in.

MB: Are you talking about the multimedia platforms?

TS: Well, I'm thinking about young photojournalists now. When I had lunch with Don, I asked him, if we were starting again, now, how would you do it? And basically, it would be the same as it was when he was working for the *Sunday Times*. He got on the most important stories in the world, and he told them differently and better than everyone else. Of course, when he was working in various conflict situations, he was only competing against 20 photographers, and now it would be 200 or 2,000, but he still told the story better. It's also true that he did have a vehicle—the *Sunday Times* or the *New York Times*—to publish his story. The challenge for young photographers is not so much about taking the photographs; it's about making the photographs mean anything in front of an audience that has seen way too many photographs. That's really tough.

MB: The Internet provides a lot of new ways to distribute work, but the challenge is how to generate revenue from that.

TS: Well, making a living off them, that is a whole different thing, but one leads to the other. Any kid can go to Zimbabwe now and do a story about nuns or famine or farmers and bring the pictures back, and pretty much every one of the magazines around here won't use them, unless they're exceptional. But, you could call the BBC. They will run 12 pictures as a photo essay, but they won't pay you anything. You can put them on YouTube, on your website; you could put them on lots and lots of things, but they won't have any impact and that's the problem: There are so many images around, the challenge is—if you're a young guy, how do you force your imagery in front of people who will pay you for it? [There are]

many young guys who are doing very well, and doing exactly that, but they're better than everyone else. And that's the point: At the end of the day, are you good enough? I see young photographers all the time. I'm doing a thing tomorrow night at a college, and there are 25 photographers who have been paying a lot of money to be taught, but there's only one girl who really understands both the business and herself as a photographer. That's one of the problems: too many young people studying photography. Some of them come out and do very well for a very short period of time. They spend a lot of time and money doing one subject, and they win a grant or award, so they carry on doing that one subject. The real challenge is to be a photojournalist for 20 or 30 years and still keep your energy levels up. The hardest thing for my generation is to keep competing against these kids, who will give their work away just to get published. They all think that it's different for us. But it's not. I haven't got a story to do right now. I haven't got a commission. I haven't got anything, other than watching the news trying to figure out what story I want to do next, and then wondering where I will get the energy at age 57 to pack my bags and go again. And they think it's hard for them? They have this curious idea that because you've been doing something for a long time, people will pay you more and send you on things.

MB: Do you mainly do self-directed projects now?

TS: You know, I've been shooting advertising for the last year. I thought I'd hate myself, but it's been a real learning curve. Advertising is a team game. You have all of these meetings with account people, art directors, and producers, and then the day of the shoot there are 70 people there, including security, hair and makeup, and drivers. And then there's this terrifying moment when you realize there's silence, and you think, "What's all that?" and you realize everyone is looking at you, the photographer. That is terrifying for a photojournalist because, in my other world, you know, I'm working with two Leicas, trying to stand in front of people without them noticing me, working quietly on my own, no assistants, no nothing, except me, my eyes, and a pair of cameras. So I've had to learn a whole different skill set. I've learned how to be a conductor, how to take control of a set with a lot of people standing around. It's been interesting, but I've had just about enough of it now.

MB: Do you think your year of advertising is going to change anything in the way you shoot when you go back into the field?

TS: It's an interesting question. I don't know if it will change how I shoot, but it has made it possible for me to go back into the field because it's made me more financially secure. And it has reconfirmed my love for photojournalism in its purest form. So, taking a breather from going to Haiti and going to Afghanistan is not a bad thing when you've been a professional photographer for 40 years. Yeah, it's 40 years this month. I've never done anything else but take pictures. I was 17 when I joined a weekly newspaper. And you can't do anything for 40 years unless you really love it. It's a marathon, not a sprint. It's fine when you come out of college, and you want to take on the world. You want to be a war photographer, but very quickly you become an antiwar photographer when you realize what war is. But the whole thing of taking a break and shooting some other kind of work has been really worthwhile. It's good to experience another form of photography, but at the end of the day, photojournalism is where my heart is.

MB: You've been a photojournalist your whole life. How do you adapt that style to advertising?

TS: Everyone thinks it's easy, but it's not. You can't hire a photojournalist and immediately expect them to work with an art director. We're not used to that. The first thing they say to me normally is, "Oh, the client wants this in color," and so you have to be prepared to compromise. You have to satisfy a multitude of people, whereas in photojournalism you just have to satisfy yourself. But in the end, it's still about pride in doing a good job.

MB: You said, "photojournalism in its purest form." What is its purest form?

TS: Paparazzi.

MB: But you don't do paparazzi.

TS: No, but if I—if you really want to get down to it—if I'm sitting in a bush, 300 meters away with a lens, and you don't know you're being photographed, you won't change what you're doing. As soon as I put a lens

on you, from here [sitting on couch], you're going to change; one way or another, you'll change. Long-lens paparazzi photography is the purest form of documentary. Or any kind of photography where people don't know they're being photographed, like that photographer who made those wonderful photographs in New York where he set up a camera and lighting system in Times Square.

MB: Oh, Philip-Lorca diCorcia.

TS: Yes, it was interesting. . . . I watched a program last night on Ron Galella. It was interesting how he worked. As soon as you went into his house, you saw the millions and millions of negatives. Everything was in its place and dated, and you just know that this guy had worked his nuts off for years and years and years, because you don't get that many negatives without being out there night after night after night, and then he comes home and meticulously organizes them. And you kind of think, "Ah, he's not just a guy who's just out on the street every night. He's a hunter." He was hunting at a time when the stars were getting a lot out of it as well. Now it's almost like a feeding frenzy; it's awful.

MB: But aren't all photojournalists hunters of some sort?

TS: Yeah, definitely. We are hunting the moment. And there are those who capture the moments, and those who will shoot forever and never get anything.

MB: Do you have a favorite photograph?

TS: My favorite photograph is Larry Burrow's picture of the Marine in the mud. It makes me speechless every time I stand in front of the original in an exhibit. And you do need to look at pictures like this to reenergize.

MB: Do you have a favorite picture that you took?

TS: I have about two or three that I look at and I think, "I couldn't do any better than that." [Stoddart is flipping through his book, *iWITNESS,* to point out photographs.[11]] I was shooting women in Sarajevo [in the suburb of Dobrinja] in one of the most dangerous areas during the siege. And this woman [Malitha Vareshanovic] came walking along going to work, looking very proud and defiant, and I just shot three or four frames with her as I was backing up, and the soldier with his gun was about five meters

away. And the moment I shot, when she looked away from my camera (Figure 3.9), she looks like Sophia Loren. She has pride. I mean this was her war; this was her way of saying, "You will never win. You will never defeat us." This is the way some people went to work. It's the defiance. So, that's one of my favorites. There's another one from Bosnia that I shot in 1992. Mothers were queuing to put their kids on buses that would evacuate them. The Serbs were allowing them to send their children out, because obviously if you send your kid away, then it's going to deflate you even more. I was shooting the queue, before they got on the buses. And I like this image because it's the kind of picture that I aspire to. I made it with a short lens, so I am in very close, and you look into their eyes—both the mother and child—and you know what's going on. You see the details—the boy is dressed in nice clothes, and a single tear drips down the mother's cheek. I don't have children, but if you're going to send your kid[s] away, you dress them in their best. The idea that the little boy is completely bemused about what's going on and she is trying to hold back her tears and she's going to send him away tells the story for me (Figure 3.10).

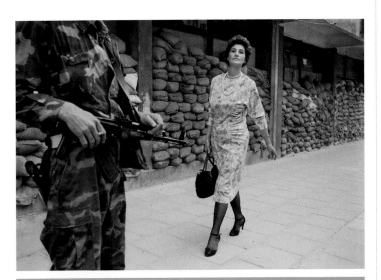

FIGURE 3.9 Tom Stoddart, *Untitled* from *iWITNESS, Siege.* In the dangerous suburb of Dobrinja, Malitha Vareshanovic walks proudly and defiantly to work during the siege of Sarajevo, 1993. Her message to the watching gunmen who surround her city is simple: "You will never defeat us." ©Tom Stoddart/Getty Images

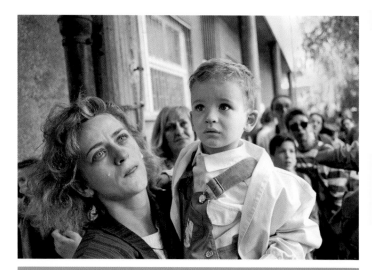

FIGURE 3.10 Tom Stoddart, *Untitled*. Tears of anguish for a mother as she prepares to send her confused child out of Sarajevo on a bus promised safe passage by the Serb forces during the siege in 1992. ©**Tom Stoddart/Getty Images**

MB: The boy has no idea he's being sent away?

TS: That's what I thought then. This photograph has been seen many times, worldwide. Three years ago, I got an email from a lady in Perth, Australia, who told me, "I know that woman. She's my neighbor." So I went to Australia to find her. Her name is Gordana, and her son, Andre, who is now 6 foot 2. What I didn't know is that she had bribed her way onto the bus, and she left with him. It was quite a difficult meeting between us because she doesn't like the image.

MB: Why not?

TS: She understands why it works, and she understands why it's been used a lot, but for her, she didn't want to be portrayed breaking down and crying. She was fighting back her tears at the time, and she didn't want to be depicted like this—crying. But at the same time, she let me photograph her again—she's still a beautiful woman—I took her picture, and we had a long discussion about it. It was great to find her. It was a way of closing the circle, and as a photojournalist, you don't get that very often.

MB: Has that ever happened to you before?

TS: Not really. Not on an image like this, not on a photograph taken in a split second. With the other photograph [of Malitha Vareshanovic], I actually know she is still in Sarajevo because a Bosnian photographer actually re-created that picture. A television crew took her back to this spot. It's now a shopping center, and they got her to walk past, and she's still very proud, you know, the same, but obviously it was set up.

MB: Your story reminds me of a novel I just read, *The Painter of Battles*, that details the conversation between a war photographer and a man he had photographed in a split second, and the effect that the photograph had on the man's life. That moment creates a relationship.

TS: It's an interesting discussion because this was in Kosovo during the ethnic cleansing, and I was one of the first photographers to get back in the country. The first day of going back in—I came in with NATO troops—I was working on my own. And I came on this road, and I saw all these wallets just strewn about. The Serbs had forced 500 Albanians down this road, and the Serbs had taken their money, but they'd also taken their plastic wallets with their precious photographs. The wallets I was finding still contained the photographs, but they were faded or stained by the sun and rain. So I took one photograph from each wallet, and I photographed the faded photographs because photographs are really the true face of the ethnic cleansing: the young kids, the young lovers, husbands and wives. I don't know who they are, but I know where the village was, and at some point, I'm going to go back and try to find these people. These are so beautiful, don't you think?

MB: This project reminds me of the memorials with photographs and phone numbers that people put up after 9/11.

TS: Yeah, that got me thinking about what photographs mean to people. They are memories. I was in New York photographing after 9/11, as most of us were, and I copied some of the information on those memorials. Six months later, I called all the numbers and found some of the people who had posted those photographs. I found one girl, Stacey, who was pregnant then and had lost her husband. She had just had a baby. I did this after 6 months because I knew that all the magazines would be doing

Photographs are important. They're much more than pieces of paper, aren't they? They're emotional—they're everything.

anniversary stories. That is the freelancer in me, thinking "don't wait for the anniversary, don't wait for 12 months"; you've got to be thinking 6 months ahead of everyone else. I've always collected the personal things I find left behind. I've got stuff from the tsunami and all that. Photographs are important. They're much more than pieces of paper, aren't they? They're emotional—they're everything.

MB: They're also evidence and witness.

TS: Which is why I took one out of each wallet, but still thinking, they're not mine; they're not my copyright. I can't make money off of them, but yet I've got the album in there covered in dirt and shit.

MB: I want to ask you about maybe your most iconic photograph, the one you took near the feeding center in Ajiep, Sudan, where the well-dressed man in white has taken the sack of corn from that emaciated boy who is too weak to walk. That photograph has been criticized, and you've been criticized. Do you think it is misunderstood?

TS: Does the camera lie? That depends who's holding it. This was a five-day assignment, not a long project. It was more like parachuting into the famine. If you see the photograph in the sequence, you understand that this happened all the time. And sadly, if we went there today, we'd see that nothing has changed. Sadly. Anyway, this story was shot quickly. There was a feeding center and there were thousands of people waiting to be fed and I was working at the back of it. This kid came crawling along with the bag and, you know, as I took the picture, this guy flashed into the frame and just picked up the sack of food. I was lucky, in a way. The photograph works because of the stick the man is holding and because you can see the food. If you couldn't see the food, it would be less effective. And it works because

of the disdain of the boy looking up at the man. When it was published by one of the major news magazines in the States, they were inundated with people saying, "Why didn't the photographer stop this? How could he let this happen?" The magazine asked me if I wanted to reply, and I told [them] I wanted to wait and see what would happen. And then a school teacher showed it to his class, and I think all 20 kids wrote to the magazine, and I did have to say, "Look, this is just a case of shooting the messenger. Don't write to me. Write to your senator. Write to your congressman. This is the reality of life in Africa. The photographer is just there capturing the moments."

MB: I read that this image raised money.

TS: Well, we gave three photographs to the *Guardian* [a London newspaper], and they ran them on the inside pages. Within a week, they'd raised 100,000 pounds (about $150,000), which went directly to MSF. That was great. This photograph was effective in raising money in part, I think, because I am in close. I like to get in close. I like to see their faces, into their eyes, and therefore into their soul. I like to use strong lines and graphics. But it's also about distance.

MB: What do you mean by that?

TS: Well, it's about the instant decision you make on what composition will be the most powerful. Here, if I weren't back a little, the man in white would be out of the frame. That's where someone like Jim Nachtwey is a genius. He's the fastest photographic computer, ever. If you look at this scene in totality, with this person standing there, and this child here, it's not about what you keep in, it's about what you take out, with your feet. *That* is the instant decision, and that's where Jim is exceptional.

MB: Do you never crop your photographs?

TS: I can't think of the last time I cropped a picture, no. No, these are all in camera even though a lot of it is shot very quickly, obviously.

MB: I think your photographs of famine are more nuanced than Nachtwey's. You don't always show faces. I really like the photograph

where you're shooting three boys, walking away from the camera, carrying bowls. They are all emaciated, and we can see that the land is parched, so we understand the story, even if we don't see their faces. Or the one where an older girl is holding a younger child, and the moment is very loving (Figure 3.11).

TS: Jim would never shoot a picture like this because he just takes you down and down and down. And I don't want to do that. I think this is a beautiful picture. I love the way the lens from the Rollei kind of drops off. The only way we know that they might be begging is their food bowls. It's about siblings, and love, the humanity even in this bad situation. Another picture I really like [he's looking through the book and finds a photograph from the Ajiep feed center in Sudan, inside a hut, with very soft shafts of light, where one person lies dying in the right side of the frame while a young woman gives birth a few feet away (Figure 3.12)]. This is an amazing picture; you know, birth and death in one frame. I only shot three frames on this because I didn't think the lens could handle backlight. What's really interesting is that there are shoeprints in the dirt floor. I hadn't noticed them before, and there was a child visiting an

exhibition in South Africa. He was looking really closely at the photograph. His teacher asked him what he was looking at, and he said, "Well, someone's wearing shoes." Only someone who understands African culture far better than I do or someone who doesn't have shoes would notice that. I am still amazed that [I'd] never picked up on that.

MB: The photographs in this book are amazing photographs, but since they're mostly of those kinds of scenes that well-off Westerners don't want to be reminded of. I am curious as to how the book was received by the public.

TS: Actually, I've got an email at the moment. I haven't actually replied to it yet because I haven't actually worked out what they mean. They emailed me through another person who knows my work. They'd seen my book and said, "Why do you take such . . ."—I need to get the exact phrase, but something like "sensational" pictures or "overly sensational" or something. I'd started to look up what *sensational* means, in terms of the English language and whatever. But how do you answer that? I will go look it up. . . . Another question she asked with all sincerity was "What was your purpose in capturing the *iWITNESS* images that so disturbed her?" I'm certain she didn't mean to be critical. . . . In fact, this is what I need to clarify whether this person was being critical when she said, ". . . has been overly sensational."

MB: Does she think all of the photographs are "overly sensational"? That reaction is what I was curious about. People sitting in the comfort of their houses, with plenty of food in the refrigerator, don't want to be reminded of famine and war.

TS: It actually makes me nuts. Do you know how many people died in Sudan? How can you sensationalize something that is already a terrible tragedy, a terrible horror? How many people die in wars? How can you think like that—that these are "sensational" photographs when nothing that a still photographer can bring back in a single frame can show that kind of horror that these people experience every day. You know, there's a whole chapter on AIDS in here: 9,000 people a day are dying. But there's not one photograph that really captures the real horror of what it means for a whole continent to be blighted by such a catastrophe, and so, yes, it's a really odd statement.

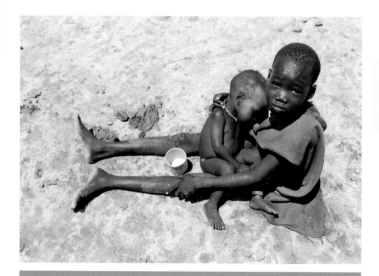

FIGURE 3.11 Tom Stoddart, *Untitled* from *iWITNESS, Famine.*
©Tom Stoddart/Getty Images

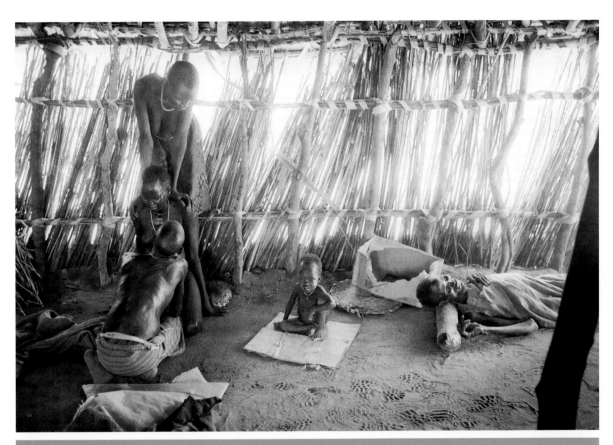

FIGURE 3.12 Tom Stoddart, *Untitled* from *iWITNESS*, *Famine*. A new life begins as another ends in the Ajiep feeding center, southern Sudan, during the famine, July 1998. ©**Tom Stoddart/Getty Images**

MB: What is your response to someone who truly needs to see these photographs but doesn't want to?

TS: Well, my response is: The person who emailed me on behalf of her friend is a teacher. Why doesn't she understand? What are you telling your kids if you're disturbed by this reality? You *should* be showing it to them, you know? You should be showing them what happens to kids when they don't have food, or if they are unlucky enough to live in a place where AIDS is rampant and so many people are either infected or affected. There are more than 14 million children orphaned by AIDS in Africa. They're innocent. People don't want to know. You know, a lab here put three pictures in a window—really big. They were all about AIDS and the idea was life and death. One was of a woman giving birth. One was life and one was death. So anyway, a guy walked into the lab and complained three times because he said the window was on his route to work. And he complained about the birth picture. Three times he walked in and said, "This picture is offensive." He walked to work every morning, and he went in and complained, at least twice, about the birth picture. So you just kind of go. . . . How can you? Or you have to remember that for every person who is like that, there are other people who get it, people who understand that you are trying to bring back a message that's valid and honest, that people can concentrate on for more than a nanosecond. If you can get them to stop and think just for a little while, a little bit more about what's in front of them, maybe they will do something to try to change it. The challenge is where do you place these pictures now? How do you get them in front of the masses?

MB: Do you think that photographs can still make a difference? Is that why you need to get back into the field?

TS: Well, it starts with photographs. Or really it starts with one person, one photographer. For example, Gene [Eugene Richards] gets these truly amazing photographs, and you think, "How does he get in so close? How does he get that trust?" And you realize that it all starts with him. He is an exceptional person.

MB: Which other photographers do you admire?

TS: At the end of the day, we're [photographers] not operating on people and saving their lives, you know; we're not brain surgeons or whatever. But what we do is very important. Gene is probably my favorite photographer right now because he does social documentary on the highest level. Jim [Nachtwey], you just have to take your hat off to him because of what he's done for the totality of his career. Salgado, because he made black and white sexy again at a time when all the magazines were demanding color. Chris Morris, because he's just a superb photographer and such a nice guy and still full of enthusiasm. And then there are younger guys I admire such as Marcus Bleasdale. You know that thing we were talking about: the guys who won't make it and the guys who will? Marcus, from the moment I met him, I knew he would make it because he's a very special person. And Brent Stirton is another person I love. He's very intense, but he takes the right pictures for the right reasons. It's a travesty that that gorilla picture didn't win the World Press (PHOTO) award.

MB: Going out in the field is very physical. Do you think about that?

TS: Of course. As you get older, you can't quite keep up with the 25-year-olds, and why would you? Photojournalism is a very physical job, and it's a dangerous job now. Joao Silva got his legs blown off last week.[12] You know, these guys give a lot—not just physical, for every guy who gets injured like that there are people who just get f—ed up, basically. So it is a difficult life. I can show you my X-rays and you'll understand why, you know, everyone gets hurt. It does take a toll, but it's how you deal with it.

MB: But you still look forward to going back into the field?

TS: Well, yeah, it's just something I have to do. I want to get back, but I don't need to test myself anymore. I know I'm a coward. I don't need to go to war. I need a good story.

Jonathan Torgovnik

Jonathan Torgovnik is an award-winning documentary photographer most well known for his project *Intended Consequences: Rwanda Children Born of Rape.*[13] The work, published as a book and an Emmy-nominated multimedia film, began as an assignment for *Newsweek* magazine in 2006 to cover the effects of AIDS in Africa, for a story coinciding with the twenty-fifth anniversary of the outbreak of HIV/AIDS. While on that story, Torgovnik photographed Tutsi women who "survived" the Rwandan genocide, as rape survivors, impregnated by their Hutu rapists who also infected many of them with HIV/AIDS. The women talked about the complex relationships they had with their children born of rape. Torgovnik realized that this story needed to be told, so after completing the assignment for *Newsweek,* he returned to the United States and used his savings to make three return trips to Rwanda. In 2007, wanting to do more than just publish the photographs, Torgovnik founded Foundation Rwanda to raise money to provide secondary school education for these Rwandan children. As of 2010, the Foundation had raised more than $1 million and supported a couple hundred children, but Torgovnik would eventually like to be able to support many more.[14] Torgovnik, represented by Getty Images, balances his work with the Foundation and new photographic projects. In this interview he talks about his role as an activist, the need to maintain balance, and Foundation Rwanda.

Jonathan Torgovnik, New York City and Perpignan, France, 2010

MB: It seems to me that some photographers of your generation don't just stop at the photograph. They look for a solution. Is that accurate?

JT: I have always been interested in social issues. My generation of photojournalists all work on these issues that we feel need to be reported,

and by publishing this work in mainstream media, we create an amazing awareness that hopefully can create social change by influencing public opinion. Now I don't think that's enough. I think we have a duty and a responsibility to use our photographs as a call to action, if we want to make a difference. Just going out there and getting the story isn't enough anymore. I think there are more documentary photographers today who are trying to make that extra step to help the cause, beyond just taking photographs.

MB: Why did you change your position on the photographer's role?

JT: It evolved in a very organic way as I got more involved in the project I started in Rwanda. I had never heard such multilayered stories with so many levels of trauma. What happened to these women was just pure evil. They witnessed the genocide and horror; they survived brutal rape and then being stigmatized because they were raped. But the horror just didn't end for them. They were still, 15 years later, living daily with the despair of raising a child fathered by a brutal rapist. That was the breaking point for me. That affected me to such an extent that I felt that just getting their stories and getting them published will not do justice to the suffering that they lived with for many years, for this long-term consequence. These women talked about either wanting to commit suicide when they found out they were pregnant or killing the child when it was born. Some thought of abortion, but they [didn't] know how to do it. I don't know how many women chose to abandon their child or committed suicide or killed the kids. Who knows? Who knows? The four families I originally studied *chose* to keep the child. Just thinking about it, I realized I couldn't just publish photographs and hope that the public would do something because I didn't think they would. This community is so isolated, and there are estimates that 20,000 children were born after the genocide, so it's a whole generation that is growing up that no NGO or government organization proactively wants to touch or help.

MB: How did Foundation Rwanda originate?

JT: I usually asked the women at the end of the interview what their hopes were for the future, for them and for their children. And the first reaction was, "Future? Future for us is an abstract word. We live day to day." Can you imagine having no sense of a future? But I pushed and said, "Ok, if you could have anything, if you could think about the future, what would you want?" They all said, "Education for our children." They weren't asking for anything for themselves. They live in extreme poverty, yet they understand the value of education for their children. I was so impressed by this that I wanted to help. I initially thought I would just raise some money from friends and family when I got back to New York, and I'd take that money back to Rwanda personally and try to help with the school fees for some of the kids. We got our big break when *Stern* magazine in Germany ran the story with a note at the end that we were trying to help these families–$150,000 in donations came in. I was shocked. I thought we might get $10,000. The story also ran in the *Saturday Daily Telegraph* magazine in London. Honest to God, I was shocked. I could not believe that the *Telegraph* weekend magazine would do a cover story about rape victims in Africa and that they would pitch Foundation Rwanda and ask readers to donate. In hindsight, I think I had success in getting it published because the images are very beautiful; it's the words that are gruesome. Another $100,000 came in, so now I knew we had to have a proper foundation. Jules quit her job and helped set this up. We didn't touch the money until we had our 501c3, put a board together and a plan. The support for Foundation Rwanda has been amazing. We've raised more than $1 million.

MB: You mention European publications and how much money that raised. Was the story published in American magazines?

JT: It was hard for me to publish this story in America. It finally ran in *Mother Jones* and eventually *Newsweek*, but they wouldn't mention the foundation.

MB: Do you think that reflects a difference between the European and American mentalities regarding activism?

JT: It's an interesting question. I think it is different. In Europe, there's a culture of individual giving; in America, more corporate giving.

MB: You chose to use portraiture to tell this story. Why?

JT: I know that mainstream magazines don't want to publish very graphic photographs, so I knew I needed a different approach. It's a challenging project [for] a still photographer to try to bring, in a subtle way, some kind of trauma that happened many years ago. I also wanted to get the tension between the mothers and children, so I thought environmental portraits would work. I chose to shoot with my Hasselblad and color film. I used ... 65 and 80 mm lenses. I also decided to use classic lighting to light the outdoor portraits. So I used my one ProFoto strobe with a soft box to create fill flash to balance the daylight. That's important with African light and African skin tones. For the indoor shots, I put the camera on a tripod and used natural light to create highlights on the dark skin. I also deliberately made the photographs after I did long interviews because I knew the women would experience so many emotions when they gave their testimonies that I would get a stronger portrait when I confronted them with my camera. It was the first time most of them told their stories to anyone, and talking about the rape was a difficult journey for them but also a relief. I felt at some point that I was ... pushing too much, so I would ask them how they were feeling. They said, "We're very emotional. We're not feeling very good, but we're happy that we did it. We feel like we've held it for so long. Now maybe we're ready to start a healing process."

MB: Do you think you could have gotten these emotional and nuanced portraits (Figures 3.13 and 3.14) if you hadn't done the interviews first?

JT: No. There's also something to be said about the energy between the subject and the photographer, what kind of energy we bring from the conversation to the photography session. I believe that the women felt I was there to genuinely tell their story.

MB: What effect do you think it had that you were a foreigner and a white man approaching these women?

JT: It helped that I was a foreigner because I wasn't someone they would know. They tell me their story, but I leave and I won't share it with their local community. They knew that I would be taking this outside of Rwanda, and they wanted the world to know about how they were

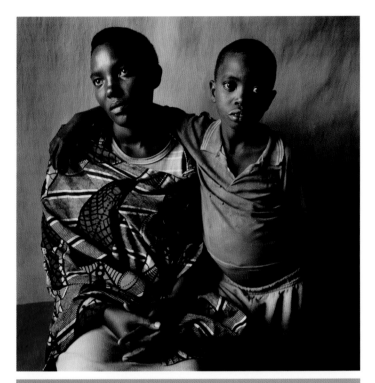

FIGURE 3.13 Jonathan Torgovnik, *Untitled* from *Intended Consequences.* ©Jonathan Torgovnik/Reportage

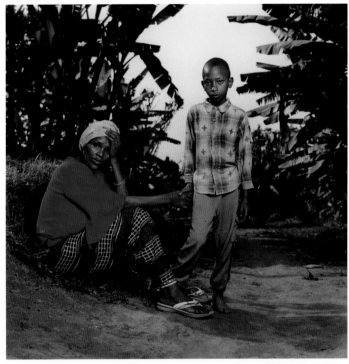

FIGURE 3.14 Jonathan Torgovnik, *Untitled* from *Intended Consequences.* ©Jonathan Torgovnik/Reportage

suffering. But being a man was difficult at first. I was lucky to work with an amazing, sensitive interpreter, who also was male, ironically. The women trusted him because they knew him from an NGO that does work supporting women. But they did tell me, "You know, in the beginning when you walked in, I wasn't sure I was going to say anything to you." One woman told me that the only image she had of a white man was the French soldiers who came in during the genocide to help the Hutu militia finish the job. So in the beginning, some of them associated being a white person as not being a good person. It was a very delicate situation, but as we went along, we talked and I think they knew that I was just there to hear their stories and share these stories with the world.

MB: The title of your interview on the MediaStorm site is "Unspoken Language." It seems like this was underlying these interviews and your ability to connect to the women.

JT: There is an unspoken language with photography. You know people always ask about how we get access. Sometimes you stand there with your camera and you look at [whomever] you want to take pictures of and they look at you and you don't need to ask them if it's all right for you to take the picture. You have some kind of communication, they know why you're there, and you know why you're there. But it's also true that if I am not comfortable with what I am doing, if any photographer isn't, people sense that. It's an animal instinct. If animals sense … you're afraid of them,

they'll attack you; if a subject senses that, they won't trust you or let you photograph.

MB: Sitting here talking to you, I understand why those women trusted you. You project a genuine interest in what I'm saying, for example, so that translates as an interest in me, as a person.

JT: It's exactly that. It's never about access. It's always just between me and someone, and it doesn't matter where I am in the world. I always want to hear the story. It doesn't matter what story you're telling me; I really want to know your side of it. People feel that and they open up. And that's what happened, of course, with this project. I felt that these women were the strongest human beings I have ever met in my life by far, and I admired what they had been able to go through and still stay strong and take care of these children.

MB: Wasn't it hard for you to hear all of these stories? How do you handle that and still make such beautiful photographs?

JT: The first woman who I interviewed after the initial trip was specifically still very, very traumatized in a way that is really debilitating her life. The interview I did with her was so heartbreaking that when I finished the interview, I could *not* take pictures. It was the beginning of the project, and I was not ready for how emotionally draining it would be on me. Of course, nothing compares to what they're going through, but I physically felt that I could not now go into a whole two hours of sitting in front of her doing these portraits. So I asked her if it would be okay for me to come the next day. The next day I actually had to say to myself, "Jonathan, you have to do it. It's hard, but you know what: that's what you're here for. You have to be strong and push yourself." So again, comparing myself to them: They're there, they're opening their hearts to me, and I needed to react to that as well.

MB: How do you maintain that balance, though, for the duration of a project like this?

JT: I don't try to maintain a balance. I push myself, and that's how I elevate the picture and make it ever more powerful. I make sure that I'm loyal, in the end of the day, to the work that I'm doing and remind myself

that in a way that I'm only a messenger. It's not about me; it's about these women and their stories. I'm a vehicle to bring these stories to the public. Sometimes photographers start feeling how important we are. And I think that's wrong. I need to remind myself of why I am doing the story: to create a space for their voices to be heard. No one wants to listen to them. They are rejected, shunned, and ostracized. They were ignored when it happened and forgotten by the world now. So, I'm a vehicle to bring those stories. I remind myself that this is why I'm there, and I force myself to really concentrate. On the interviews, on the photographs, everything that happens in the hours with these people, I want to stay loyal to them, to their story, and to elevate this to the point that will be most effective photographically, and journalistically, to be effective. I don't distance myself. On the contrary, I immerse myself in the emotion. I cry with them; I sit with them there, you know; I'm in tears, but I continue asking the questions and they continue speaking. Then for the portraits, it comes back to that unspoken language. [When I'm] standing there in front of a woman who doesn't speak my language but knows why I'm there and we just had this intense conversation, I don't need to say much. I just need to stay and let enough time pass and run through enough rolls of film that both mother and child are comfortable.

MB: Do you think there is a key characteristic that distinguishes activist photography?

JT: The word *personal* is very important to these types of projects. They become personal for us. It becomes a mission for us. Shooting in Rwanda wasn't just a job for me. It became personal. It became an obsession. So that's one of those things, for sure. When we are connected, we become more dedicated, more personal, and we're not objective. This whole idea that we need to be unbiased and objective is ridiculous. Who can be objective? Look, there's no objectivity in journalism because, you know, we're not objective. It's impossible to be this involved and be objective. But there is a difference between not being objective and pushing an issue by marching in the street or something. I'm not advocating that photographers should do that. I'm saying you always have a point of view, and you always identify with something that you're working on. How you choose to resolve that is a philosophical question.

MB: For you, as you said earlier, it's using photographs as a call to action. How do you do that?

JT: You have to make it easy for people to get involved. It doesn't take much to ask a magazine to list a website link, a telephone number, or a bank account so people can donate if they want to or help in some other way. I think that people want to help if we can tell them what they can do. It's easier to do this in Europe. American media has this idea of journalistic purity, and they think that listing a website link is crossing the line. So in America we need to tap into the online communities. For example, we got Hulu to give us free space for a Foundation Rwanda service announcement. It ran during an episode of *The Office,* and we got a lot of individual small donations online and hundreds of thousands of hits to our website. We've run the story in many online publications, including *Slate,* and we got about $10,000 worth of donations in two days. Of course, that just means that the people who read *Slate* are a proactive, political demographic.

MB: Do you think that you will start other foundations, or is this project just special?

JT: I really don't know. Foundation Rwanda is something that evolved in a very organic way from a photographic project. I'm very proud of it, and I'm doing as much as I can to help it, but I need to take a step back because I've been neglecting my new photographic projects, and I still want to make my living from my photography. At the end of the day, I'm dedicated to making pictures and telling stories and shedding light on issues I feel are important. I'm proud of what we did, but I don't think that all photojournalists have a duty to start foundations. I do feel that photographers can take a little more initiative. It doesn't take much to suggest that a magazine mention, say, the great work that Médecins Sans Frontières was doing in Haiti. We can ask them to put just one little line at the end of the story that says "To learn how to help, go to this website." It doesn't take much! I think that a lot of photographers just don't think of it. They move on too fast. They do the story and then move on to the next story and the next story and the next story. We need to take that extra step, because if we all made sure that we put a call to action out, people would help. I believe that.

Ed Kashi

Ed Kashi believes that documentary photography can make the world a better place, and as a photojournalist, filmmaker, and educator, he has devoted his professional career trying to do just that. He has documented some of the most serious social and political issues of our times, including the plight of the Kurds, the devastation resulting from oil production in the Niger Delta, sustainability in Madagascar, and the very serious problem of the aging population in America (Figure 3.15). He is intense, passionate, and amazingly open, and not surprisingly, so are his photographs, which have garnered him numerous prestigious awards, including a Prix Pictet Commission and the UNICEF Photo of the Year. Kashi's photographs have been exhibited worldwide. He's published major books, including *When the Borders Bleed: The Struggle of the Kurds* (New York: Pantheon, 1994); *Curse of the Black Gold* (New York: powerHouse Books, 2008); *Aging in America: The Years Ahead* (New York: powerHouse Books, 2003); and his most recent, *THREE* (New York: powerHouse Books, 2009), a book about triptychs. Always innovative, Kashi has embraced what he calls multiplatform journalism. In partnership with MediaStorm, he produced the "Iraqi Kurdistan" flipbook.[15] In 2002, Kashi and his wife, Julie Winokur, an accomplished writer and filmmaker, founded Talking Eyes Media, a nonprofit production company that produces short films and multimedia pieces that explore significant social issues. Kashi is a member of the photo agency VII. Here, he talks about advocacy journalism, responsibility, and the changing nature of photojournalism.

Ed Kashi, New York City, January 1, 2011

On advocacy journalism:

EK: In a literal sense, I'm advocating for change. I want my work to be taken by others and utilized to make change—whether that's through academia, education, training, or distribution through the media. Of course, the potential avenues for distributing work have expanded tremendously, and to me it's exciting, and it's ultimately very rewarding. The projects that I think resonate the most as advocacy journalism are *Aging in America*, the *Niger Delta,* and my work on the Kurds. There have been smaller projects that embody or reflect that goal of trying to create change or educate, but these three are the best examples. I also believe that advocacy should continue beyond the photographs. When I spend time researching and shooting a long-term project, I often become a small "e" expert in the field. [Since] 2003, after my *Aging in America* project came out, I have been invited to speak about these issues to forums that aren't photographic. To me, that's wonderful. It's the epitome of advocacy journalism, to be invited as an expert in the subject you've been photographing. It's the nature of documentary work for us to see things with our own eyes, to acquire this valuable wealth of knowledge. And what kills me about my own profession is, we don't seem to value that; it's just all about the picture. Photojournalism can be a very myopic profession, which is ironic, given that what we're telling people is we want to go out and look at the world.

FIGURE 3.15 Ed Kashi, *Untitled* from *Aging in America: The Years Ahead.* ©Ed Kashi/VII

On the impact of a single image:

EK: I have no pretention that a single image can change the world anymore, but I do feel that images still have tremendous impact. I've witnessed that through my work alone. For example, I have a picture from the Niger Delta of a boy carrying a freshly killed goat through this horrific scene of smoke and haze from burning tires.[16] A woman from upstate New York saw the picture when it appeared in *National Geographic* and called me and asked for a print. I sent her an inexpensive print. Six months later, she contacted me and said that she and fellow church members found that boy and were now paying for him to go to school. I always use that as an example that photography can have an impact. Seven years ago, we did a story that appeared in the *New York Times Magazine* about a woman in Dallas with breast cancer, and she received $50,000 in donations after that story appeared. And there are other nonmonetary reactions— whether it's money, whether it's volunteering, or just the sheer number of emails we received from the *Aging* project and our video called *The Sandwich Generation*.

On documentary as fine art:

EK: Everyone is judgmental when documentary photographers exhibit in galleries, and that really bothers me. First of all, photographers have to make a living. [Second], most photographers are also trying to be artistic. If I can get my pictures on a gallery wall, I'm thrilled to have that opportunity to reach more people in yet another venue. And then hopefully someone writes about it and then I'm reaching even more people. Maybe I'd feel differently if my prints sold for $30,000 or $50,000 because that might change the context, but they don't, and I don't think they ever will. But my personal philosophy is I want as many people in the world as possible to see my work because that can only increase the potential for impact.

On the *Aging in America* project and becoming a subject in his own photographs:

EK: The project *Aging in America* began in '95 as a major personal project, and the first segment of the story was published by the *New York Times Magazine* in 1997. After spending a decade photographing international issues, I wanted to focus on an important domestic concern. I wanted to answer the question: What does it mean when a society grows old? We [Ed and his wife, Julie Winokur] had spent eight years on it, and suddenly it became very personal because we decided to move from San Francisco to New Jersey to take care of my 82-year-old father-in-law, Herbie, who was suffering from the beginnings of dementia. We became part of that "sandwich generation" taking care of our two children and an aging parent, so we decided to tell our own story. The project became *The Sandwich Generation*, which is a 15-minute multimedia piece, and after being commissioned to do another "one year later" piece, we turned it into a 30-minute film.

It was odd for me because I was physically involved with taking care of Herbie, but I also had to stand back to document it. Being the photographer allowed me to have a certain distance from the incredibly convulsive changes taking place in our lives. But I also resented it because I didn't want my house to be "the field." I had just come back from a long trip in India and I wanted to just chill out and I didn't want to look at my interior life as subject matter. When I'm working, I have to look at reality in a different way; you can't relax because you're analyzing, "Oh, shit that's a great moment," and all I want to do is have ice cream with my kids and watch TV with them and whatever. But in the end, I'm so humble and thankful that we had this opportunity to care for Herbie, and we made these movies that might help others in our situation. I have come to realize that this is an example of how being a journalist made me a better human being. And, I mean, talk about a form of activism. Here, the creators themselves are changed. We've gotten hundreds and hundreds of emails, and our movies are being taught in textbooks about multimedia, as well as being used in social work for geriatric classes, in nursing programs as a teaching tool on both the high school and university levels.

On multimedia:

EK: I'm totally excited about multimedia. It has increased our authorship. It's given us a new platform to create, to reach audiences we might not reach. We call it "multiplatform storytelling." Instead of going out with a notebook and a pen, you go out with a still camera—*still camera*—and video. But not only video: this is very crucial. Now I'm shooting with the

Canon 5D Mark II. But up until two years ago—year and a half ago—we were working with a video camera and a still camera. Now it's more integrated. The quality from the Canon is incredible. I used it for a piece on Agent Orange I did last year in Vietnam. That's another example of advocacy. The Vietnam Reporting Project invited me and other media professionals to shoot stories on Agent Orange.[17] I shot mostly video and collaborated with a still photographer, Catherine Karnow, but I did shoot some stills and one of them (a photograph of Nguyen Thi Ly of Danang) won the top prize in UNICEF's Photo of the Year as well as a World Press award this year.[18] It's ironic that I went there with the video hat on, but I shot some stills and it was one of my stills that won these awards.

Shooting video is a different process for me. When I'm a still photographer, I'm so much more relaxed. I'm physically relaxed and I just have a little camera and I'm in and out. You pounce on something, and then you relax. When you are doing a narrative video piece, you have to be so conscious of the story, not just pictures. With still photography, we're finessing the truth; we're taking these arbitrary slices of reality that occur in a fraction of a second. In video, you're held more accountable because it is a prolonged moment. It can last 30 seconds, 60 seconds, or 10 seconds. So in some ways it's more of a real moment; it's human reality in time and space with video. With video, you have to comprehend the narrative as it is happening. With photography, you have [to] be really responsible after the fact because context is critical in how you present your still images.

On responsibility:

EK: Sometimes photographs reinforce stereotypes because we photograph the same subjects all the time. It's an aesthetic challenge not to do that because, as a photojournalist, I want to make a really compelling, powerful, and visually amazing photograph that tells the story, and often the only way to do that is to get that stereotype image. If I photograph the starving mom, smiling, with her baby in the village, no one's going to care, so I make a more dramatic photograph. We all do, and photojournalism is criticized as a genre that doesn't change. But is that

the point? Of course, we all want to break new aesthetic ground if we can, but if the purpose of photojournalism is to tell stories of our world and make us understand things, then you don't want to write in Sanskrit. You don't want to use the real misery of people for your artistic palette. Don't go into people's lives just to make cool photographs and advance your career. That feels exploitive and abusive to me. Look, I can't escape the fact that I'm entering people's lives often in difficult or compromised moments, and because of how I work, I'm getting an intimate glimpse into their lives. So I can't escape the fact that I'm having an impact on them and that I want to make sure that whatever I produce is worthy of that inconvenience or that imposition or the pain or embarrassment I might cause them. But it is a great gift to have the chance to be deeply involved in someone's life, so I won't trample over my subjects to get my picture. I am very sensitive to my subjects and that helps me get the "candid intimacy" that I seek in my photographs. There's no sense of me being there. And I take pride in that because it creates images that are more engaging and evoke more compassion for the subjects. I want to get the viewer to care! Then I can, through that, communicate the facts, such as that we take 50 percent of Nigerian oil—$700 billion of wealth has been generated in the 50 years of oil exploitation from that land, yet the people in the Niger Delta have nothing.

On goals:

EK: I'm seeking relevancy. Succeeding in the photo world is not easy, but having done that is not enough and certainly is not the ultimate goal. I want to be part of some movement that makes a difference. I truly believe that photojournalism is meant to make the world a better place. That's what I strive to do with my work, and that's what keeps me going. I do get quite angry and frustrated sometimes, but I'm a survivor. No matter how bad things are, I wake up ready for another day to make a difference and be productive toward that mission. That's my natural instinct. And then there are the incredible human moments I observe. Even in the muck of it all, even in the worst circumstances, there are moments of just absolute serene beautiful, purely beautiful humanity.

Brent Stirton

The first thing you notice about Brent Stirton, an award-winning South African photographer who works as a senior assignment photographer for Getty Images, is that he's a big, tall man. The second thing you notice is that he is surprisingly gentle and soft-spoken. Stirton, who has a degree in journalism, is a self-taught photographer who taught himself quite well. In his short 14-year career, he has become a very well-respected documentary photographer known for his work on sustainability and humanitarian affairs: HIV/AIDS, environment, poverty, conflict and postconflict recovery, and women's empowerment. He works regularly for *National Geographic* (it's not unusual for him to be fully booked two years in advance) and has traveled to more than 130 countries. His images have appeared in every major media outlet, and he has won almost all the illustrious international awards for documentary photography. He was named one of the 10 heroes of photojournalism in 2007 by *American Photo* magazine and appointed one of the 200 Young Global Leaders in 2009 by the World Economic Forum. His most well-known and highest revenue-generating photographs at first seem contradictory: Stirton photographed the murdered mountain gorillas in the Virunga National Park in the Democratic Republic of the Congo,[19] and he photographed both Shiloh Jolie-Pitt and the "Brangelina" twins' photographs (although he won't admit to that on the record). Stirton sees no contradiction, commenting: "Photojournalism is education for change, Jolie-Pitt is about finance for change. Once you've seen the hospitals and clinics that money has built there's no problem."[20]

Brent Stirton, Perpignan, France, September 2, 2010

On the value of research:

BS: Photographers can sometimes be lazy about research. I need to do a lot of research because the issues that I photograph are intangible. I have to figure out the dynamics of the issue and then work on an image that translates to the "everyman." For me, research takes place on the ground—talking to people—and on the Internet and in libraries. Yes, I still use libraries. Sometimes as journalists we tend to run toward sensation and ignore the cause and effect of an issue, and I think that's irresponsible. An issue is not as simple as sensation. If you can try to get beyond sensation, you're also getting beyond your own ego. And if you prepare by doing research, and you know what you're talking about, you come with some security about the possibility of image making, but you also come with some degree of respect for the local people and what's happening to them, and that's key too.

On being a photographer, not an artist:

BS: Sections of the fine art world regularly ask me for images, and I am asked to donate images for fund-raising, which I am happy to do, but I am a photographer. My job is to try and communicate the esoteric, and to educate, but I don't see that as art. We [photojournalists] can get a little too caught up in ourselves if [we] go down the art route. I'm not really that interested in myself. I'm interested in what's going on in the world and how I relate to that and how I can manifest it into an interesting visual.

On what it means to "communicate the esoteric":

BS: In the last five or six years, I've become a specialist in diminishing cultures and cultures that are transitioning and transforming. These cultures are subject to the pressures of globalization and overpopulation. My job is to break down what the dynamics are, to put them into a picture or series of pictures that talk very succinctly about the potential consequences of those developments, of those ongoing dynamics. For example, I was working on pastoralism and transition in Kenya. Going into these projects, I know that they are not necessarily going to be a big seller, so I have to make those pictures as beautiful as possible in order to get attention, because as I said earlier, magazine editors run toward sensation, and these are not sensational subjects. We miss a great deal if we only publish sensational stories, but that is human nature.

With today's media formats, it's very difficult to tell a fully comprehensive story. I think the greatest tragedy of modern journalism is the 24-hour news cycle. I know some very, very well-paid personalities at the networks making huge sums of money, and I ask them regularly, "When are you going to go back to long-form documentary? Because if not you, who?" I just want to do work that is intelligent. I think it makes me smarter, and I'm interested in some degree of personal evolution here. I would rather work with think tanks and advocacy groups than with media. Working with the *Geographic* is great because they're both. I am smarter as a result of working for *National Geographic*. It may not appear so this morning, but it's true.

On working with advocacy groups:

BS: I've worked for every single one of the major advocacy groups and a lot of the minor ones. Like any kind of partnership, working with an advocacy group involves compromise. I go out there, and I make the pictures they need because I respect the agreement we've entered into. I also make the pictures that I need. If it's a matter of this week it's for you, and next week it's for me, then I'll do that. This is not rocket science, you know. But photographers can get caught up in other bullshit: "Oh, I won't be able to do my own work. I cannot possibly work with you guys because you have an agenda and that's not pure journalism." Bullshit. Journalism is a collaborative process at best, whichever subject you're working with or whichever organization is helping you. Let's face it: Most of these groups make it possible for us to do our job because they fund us or give us access. Now it's payback. I'm trying to make a photo essay in a difficult place; you've helped me. Thank you very much. How can I pay you back for that? I give pictures away all the time, and I'm really kind of enthusiastic about doing that.

On responsibility to the subject or the story:

BS: The responsibility you feel is always linked to how much time you spend on a story. The longer you're with people, the more potential there is for you to care about them and for them to care about you. The reality of our profession is that most people understand what we do better than we give them credit for. Just because people are sitting in a tent somewhere in the middle of a refugee camp or just because they happen to be particularly poor doesn't mean they're not sophisticated. The biggest guilt factor behind photography is that there's a very parasitic quality to what we do. And the only way to defend yourself against that is to radiate integrity. "I want to engage with you. I want you also to see what kind of integrity I have when I'm photographing you." I think I always try to act in a dignified way. I am not off to make the most sensational picture I can make; I'm off to have the most sensational interaction I can experience. I'm gentle with the people I work with because I have a big physical presence. I'm always taller and bigger than the people I interact with. If I could wish for anything, it would be to have a lesser physical presence. So I have to be like a gentle giant.

You know, a photographer can get away with a great deal because of a tone in the voice. It's either a natural thing in you or it isn't. There's just a subliminal humanism that's occurring between you and the subject. Just the fact that you're the same animal means that there are certain signals that are going to occur between you. But I'm also a big weeper, you know? I'll be in tears on every second assignment; they're just like, "Oh f—, this guy really cares." I don't fall apart. I'll sneak off to a little corner, have a little cry, and then go back to work. But people see it.

On sentimentality and anger:

BS: I'm so antisentiment. I just don't do that because, yes, there's trauma in seeing what we see. But Christ, I didn't just lose my leg or my home or my wife or my kids; that didn't happen to me. So as a photographer, well, just get your shit together. If it's filthy in the field, you should feel that's a way of paying for your photographs. What tends to happen to me is, I'll be at some gallery opening in New York and I'll get angry. Or I'll be having some interaction with some arbitrary guy in the first world, and all that repression is directed at him, and halfway through, I'll apologize. I'll be like, "Sorry, man, I had a stressful week." But you can't explain what that really means. Most of our outbursts occur in the first world because we cannot afford to be expressing those things where we're working.

On being involved:

BS: I stay involved because most of my work results in exhibitions to raise funds for the organizations that I support. I'll think, "Wow, you guys are amazing," and I'll try to channel something back to that. I stay involved with some stories more than others. For example, I hear from the rangers I photographed for the story on mountain gorillas every three or four months. I spent enough time with a couple of those guys to care about them. We've also raised a very significant amount of money out of that set of images, and that was great. So, like I say, if I'm there long enough, I'll be able to establish a long-term relationship. On most of my jobs, I don't speak the language, so I also have relationships with my fixers. I think I look after my fixers very well, both monetarily, and I try to treat them as well as I can. I hate to see journalists getting harassed and taking it out on their fixers. I want to say, "Be careful, you know? Those guys are keeping you alive."

On how he chooses stories:

BS: To a large extent, I'm too busy to pick my subjects, but I am lucky to be doing stories that I think are important. For the last few years, my stories have been almost entirely about some aspect of sustainability, and these fit into my personal projects, which, because I am so busy, almost have to be an amalgam of what I see when I'm doing other projects.

For example, I've always been very interested in water and just how that's playing out today. But those pictures don't come from going out and working specifically on that issue; it comes from seeing the water themes from the various assignments that I work on (Figures 3.16 and 3.17). I'd have to make a conscious decision to stop working for other people to work on other personal projects, and I'm not prepared to do that yet.

On the mountain gorillas in Virunga National Park:

BS: The gorilla story is by far the best feature Getty ever had. I know that they've made more than half a million in sales, just for editorial alone. The photographs continue to sell, and I continue to get requests on a monthly basis. It used to be a daily basis, then a weekly basis from a variety of organizations, and for the most part, I've tried to honor those requests. Although I ended up embracing the story, it didn't originate with me. Scott Johnson, the Africa Bureau Chief at *Newsweek,* assigned the story, which was to focus on this unique group of park rangers who had just received paramilitary training in South Africa so they could combat the 11 paramilitary groups and two rebel armies in the park, which is a dangerous area to work in. So, that's an incredible thought: We'll train a group of rangers to just take on all those guys. The story was to photograph the first class of rangers. I was there for two days, and then we heard that those gorillas were murdered. We were two hours away. I went in there and photographed the rangers carrying the gorillas out (Figure 3.18). Then we had to flee Congo because the powers that be knew that two white journalists had seen something that they didn't want them to see. I went back a few months later. These images have gotten such attention that we have been able to put pressure on the government to stop this.

On his photographic style:

BS: I'm a progressive photojournalist. I'm not a classicist in any way, so I am always interested in new ways of photographing a story. I use lighting, and I've worked out techniques that allow me to do lighting while I'm moving so I can make spontaneously lit imagery. As a result, I can maintain your attention longer than a lot of people can. For the most part, I use Canon 580s and ProFoto lights. I have specially modified backpacks that I carry. I use the small units, and most of the time I work with one

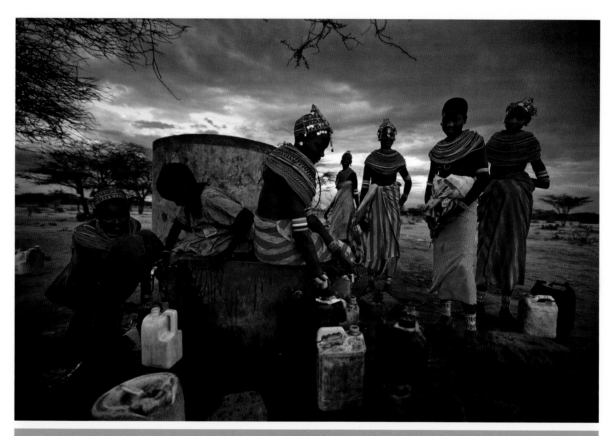

FIGURE 3.16 Brent Stirton, *Untitled* from *Water Issues: Water Is a Gender Issue*. Rendille women collect water from a well at the new Manyata Koya, a relocated village that moved 42 kilometers from the original Koya in 1992 due to heavy cattle raiding and fighting with the Borana tribe. North of Kenya, February 27, 2010. © **Brent Stirton/Getty Images**

FIGURE 3.17 Brent Stirton, *Untitled* from *Water Issues: Fog Harvesting—Megma Valley*. Nepal, November 2003. © **Brent Stirton/Getty Images**

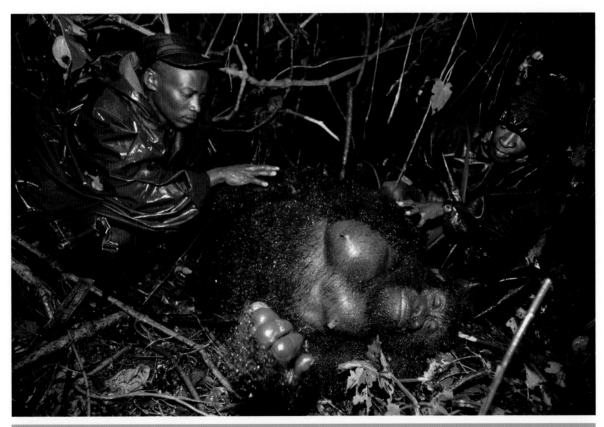

FIGURE 3.18 Brent Stirton, *Untitled* from *Gorillas New Threat of Extinction*, Bukima, Virunga National Park, Eastern Congo, July 24, 2007.
© Brent Stirton/Getty Images

light. I also run my camera flashes on manual, and I meter so it creates a different quality of light. I grew up on slide film, so I don't do anything without a hand meter. That's just my way of working. I know what's going to happen. I can judge distance and exposure very quickly.

On postproduction manipulation:

BS: I grew up on slides with a half stop of latitude. Digital has been an incredible blessing in terms of making things easier. But the amount of postproduction manipulation has become pretty crazy in the last couple of years. It's too much sometimes. I also think it depends on the venue. For example, the *Geographic* wants raw files. They want to see everything that you shoot, and they are sensitive, paranoid even, about excess manipulation. I respect that. It makes you a better photographer because you have to pay attention. The world's beautiful enough if you really know how to work with light. People think that I do a lot of postproduction manipulation because some of my photographs can look surreal, but that's because of my lighting. I am changing the way that the place looks, but I am doing it through light. If you're working editorially, I think that postproduction manipulation should be limited to the kind of dodging and burning that you could do in a darkroom. It's not an option to remove objects or people or move things around. I also don't crop. I move in close. I shoot what I need to shoot. I try to be precise and disciplined, but what I see is that for a lot of the young guys today, it's just a lot of spray and pray.

On spending months in the field working alone:

BS: I don't know; why do I want to be by myself when I'm shooting? There's an element of selfishness to it. I don't want to share this with you because there's this tiny amount of time, and I just really need to be intensely involved with who[m] I'm photographing. I'm not a casual photographer; I really need to feel for what I'm doing, and having people around is a major distraction. And I'm South African, so believe it or not, we're naturally courteous. People don't realize that we are naturally courteous because South Africans are rough around the edges at the best of times, you know? So it's a huge distraction for me to pay attention to being courteous and respectful to my fellow photographers while I'm trying to make a meaningful picture. Photographers can be a prickly, insecure,

egocentric bunch. I don't want to be like worried that I'm in your picture, or that I'm offending you, that your ego might be bruised or this or that, or look after younger guys. I mean, I'll do that—if they get hurt, I'll look after them, but that's not what I'm there for. I think there's a lot of guys who get off on the brotherhood aspect of it or the whole camaraderie thing, but I don't need any of that. I never did.

On social change:

BS: Photographs can contribute to slow change, but social change on a grand scale is slow. I know that a photograph can change an individual life—absolutely because I have direct experience of that. For example, I shot the photographs of Angelina Jolie and Brad Pitt's baby, Shiloh. Those photographs (and others) raised millions of dollars for the Jolie-Pitt Foundation, which makes them among the most expensive pictures sold, by a very long way. That money has been used for humanitarian aid. Their foundation supports hospitals in Third World countries. You walk up to any one of those kids in those hospitals—any one of those people who wouldn't have that hospital without that support—don't tell me that's not affecting someone's life. The gorilla conservation groups have told me that my pictures have raised something like $5 to $7 million directly for gorilla conservation. When I won the Visa d'Or at Perpignan in 2008 for the gorilla story,[21] I gave the money to an organization and they put two rangers through university.

On the value of giving back:

BS: The first time I gave my prize money away was when I won 1,500 euros from the World Press in 2002 for a story I did in Sierra Leone on young girls who had been abducted by RUF rebels. The rebels would use the girls as bush wives.[22] One girl was 10 years old when the rebels took her and 11½ years old when I photographed her. She had tried to escape, and they took battery acid and they burnt off her breasts. The moral vacuum of that world is incomprehensible. I gave my World Press prize money to help build a house for those psychologically damaged young girls. It was a big house, where women could come to on a regular basis and deal with each other, because there's no way anyone else could relate to what they'd been through. In the face of what these people

have been through, for you to profit from these pictures—I find that questionable. It has to be a two-way street. But I am not a Puritan about it. I need to make a living. I'm spending a lot of money to be there, and I'm taking a risk to be there. That's the reality. But I believe that if you have achieved a position where you can sustain your lifestyle and afford to pay for your next couple of assignments and have some degree of security, then you give something back. It's not selfless, but at some point, if you're not acknowledging the fact that you profit from other people's misery, then you lack some degree of sensitivity.

On his favorite story:

BS: The story that touches me the most is usually the one I've just completed. That's how I want to work. If you're not feeling something for the story you're working on, then what the f—are you doing shooting this stuff? So right now, my favorite is the story I just did in Yemen. I was shooting in Sa'ada, and I know that I am unlikely to see fighting, so I need to see consequences. So I look for these victims, and I look for the one that's going to offer me the most empathy, the most sense of commonality, the most sense of responsible humanism. So I found this six-year-old kid. He had been walking with his uncle, and his uncle stepped on an antipersonnel mine and was eviscerated in front of the kid. The mine took out the boy's left eye, and it sprayed shrapnel on his body in a way that can only be described as lewd. It's so grotesque that something—such a—you know. . . . Let me think about this one. You know, kids are perfect, perfect! Anyway, the thing about that stuff is that you have to be responsible. People give me a hard time about f—ing lighting in those situations, and then my little South African military element comes out, and I will f—you up because you have no idea how much responsibility I feel. You know, so it's kind of—I find this kid and it breaks me up—sorry about that. People don't think that we feel, but please,

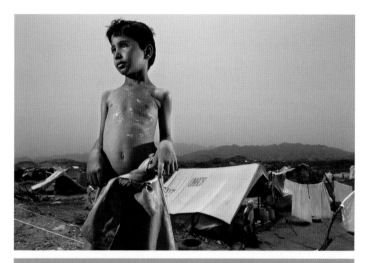

FIGURE 3.19 Brent Stirton, *Untitled* from Republic of Yemen, Al-Mazraq, Yemen, August 2010. © **Brent Stirton/Getty Images**

photographers feel all the time! Anyway, I find this child because I do some f—ing research. I make sure that the journalist I'm with gets to see him, and we get his story because I know it will be hard for people to ignore these photographs. He's a six-year-old boy—and the thing with kids is they're angels. They're angels, you know? I think it's a trust factor, a lot of times. I want to take him to photograph him, so I put my hand out, and this six-year-old boy who's just been blinded and has all these terrible wounds puts his hand in mine—his mother has fallen apart, his father's dead, uncle got blown away, sister was hurt in this blast, his home is nowhere (Figure 3.19)—but still he reaches out, puts his hand in mine, you know halfway walking—it's painful for him to walk, so he asks me if I can f—ing carry him. So I carry him. And he holds you tight, like this, and it's—you know? That's why I do this job.

Photographer Portfolio

Stephen Dupont

It's odd to think that Stephen Dupont, known today as one of the profession's best conflict photographers, began his career as a commercial photographer specializing in photographing celebrities.

Dupont's documentary work, which he switched to in the late 1980s after a trip to Cambodia with fellow Australian photographer Ben Bohane to document the Vietnamese withdrawal from that country,[23] has earned him the most prestigious photography prizes, including a Robert Capa Gold Medal citation from the Overseas Press Club of America; a Bayeaux War Correspondent's Prize; several first places in World Press Photo, Pictures of the Year International, and the Australian Walkleys; the W. Eugene Smith Grant for Humanistic Photography (for his ongoing work in Afghanistan); and the Gardner Fellowship at Harvard's Peabody Museum of Archaeology and Ethnology in 2010. The Gardner Fellowship is funding his current project in Papua New Guinea. Dupont, a senior member of Contact Press Images, also is a member of the Australian collective called °South (Degree South), a group of eight Australian documentary photographers who have dedicated themselves to covering the world's wars and conflicts, usually at great personal risk. The collective's manifesto accurately describes Dupont's conflict work and methodology: "The dedication of °South is to record 'evidence' in a fair, truthful and informative way." Dupont's work certainly does that, but with "the courage of a solider and the eye of a witness."[24] He makes photographs that are both compassionate and at times damning, often shouting "This must not continue!" When he turns his camera away from war, he makes hauntingly beautiful photographs of fragile cultures and marginalized peoples. Here, Dupont talks about his work in conflict zones, the making of art books, and the future of documentary photography.

Stephen Dupont, Perpignan, France, August 31, 2010

On the importance of research:

SD: I research extensively with all my projects, especially the ones I'm spending a lot of time on. In fact, research often leads to the story. My first book was about India's last steam trains. That came about because I read a story about the demise of the steam train in India (Figure 3.20), and I was kind of interested because I thought this was going to be very visual: steam trains, India, factories, you know, all of that; wrecking yards, the trains, and I'm thinking Salgado's *Workers*, which was an inspiration for me; and I was like, "Wow, I'm going to go and check this out." So I looked up the writer who was living in Delhi, and I got myself to India and spent a year traveling the whole country searching for these trains. I started to go out and look for these steam trains. I basically found out where they were, and then I had to get official permission from the ministry in order to get the access that I wanted. So that's an example of how a simple newspaper article developed into a story that consumed my life for a year.

And then while I was in India, I came across my next book, because as I was finishing the train story, I was thinking what's my next book going to be like? And I saw an article in an Indian magazine about a wrestling school in Delhi, and I thought, "Wow, this looks really incredible. They're wrestling in mud." So I went to the wrestling school and I made these pictures, and that body of work ended up winning the World Press and getting published; and I thought, wow, maybe there's a story behind wrestling. So I researched the history behind wrestling, and I found out that this is the oldest sport in the world. People have been wrestling forever, but basically it went back to before the Romans. So, I kind of felt,

FIGURE 3.20 Stephen Dupont, *Untitled* from *India's Last Steam Trains*. ©**Stephen Dupont/Contact Press Images**

well, look at these traditions of wrestling, and I found all these countries that still wrestled in their ancient culture, in their ancient way, and it ended up being a book project over 10 years.

I also did a lot of research for the work I've done in Afghanistan. I first went there in 1993 to cover a refugee crisis, because I'd read that hundreds of thousands of refugees were fleeing the civil war in Tajikistan to go to Afghanistan, which was having its own war, and I just thought, "This is a f—ed up situation: You're a refugee, and you're leaving one war to go to a worse war?" I just thought this had to be documented. It was the middle of winter, minus 20 degrees Celsius, when I got to the refugee camps. The refugees were dying of cold, and they were living in the worst conditions imaginable. On top of that, Russians were shooting them as they were swimming across the Amu Darya River to flee. It was tragic. So I got involved in that, and I met one of the doctors from Médecins Sans Frontières (MSF), and I remember him saying to me, "Man, you think this is bad? You've got to go to Kabul and see what's going on there. The whole city looks like Dresden or Chechnya." He told me that there was only one journalist there, a woman named Susie Price from the BBC. I thought, "There's one Western reporter covering this story, and she's a radio journalist?" He offered me a lift to go to Kabul with the doctors, so I went in, disguised as a doctor. I hid my cameras to get through all of the checkpoints. I started photographing a city under siege, basically, and ended up returning a couple times a year to photograph the civil war. I met Massoud [Ahmed Shah Massoud], the former alliance leader who was the minister of defense, and I got to know him and ended up doing this ongoing project about this leader. So I became quite attached to what was going on. It became quite addictive in a way. I really felt that this was a place and story that could be told, and it felt right.

On Afghanistan:

SD: I knew that this was a story that wasn't being told, and I thought that through my photography and my journals I could build up a body of work that one day could have some purpose in this world, in terms of history, in terms of telling the story of the people of Afghanistan. I stuck to it for 15 years, and I'm now coming to the end of a very long road and incredible journey. I've produced a retrospective exhibition and also am working on producing my own books about Afghanistan. My recent project on a Marine platoon is interesting. I'm constantly trying to find new ways to show a story. Since 2001, because of the American involvement, a lot of people have been focusing on Afghanistan, so I've had to constantly challenge myself to find new ways to tell the story. So last year I went with a Marine platoon down in Helmand Province, but rather than doing the usual embed and document the guys in the field at war, I focused on portraiture. I took my journal, and I took my Polaroid kit because I wanted to shoot these on Polaroid, and did everything one does in order to get close to these guys—go out on patrols—but on the side I was building up this personal reportage of portraits that I was making of them on the base. I photographed an entire platoon because the idea was to show what it means today to be a soldier or marine fighting in Afghanistan. I wanted to go beyond photography and produce a pure, raw, honest documentation, so I asked each Marine to answer a simple question: "*Why am I a Marine?*" and that became the title of the work. So within my journal, you've got all the portraits of an entire platoon, and then next to the portraits are very personal testimonies each Marine has written (Figures 3.21 and 3.22). The personal statements vary from very nationalistic to very antiwar. I printed the entire journal in its raw state with their handwriting and the Polaroid portraits.

The Library of Congress just purchased the original Moleskine journal for their collection of photography journals. [Aperture published a book about the history of photo books from the LOC Collection, which features Dupont's image.[25]] When I saw who else was a part of the collection, I thought, "My God, to be a part of that history." So the progression of this object has created more interest than I could imagine. I've spent the last 15 years doing some of my best photography in Afghanistan, and this body of work—as much as I love it—is not what I consider my best work, but I also think it's an incredibly important statement about the war because it tells you what's going on in the mind of the Marine. It's just great to get that personal testimony when they weren't holding back and they weren't being told what to say or what to do. I only got that because I earned their trust. I was there for a month, but it was only in the last week that I got them to open up in a way that I felt was honest and important enough to then make this documentation. Now the Marines have contacted me and want to show this work at Quantico

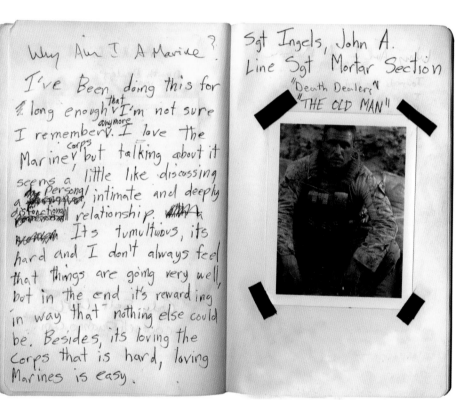

FIGURE 3.22 Stephen Dupont, Detail of *Sgt. Ingles, John A., Line Sgt. Mortar Section*, from *Weapon Platoon Portraits*. ©Stephen Dupont/Contact Press Images

facelessness behind gang warfare because I couldn't actually go out with them where they're raping and pillaging, so I shot portraits. I was never a portrait photographer, but I'm loving it, and that's been really important for the progression of my whole body of work. [powerHouse is publishing a book on this work called *RASKOLS* in Spring 2012.]

The New York Public Library put on a show a couple of years ago with a series I did called *Axe Me Biggie*, which phonetically means "Mister, take my picture." It's a series of anonymous portraits on a street in Kabul, in 2006. I wanted to make a statement: This is what happened between three o'clock and six o'clock on this one afternoon in Kabul. So I took only one shot of each person: 100 Polaroids of 100 people in three hours. It was total madness and absolutely chaotic: police and crowds of people around us. I made a book of this entire photo shoot. I think what makes these photographs so special is not so much the subject, but the people in the background who didn't know they were being photographed (Figure 3.23). I had no idea that I would even come out with anything; it was a total experiment, you know? Also, at the time, it was therapeutic for me because I'd seen so much horror and so much devastation, and I'd just finished spending six weeks documenting heroin abuse in Kabul with my good friend and writer, Jacques Menasche. I was so drained I needed an escape from that life, that depression, and that trauma. This project was so uplifting; just a simple portrait series and it ends up getting a lot more attention than my other work. The New York Public Library liked it and bought a portfolio and exhibited it and took it into their collection, which was great.

On being emotionally involved:

SD: First and foremost, I'm really open to allowing myself to immerse myself in situations where I have to go to that extent to get the kind of pictures that I'm doing. I tend to block my own personal emotion while I'm there and I'm immersing myself in a situation where I'm allowing adrenaline, excitement, and the passion of getting involved with and photographing incredible things that are pieces of history to keep me going. For example, I produced a body of work with Jacques Menasche titled *Stoned in Kabul* about two brothers in Afghanistan who were basically shooting up every day. That story became incredibly intense

and then tour it around the whole country. So it's gone from my journal to the Library of Congress to an exhibition and now almost a recruitment campaign for the Marines, because the text is quite positive at times, but it's also very honest and raw, and I think they like that about that.

On the demise of Polaroid:

SD: It's killing me that Polaroid doesn't exist anymore because in the past five years I've done many portraiture projects, including a body of work on the gangs in Port Moresby in Papua New Guinea. I tried to show the

FIGURE 3.23 Stephen Dupont, *Untitled* from *Axe Me Biggie*. ©Stephen Dupont/Contact Press Images

to block out a lot of that emotional stuff, but when I get home, it's another world, and that's often where some of those emotions come out.

When I'm editing the work or sort of playing it in my head about what I just experienced, that's the most challenging part emotionally. When you're there, you're just with it, and you're really living it, and it's an incredible feeling. You don't feel fear because it's almost as if you're living on the edge at that very time and moment. You know it's dangerous; you know you could die, but you just live it. And you've got to live it in order to get through it. But it's when you get home that the blowback happens.

You may not know, but I was in a suicide bombing in 2008 where I was five meters from the blast inside a police vehicle. My colleague was really badly wounded, but I walked out of this bombing literally unscathed physically, but emotionally it was one of those turning points in my life. It was the closest I'd come to being killed, and it was a situation where I should have been killed because I was five meters from the bomber. And everyone around me was dead, and I walked out. It was totally surreal. I was knocked out from the blast, but I woke up and realized we were under fire, so I ended up running with the police and ended up sort of hunkering down and realizing what had just happened, but also that I am a photographer and I had to take pictures. So I just went into autopilot where I photographed the aftermath of this bombing. It was horrific and one of those rare situations where you're both a victim and a witness. I found that incredibly interesting, so I filmed myself talking to the camera and doing this report about what was going on there and then photographing as well. But when I left and was back with my family, I had time to reflect, and that for me is the most challenging. I think I am okay with it. I don't have a set plan of how to deal with posttraumatic stress. I just live life. I surf because I live on the beach. There are life-changing things that happen to me, and I just feel incredibly honored to have seen what I've seen. That helps me override all the stress and keeps me going back to make pictures.

On the future of documentary photography:

SD: I know that there is a lot of negativity about photography today, but I feel incredibly inspired by it still. I feel that there is a definite journey that I'm taking, and I believe that people will somehow use my photography

because I had to stay with them all the time to get the story that I wanted to tell about heroin addiction in Kabul in 2006, to reflect on why so many people are getting addicted to heroin. They were refugees in Iran where they picked up the habit. They come back to Afghanistan, and then suddenly Afghanistan is producing the world's heroin, so there's this incredible blowback. These brothers were the microcosm of a macrocosm of a whole nation of a million drug addicts, and no one was really talking about it. But to spend so much time in that kind of world, I have

in a way that I've always dreamed about its being used—beyond the printed page. The future of magazine and newspaper photography is pretty dire, so I'm looking well beyond that to collections, universities and educational outlets, and fellowships so the work can be seen by another kind of audience with maybe a more established set of historical platforms. It's incredibly important to me that the work not be a throwaway thing. I make handmade books and design them myself and hope they will have some sort of purpose somewhere.

On activism:

SD: There is an activist attitude and philosophy in my photography because I choose my projects. I pay my own way to fly somewhere to cover a story for a long period of time. I'm sending myself somewhere because I want this story to be told, so there is an agenda right there. I'm not going to cover a story unless I feel strongly connected to it, so it's personal for me. I'm definitely giving my slant, and I do have an agenda of what I want to cover and how I photograph it and what gets seen from an editing point of view, but I still believe that what I'm doing is pure, honest photography, but I'd be lying if I didn't say I'm projecting my own vision. That goes for everything I do. I'm not out there being an activist in the public sense, but there is an activism in my pictures. I'm showing what I want to show. I am the author. This is my vision. Even the first war I ever went to was my personal story. It was the civil war in Angola, which was an unbelievable situation of human tragedy, and I felt that this was a war that wasn't being covered, so I had this personal energy, almost a vendetta, to go and tell this story of these people—a hundred thousand people dying in Quito of starvation because they can't get out of the city, and no one's got pictures. Well, damn! This is important! So there's all sorts of reasons behind why I do what I do, but I think it does all come down to what's personal.

India is a place that has endlessly drawn me to cover, not so much conflict, but just stories about the country and about the people, because I love India. It's sort of a place that I feel will always draw me because I love the country. I have to be passionate about something; otherwise, I won't make good pictures. Excitement creates the pictures that I want to make. I have to walk around with a smile on my face in a way.

On photo books:

SD: I am really interested in making handmade books now. Even my Afghanistan work, 16 years of work, I am putting into several books at the moment. I will try to get at least one book published. I'm doing a box set of six handmade books, which might end up like a collector's limited edition. I'm lucky because I just received the Robert Gardner Fellowship for Photography at Harvard to do my next project, which will be to spend a year documenting society in Papua New Guinea. I have already started photographing gang warfare, settlement life, and life in the villages. The Peabody Museum is going to publish the book and exhibit the work. I think it will be quite ethnographic in a sense because it will include portraiture.

On a new project in Papua New Guinea:

SD: I will be traveling to Papua New Guinea, but I won't be there full time. My subject is the detribalization of society and how society is changing through Westernization and globalization. I will be looking at two different communities—one in the highlands and one in Port Moresby, the capital city—and documenting them from the grassroots up, and showing the contrast between an urbanized community that has come from the villages and a community that's trying to hold on to their culture. New Guinea is incredible in that it's one of the last discovered places on Earth, so it still has that very tribal, very ancient culture that still thrives there. It's close to Australia, so there's a connection there personally because I've wanted to go and document this place; and we colonized it for a while, so it has an interest there for me too. Again, this is a story that's not really being covered. The last thing I want to do is to go and do something that everyone else is doing.

On controversial photographs:

SD: I was kind *of persona non grata* with the army for quite a few years because I documented soldiers burning the bodies of dead Taliban soldiers. You see, I was with psychological operations (PSYOP), which was amazing because I couldn't believe they allowed me to go with them. No one gets to go with them, but they trusted me. They probably shouldn't have, because when I witnessed the burning of the bodies, and then what

they did afterwards, I knew it was a story that had to be told. My reflection on the situation was that the guys burned the bodies to stop them from rotting, or stinking. I think their act was innocent, but then the PSYOPs guys decided to use the situation to their advantage by using the burning to intimidate the local population. I had recorded them telling the locals, "Taliban, you are all cowardly dogs. You allowed your fighters to be laid down facing west and burned. You are too scared to retrieve their bodies. This just proves you are the lady boys we always believed you to be." I didn't want to get anyone in trouble because the soldiers were really good guys and I really liked them. But what I documented was an incredible story, and I thought that people could make up their mind about whether this was right or wrong.

I guess it comes down to a personal reflection, but as a photographer and as a journalist, I had to show what was going on. The story basically splashed around the world, America got whipped for it, and the soldiers were reprimanded. I think it was PSYOPs that screwed up because they used the burning for propaganda. That's not new. This is war; they are psychological operations officers, and that's what they do.

They f—with people's heads. But my photographs really upset a lot of people because Abu Ghraib had just happened. The photographs and videos were misconstrued, which is what can happen when something gets taken from you and used in contexts that you haven't given permission for. As soon as it made it to the Internet, it spread like wildfire. I got all kinds of comments from "Good for you" to "You anti-American hero" to "You bastard!," "You Jihadi," you know; I was punished from both sides. The public doesn't understand. War is war. Anyone who has been in the heat of combat knows that you'll do everything to survive. You want to protect your friends and brothers; it becomes very important, and it is a survival of the fittest. You don't go in there to kill people for no good reason, but you go in there to defend yourself, and sometimes you have to kill people and sometimes you make mistakes. Half the time you don't know who is shooting at you. It's very confusing, so yes, I think the military sometimes gets quite a hard rap, and it's unfair because they get a rap from people who have never been in the heat of battle, and unless you've experienced that, you've got no right to talk about it.

Walter Astrada

Argentinean photographer Walter Astrada began his photojournalism career in 1996 as a staff photographer at *La Nación* newspaper.[26] He worked for the Associated Press for several years, then as a freelance photographer for Agence France-Presse from 2005 until 2010, but is now represented by Reportage by Getty Images. Astrada's reputation has soared in the past few years as he has garnered a string of important awards and grants mostly for a project he has been pursuing on global violence against women. He has won three World Press Awards; a Sony World photography award for Current Affairs; a Days Japan public prize for his work *Bloodbath in Madagascar*; three awards from the China International Press Photo contest; The Bayeux-Calvados award for War Correspondents; and the NPPA-BOP, Photojournalist of the Year, and Best of Show. He also was awarded the Marty Forscher Fellowship fund in 2010, an Alexia Foundation Grant in 2009, the Revela–Oleiros Grant in 2008, and he has been featured in the Photo District News annual. Astrada is impassioned about the problem of violence against women, which includes domestic abuse, rape, sexual abuse, and harmful cultural practices such as genital mutilation, honor crimes, child marriage, and the selective murder of women known as femicide. "Violence against women is not only the most widespread example of a human rights violation, but probably the least evident, going largely unpunished," says Astrada.

His personal project includes segments from the Congo, where women are raped and genitally mutilated as a weapon of war; Guatemala; and India, the subject of an award-winning multimedia piece titled *Undesired*, which exposes the immense cultural pressure that Indian women feel to abort female fetuses in favor of boys because of outdated cultural beliefs that only men can earn money and women are financial burdens because families traditionally must pay a dowry. Although the Indian government has declared dowry and sex-selective abortions illegal, Indian families consistently ignore the laws. One UN report states that 7,000 female fetuses are aborted every day, and one dowry death is reported every 77 minutes. Here, Astrada talks about this project, the role of a photographer, and the reason he is an activist.

Walter Astrada, New York City, June 22, 2010

MB: What do you think a photographer's role should be today?

WA: It's not enough just to take photographs. So I have started doing what Ed [Kashi] said: Any possibility I have, I talk about my project. I try to do lectures. I think our work is to go and do a story like the one I've been doing on violence against women even if the newspapers don't want to publish it. We should still do the projects and try to publish it, and if we can't do that, we try to find different ways to show the project. I see a big mistake from some photographers that they are trying just to do cover stories that the media wants. That's not good, because if we do that, we'd only be covering Pakistan, Afghanistan, and Iraq, and nothing more. It's our duty to go to places to cover other stories, to increase some kind of awareness about important topics, and personally with my violence against women project, I think it's really a very important topic that affects a lot of women all around the world. But it's not only affecting women, even though that's what people think sometimes. It's not only the women's problem. If it's affecting the women's life, it's affecting the life of the children who are in that environment. This is a social problem. I was so lucky that I won a lot of prizes the last three years,

and so with that, I got attention to this specific project, and I was presented with the money so I was able to keep working on the project. And you know, when somebody's giving you money, they have to be sure that the work is used.

MB: What prizes and grants have you won?

WA: In 2008, I won one in Spain called Revela, from a very small village called Oleiros (in the north, near Galicia). It's amazing because they choose a project and give you 12,000 euros, and the next year when you present the work, they do a huge exhibition. But the good thing is the topic of the exhibition is the topic of the grant that won the year before. So the year when I presented my pictures, they made a huge exhibition about violence against women; and this exhibition is going through a lot of places in Spain. This is so important because this issue affects so many people. It's not only one girl, not two girls, there are millions of women around the world who are the victims of violence. When I was working in Spain and beginning this project, I checked information from America, Asia, and Europe, and when I saw the statistics, I thought, "Oh man, this is huge." I knew I needed to do something about it. I started in Guatemala with my own money, and after winning a World Press in 2006,[27] I went back with that money to Guatemala to finish it. Then I applied for grants—first, the Revela grant to work in Congo about rape as a weapon in war and then the Alexia Foundation to work in India about the sex-selective abortion of female fetuses and the killing of girls. Also, the Alexia Foundation has financed a multimedia piece that's on the Internet.[28] That will be good promotion, and a lot of people will start understanding what's going on.

MB: How did you get interested in this story? It's not such an obvious idea.

WA: My [former] wife was working with women's issues and also with women's rights in various countries, like Uganda, where the LRA [Lord's Resistance Army] were killing and raping women. So I was aware of the huge numbers of women passing through a lot of violence. It's not only in the poor countries; it's also in the rich countries. So what I did was put together projects in countries that are completely different: for example, Guatemala, Congo, India, and now I am trying to do in Spain. Maybe you have some things that are similar in all of the countries, but in general there are some points that are different, but the women aren't suffering any less. I want these pictures to help people understand the problem. I've had women's groups asking for pictures that they can use in talks to students. That's how it starts. Basically, I make photographs because that's the only thing I know how to do. So I think it's a team: I do the photographic project and try to find people who can be doing more. Sometimes people ask us [photographers] to do everything, to basically change the world. Sometimes people say, "You didn't help," but it's like, "Man, my work was trying to show what was going on" and then try to find other people to help.

MB: So it's not always about what you change, but how you engage in the process?

WA: Yes, it's trying to wake up people and say, "Listen: this is happening." But, it's not only photography's job to do that. Sometimes shooting is not enough. Looking at pictures is not enough. Other people have to be involved.

MB: Are you optimistic about photography today?

WA: The crisis is not with the photographers. The crisis is with the media; basically, they are not paying for the work. If you really want to live as a photographer, it's a hard time, for sure. But, nobody's putting a gun to my head and saying you have to be a photographer. I chose this. So in that way, I feel that I am very lucky. But three years ago, I was completely broken without any jobs. I never gave up because I really wanted to do what I am doing. When you start looking, you see more possibilities. There are a lot of photographers who miss the old times when magazines were paying more, but things like five-star hotels and big expense accounts are not coming back. I think you need to try and find another way. I am doing that now. I make assignments from basically anything that is paid, like I shoot spot news when I can, but then I do some workshops, and I apply for grants for projects that I really want to do.

MB: Do you do a lot of research before you start your projects, and what research did you do for your project on women and violence?

WA: It was very basic. I wanted at least one country in each continent, and countries with different religions, different kinds of violence, and those with the worst violence. So I chose Mexico, Guatemala, Liberia, Congo, India, Bangladesh, Spain, Belgium, and the Netherlands. I read Human Rights Watch reports and UNICEF reports, and then I researched local organizations. I knew I had to create some work so I could get grants, so my first project in Guatemala I paid with my savings. It was very good to establish the project on my own because that convinced people that I could do it. I just got on a plane to Guatemala and contacted some friends I knew from working with AP [Associated Press]. Photographers are so helpful to each other. One guy went to live with his girlfriend and left me his house for a month. He also let me use his driver. You know, that's amazing.

MB: You're working on a project about violence against women, but you're a man. How do you establish trust with your subjects?

WA: It is amazing. I know in some places you can't get in because you are a man. But in the whole project, I never received a "no." I don't know why. I think it depends on what you do when you first reach the place. Sometimes people weren't sure until I met them and I would be there talking for 30 minutes, but when they understood, they just said, "What do you need?" And basically, all of them were like that. Normally, you need one or two people to put you in contact with the rest of the people. In places like Congo, you really need to know the guy in charge, and if that person says yes, all the other doors are open. So if you get that guy, everyone will be nice with you, but if the guy is mad with you, it's over. It's like that. In Congo, I was very lucky because a friend of my wife went to Congo just to make research, and he knew that I was starting this project and he sent an email and said, "Look, I met the guy, who is a filmmaker, but his sister is the main woman who is going to talk about rape in Congo." And also she won a very important award in the Netherlands. I send her an email, and she was like, "Yeah, of course. Whatever you need, I will help you." So I went to Congo, and she took me to two or three

places—and because I was with her, it was very easy. But sometimes you really need to know who will be helping you.

MB: How do you know that?

WA: You see. When you are talking to somebody, you know if that person will be helping you. In India, it was very difficult, but I knew who was going to help me and who was not. When I was in Paraguay [lived there for three years], I wanted to do a project on prostitutes, but talking with the prostitutes, they were always complaining that who we were working with more were the transvestites. So, I thought, I will try to do a project with the transvestites. I was working at my office there, and they were working on the corner of my office, and I would try to start a conversation. And one day I start talking with one, and I said, "Look, what do you feel if I follow you during your life?" and she told me, "Okay, but first you need to come with me to my home." I knew it was a test to know my reaction, so we went to the house, had some beers, and then she told me, "Okay, come back tomorrow midday, and I will present the girls who are living here." So the next day I was there and there were eight of them, and I explained what I was trying to do and they said, "Okay, no problem." And that was the 20th of December, and I was planning on going to visit my mom for Christmas, and on the 23rd, they told me, "What are you doing tomorrow?" I said, "Nothing." They said, "Okay, why are you not passing Christmas with us?" I said, "Of course." So one day I was just a camera with color film, and one day we pass holidays together.

I showed them the pictures, and they were more than happy. So after that, they supported it, and I was shooting pictures all the time. But other times it was more talking and trying to understand. They were very open, so I think that is one of the ways: if you are honest. The only people I really lie to sometimes are the police, the militaries, and to some authorit [ies] who I know they are not giving the permission to make some pictures, so I try to just lie or just not [tell] all of the truth to get access. But to the rest of the people, I say I am doing this, for this, and this is what I want. And really, the people really appreciate that you are being honest. You can say, "Ok, look, I am doing this project, and I am not sure it will be published" or "I am doing this project, and I will be doing this multimedia piece. Do you want to help me?" And really, they say yes or no. But

normally, they say yes. It's amazing, and I don't know how to explain this. It's like there's a feeling that when they see you, it's like, "Okay, this guy is okay." I'm not trying to lie to the people who are also victims before, because I think that's important and I think that opens a lot of doors.

MB: I believe that most people know when a photographer is honest or exploitive. You've got about 30 seconds to convey that.

WA: Yes, I remember once when I was attending a workshop in Argentina. We had to choose topics, and I really wanted to do something about tango. So that night I went to a place where there were dancers, and I went up to one and explained, "Look, I am doing this workshop. Do you mind if I follow you?" The next day I was with her on a bus to the house of her sister, and the other photographers were like, "Wow! How did you get access?" I don't know; I just ask. The no is no, but if you ask, you might get yes. And sometimes you ask and get access you don't expect. For example, in Guatemala when I was doing the project, sometimes I'd reach a place where a woman was killed, so the police were standing around, and sometimes the parents were around. Imagine to go and ask them if I can go and take pictures of the funeral. Here, I don't know, but in Europe it's almost impossible. But I did it anyway and explained that I was doing a project about violence against women, and I think it's important if you allow me to go in, I really want to show what happened with your daughter. Everyone said yes.

And one other point is, sometimes I think it's because you are foreigner that they trust you. Sometimes that's more important. They don't see you as a woman or a man; they see you as a photographer. In India, I got some problems because I was a guy, so it was not so easy to get into some areas, but finally somebody allowed me to go in, I think, because I was not Indian. It's crazy. In some areas, men or women have more differences, so it's harder to get in, but in the end, if you're honest, you usually can. But if you are from that country, it's not so easy. I want to do a project in Argentina, but really I don't know if that will be so easy because there I'm just another guy in thousands of people, but in Guatemala, I was an Argentinean coming in to do an important story.

I remember when I shot the picture that won World Press (Figure 3.24). It was night and the police were around, but I saw the roof, and I thought, "I can go up there to take a picture, just in case." And the police said, "No." So I ask[ed] him, "Look, I am Argentinean; I came all the way here. I am leaving in two days. Really, my last opportunity to do the picture is today." So I went three houses away, and so I was passing through the yard, and then I was very lucky, the house that was at the top, they were building it, so there was nobody there. So I was waiting there when the police arrived, and I start[ed] taking pictures, and the guy was like, "What are you doing?" and I was like, "I am taking pictures." They saw the accent: "Where are you from?" "Argentina." "Oh, okay. Continue." I'm sure if I was Guatemalan, they would [have taken] me out. And I am sure that if I had tried to do the same thing in Argentina, it would not have been as easy.

MB: Can you describe your photographic style?

WA: My style? No, I can't. You know, basically, I take pictures about what I am seeing and about what I am seeing that is not right. I'm not thinking about the technical part of the picture because it's under control. Sometimes I am very angry when I am taking pictures, maybe most of the time. So sometimes I don't remember the picture I was taking. It's very difficult to explain. People are like, "Oh man, how can you not remember the picture you took?" Really, I know what I'm shooting, but it's more about what I am seeing because I am so angry, and there are a lot of feelings. And it's not only once; a lot of times it happens. I am editing, and I say, "Wow!" Something [...] in the moment when I was shooting, I didn't realize it was there.

MB: I think it's because you're shooting emotionally, not shooting intellectually. An athlete would call it "being in the zone." When you say you're angry, what are you angry about?

WA: I am angry about what is going on in front of my camera. I remember in Congo, I arrived two days after the genocide attacks started. For 10 days, I was alone. One day a lot of people started being displaced, and for me, you know, for me it was the first time seeing something like that, thousands of people walking, just carrying with them all their things. You really think that you have to be doing something, and the only thing you can do is shoot pictures. And also, there's a big problem. When you're taking pictures, there are sounds. Just imagine there are a lot of people

FIGURE 3.24 Walter Astrada, *Untitled* from *Femicide in Guatemala.* ©Walter Astrada

walking: this sound [makes thudding noises]. Yes? Because they are walking. And in one moment, you stop thinking and start acting, and I got this picture of the woman who is breastfeeding a boy. For me, it is a very, very powerful picture, and really I don't remember exactly. I saw the situation—the woman, the man, the tank—but I didn't exactly remember when I shot; but when I shot, I felt the same thing when I see the pictures (Figure 3.25). A lot of the feelings I had [are] in that picture because you see the eyes of the woman looking at the tank. I think it's, like you say, when you stop thinking and you start feeling, the pictures are much better. If you're thinking, you're only thinking about the lights and the composition. If you are feeling, the composition is with you because you are feeling like that, and the technical part is there too because you are a professional. But when you start feeling, you are adding more things than if you are only thinking.

MB: It must have been hard to photograph in Congo because I can't imagine that the soldiers were very happy that you were there photographing children born of the rapes.

WA: No, they weren't, but what was harder was to see the women who pass all this violence, and they try to go back to [a] normal life, but in some point [their] normal life will be taking care of this child, which was [born] after rape. There's some hope—really there is some hope—but there is that idea that you need to be caring for this child forever.

MB: What is your work in India about?

WA: The project is about the abortion of female fetuses. In the last 30 years, there are at least 40 million [fewer] women [than men] in India. So this is [causing] a shortage of women and it's bringing a problem, for example, because people are trafficking women to be sold as wives [. . .]. And imagine even in normal countries where there are the same number of men as women, there are rapes, but imagine where there are not, the rape is increasing too. So you have the violence itself, but also you are increasing another kind of violence, which is trafficking of women. In these countries, Europe, or maybe even the U.S., you traffic women for prostitution, but there they are trafficking women to be wives, but in India that almost makes them slaves. One of the reasons they want boys is

because if you have daughters, you have to pay a dowry when she's getting married. So some families ask [for] more money to the parents of the daughter, and when they don't get what they want, they throw gasoline on the woman.

MB: And they burn them? Oh my god (Figure 3.26).

WA: Yes, because they can use the excuse that she was cooking and it was an accident. So each hour in India, they burn between one and two women. So imagine the number during the year. It's a huge number.

MB: It sounds like there is barely a distinction between trafficked for a wife or trafficked for prostitution.

WA: There's not much. The people from Bangladesh and the people from Nepal speak Nepali or Bangladeshi; the places where these women are taken is Punjab principally, there they speak Punjabi or Hindi. So, imagine: I took you from here and I take you to there; you don't speak my language, and now you're my wife. How do you interact? For me, in India, it's not only physical violence. Okay, there, you can see. But it's more psychological violence, because the girls, the women, feel that their duty is to have a son. If they don't, they are not happy. They are being raped. They are being cast out of the house. They are accused of not having a boy, so the pressure that they have to have a boy is too much. Imagine every day the people are telling [you that] you need to have a boy. So, at the end [of this], girls were trafficked for prostitution and also [to] be sold as wives. So basically for me, to be there, this was like to be inside an insane asylum.

MB: What about Spain? It's more middle-class violence? So you'll be working with domestic violence shelters, something like that?

WA: In Spain? Yes. But also the killing of women is high for a country in Europe. In 2007, they killed 78. It is a huge number for a European country.

MB: You mean men killing women in domestic violence disputes?

WA: Yes. In Spain, 95 percent of the women who are killed are killed by the husband, boyfriend, ex-boyfriend, or ex-husband.

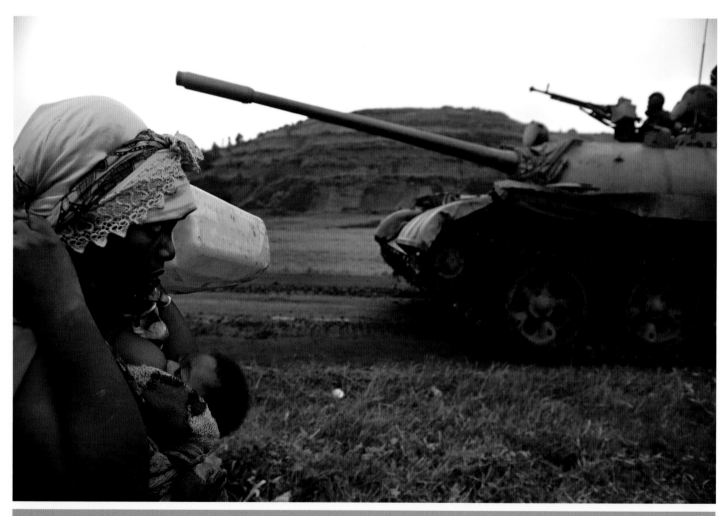

FIGURE 3.25 Walter Astrada, *Untitled* from *Congo Unrest.* ©Walter Astrada for Oleiros Revela Grant

FIGURE 3.26 Walter Astrada, *Untitled* from *Undesired, "Missing" Women in India*. ©**Walter Astrada for Alexia Foundation**

MB: Once you finish this project in Spain, will the project be finished?

WA: No, because I really want to do a book, because I really want to work with writers who know about the issues. I want to bring it to schools because we really need to start with the young kids. I think it's a long process. For example, in India, they have a big problem with people my age—maybe. But if they start working with the children. Maybe it would take two or three generations, but they would be solving the problem. That's what I want my pictures to do. Help make change.

Endnotes

1. Meyer founded ZoneZero in 1994 as an online site with the goal of providing "a platform for intelligent photography." www.zonezero.com.

2. Ibid.

3. www.eugenerichards.com (accessed February 25, 2011).

4. This image can be seen at www.eugenerichards.com.

5. "St. Kizito Orphanage," www.congochildren.com (accessed February 28, 2011).

6. Neither Brownback nor Feingold are currently serving as Senators.

7. After seeing this work, Senator Brownback introduced the Congo Conflict Minerals Act of 2009 to require electronic companies to verify and disclose their sources for cassiterite, wolframite, tantalum, and gold. Conflict minerals language was included in the Wall Street Reform and Consumer Protection Act, which was passed by the U.S. Senate on May 20, 2010, and signed by President Obama on July 21, 2010. This new legislation does not ban using Congolese minerals; it just calls for companies to undertake the due diligence required to ensure they are not contributing to the conflict.

8. *Lord's Resistance Army Disarmament and Northern Uganda Recovery Act of 2009*. 1067, 111th Cong., 2nd Sess.: This became law on May 24, 2010. http://maplight.org/us-congress/bill/111-s-1067/434817/total-contributions (accessed February 25, 2011).

9. "Pulitzer Center on Crisis Reporting," http://pulitzercenter.org/ (accessed February 25, 2011).

10. On February 24, 2011, Bleasdale used Facebook to raise money for his "fixer" in Eastern Congo who has liver failure. www.facebook.com/marcusbleasdalephotojournalist (accessed February 25, 2011).

11. Tom Stoddart, *iWITNESS* (London: Trolley, 2004).

12. Kate Day, "Photographer Joao da Silva Injured in Afghanistan," *The Telegraph* (blog), October 25, 2010. blogs.telegraph.co.uk/culture/kateday/100048282/photographer-joao-silva-injured-in-afghanistan/ (accessed February 26, 2011).

13. The *Intended Consequences* book and multimedia piece have garnered multiple awards, including an Emmy nomination in 2009; the du Pont Journalism Award in 2010; an NYU Arthur L. Carter Journalism Institutes nomination for the Top Ten Works of Journalism of the Decade in 2010; an American Photography Award for best book, 2010; and it was among the winners of the 2010 PDN annual.

14. "Foundation Rwanda," www.foundationrwanda.org (accessed February 26, 2011).

15. Ed Kashi, "Iraqi Kurdistan," *Media Storm*. www.mediastorm.com/publication/iraqi-kurdistan (accessed March 3, 2011).

16. Olivier Laurent, "VII's Ed Kashi 'We Must Change the Way We Consume,'" *British Journal of Photography*. www.bjp-online.com/british-journal-of-photography/q-and-a/1720326/vii-photos-ed-kashi-we-change-consume (accessed March 3, 2011).

17. "Vietnam Reporting Project." www.vietnamreportingproject.org (accessed March 3, 2011).

18. The photo of Nguyen Thi Ly also won second place in the Contemporary Issues of the 2011 World Press Photo competition. www.worldpressphoto.org/index.php?option=com_photogallery&task=view&id=2058&type=byname&Itemid=293&bandwidth=high (accessed March 3, 2011).

19. Mountain gorillas are among the world's most endangered species; only an estimated 720 survive, with 200 of them living in the Virunga National Park in the Democratic Republic of the Congo. In 2007, Stirton was the first photojournalist allowed back into the park, now controlled by the militia. Stirton found the shocking brutal murder of seven of the mountain gorillas. His photograph of a dead 500-pound male gorilla named Senkewkwe, strapped on his back on a litter made of saplings, being transported by the park rangers, as gently and respectfully as any group of pallbearers, shocked the conscience of the world because the murders were senseless. It's doubtful that the murders were the work of poachers because the bodies were left intact: www.brentstirton.com/feature-gorillas.php; www.guardian.co.uk/environment/2008/nov/29/endangered-silverback-gorilla-congo (accessed March 1, 2011).

20. "Brent Stirton," *The Year in Pictures* (blog), September 10, 2008. pictureyear.blogspot.com/2008/09/brent-stirton.html; www.casasugar.com/Photographer-Watch-Brent-Stirton-1981937 (accessed March 3, 2011).

21. Stirton won the Visa d'Or Feature award at the 2008 Visa pour l'Image photojournalism festival. The award is worth 8,000 euros.

22. The term *bush wives* refers to a practice of the rebels to kidnap girls and then use them as porters, cooks, and sex slaves. When the conflict ended in 2002, thousands of young girls were left homeless and deeply traumatized. www.archive.worldpressphoto.org/search/layout/result/indeling/detailwpp/form/wpp/start/2/q/ishoofdafbeelding/true/trefwoord/photographer_formal/Stirton%2C%20Brent (accessed March 2, 2011).

23. Ben Bohane is a renowned Australian photojournalist who focuses on Australasia and the Pacific regions. See www.noorderlicht.com/en/archive/ben-bohane/ (accessed March 25, 2011). He is also a member of Degree South, a photographic collective of documentary photographers. See www.degreesouth.com (accessed March 25, 2011).

24. www.degreesouth.com (accessed March 25, 2011).

25. Verna Posever Curtis, *Photographic Memory: The Album in the Age of Photography* (New York: Aperture/Library of Congress, 2011).

26. www.walterastrada.com (accessed March 25, 2011).

27. Astrada won First Prize World Press Contemporary Issues in 2006 for an image taken in Guatemala, showing public prosecutors' officials examining the body of Maria Esperanza Gutiérrez (42), who had been killed by 16 shots fired by an unidentified man, in what is part of a rising wave of assaults against women. Perpetrators of what came to be called "femicide" appeared immune from punishment, with only 14 out of nearly 2,000 murder cases being resolved since separate records for women victims began in 2001.

28. Astrada's piece *Undesired* can be seen on MediaStorm. www.mediastorm.com/contributor/walter-astrada/128 (accessed March 25, 2011).

ULISIS HOUSE IS THE SPOT. HERE WE ARE ADMIRING THE ULTIMATE BONG HIT. AS YOU CAN SEE

EVERY ONE IS MESMORIZED, YOU CAN JUST HEAR THIS PICTURE.

LEFT to Right → Juanito, Richie, Dean, Jose, Rickey, Ralphy, Ulisis.

OHHH, AHHH, Feel the smoke Rushing down your lungs. THOSE were THE DAYS.

RESOURCES

The resources in this section were selected carefully to provide you with additional information if you are interested in activist photography or in being an activist photographer. Although no list can be complete, it is a comprehensive (and accurate at the time of printing) list of sources or events that this author either follows, uses, reads, has personally attended, or that have been recommended by trusted friends. The listed websites, galleries, and online magazines exhibit or feature documentary photographs; the featured international festivals and events showcase documentary photography; the nonprofits and NGOs regularly work with the world's best photographers and use those images intelligently; the miscellaneous projects are just cool and eclectic; the grants and foundations fund documentary projects; and anyone who simply loves to look at great photographs should know the work of the photographers listed, all of whom would have been featured more prominently in this book if space had allowed.

Websites, magazines, and galleries

AnthropoGraphia

www.anthropographia.org/2.0/

Anthropographia is a nonprofit organization, based in Montreal, Canada, created by Swiss photographer Matthieu Rytz to generate awareness of "under publicized human rights issues through visual story telling" because through awareness comes the opportunity for public dialogue and action. It exhibits work online and sponsors an annual juried exhibition that travels to international venues.

Autograph ABP

www.autograph-abp.co.uk

Autograph ABP is a photographic-arts organization organized to educate the public in photography, emphasizing issues of cultural identity and human rights through exhibitions, educational events, and publishing. Says director Mark Sealy, "Autograph ABP aims to open up incisive

spaces for critical debate about photographic history, spaces that allow for challenging issues to emerge."

Blue Earth

www.blueearth.org

Blue Earth's mission is to raise awareness about endangered cultures, threatened environments, and social concerns through photography. Its website features Blue Earth–sponsored documentary projects on diverse national and international subjects. It sponsors the Blue Earth Prize for Best Project Photography in partnership with Photo Alliance (www.photoalliance.org).

Burn Magazine

www.burnmagazine.org

Founded by renowned photojournalist and Magnum member David Alan Harvey, *Burn* is an "evolving journal for emerging photographers," originally available only online but recently also published in a printed format. *Burn* publishes new stories or singles at least three times a week to an audience of "anyone fascinated by a visual and literary interpretation of our complex planet."

Daylight Community Arts Foundation (DCAF)

www.daylightmagazine.org

DCAF is a nonprofit organization that publishes in-depth photographic essays from established and emerging artists via its *Daylight Magazine* (print) and *Daylight Multimedia* (online). The Daylight Daily Blog lists opportunities for photographers as well as exhibition and book reviews and compelling art criticism from around the globe.

Emphas.is

www.emphas.is

Emphas.is, cofounded by photojournalist Karim Ben Khelifa, former photo editor Tina Ahrens, and business consultant Fanuel Dewever,

is a crowd funding site only for documentary projects. Submitted projects are reviewed by a panel of photo industry professionals, and for even the entry-level donation, backers have access to the special "Making Of Zone" where they can follow the photographer in the field through direct tweets, blog posts, videos, and uploaded images. "Our goal is to build a community of engaged donors who are interested in global issues and supporting quality journalism," says Ben Khelifa.[1]

Facing Change: Documenting America (FCDA)

www.facingchange.org

FCDA is a contemporary nonprofit collective of world-class photojournalists and writers who work together as teams to produce stories about the critical issues facing America with the goal of raising social awareness to create debate about how to chart its future. The photographers include luminaries such as David Burnett, David Chin, Anthony Suau, Lucian Perkins, and Brenda Ann Kenneally.

Fifty Crows

www.fiftycrows.org

The Fifty Crows Foundation, based in San Francisco, seeks to inspire social awareness by coupling great documentary photographs with action and media campaigns. It runs the International Fund for Documentary Photographers, which supports emerging documentary photographers working on projects related to a common humanity.

Foto8

www.foto8.com

London-based former photographer Jon Levy is passionately devoted to documentary photography.[2] Through his print magazine, *8 Magazine;* his online magazine, *Foto8.com;* and HOST gallery, Levy has supported what he calls "the strongest, bravest, and most insightful and creative photojournalism and documentary photography." The online magazine, live since 1998, has presented more than 100 stories by independent photographers. "There is no story that can't be retold," says Levy.

FotoEvidence

www.fotoevidence.com

FotoEvidence was founded by Svetlana Bachevanova, an award-winning Bulgarian photographer, to continue the tradition of using photography "to draw attention to human rights violations, injustice, oppression and assaults on sovereignty or human dignity wherever they may occur." It sponsors an annual Book Award that recognizes a photo project documenting evidence of a violation of human rights, and publishes photo essays and videos in the Report Injustice Now online gallery.

Humanising Photography

www.humanisingphotography.org

Humanising Photography, founded by photo industry and NGO professionals Jessica Crombie and Emma Boyd, is a network of "lens-based media professionals" brought together via monthly salons in London and online blogs to create a resource hub to facilitate discussion and exploration of "visual politics and the relationship between lens-based image making, human rights, humanitarianism and communication."

On The Ground

www.ontheground.ca

On The Ground is a Canadian charity that furthers the work of documentary photographers by supporting socially relevant projects that focus attention on critical issues by providing first-hand, on-the-ground information.

MediaStorm

www.mediastorm.com

MediaStorm, a multimedia production studio, represents the best of contemporary journalism. Founded by journalist Brian Storm, MediaStorm works with the best visual storytellers, interactive designers, and global partners to create cinematic narratives that speak to the heart of the human condition. "I used to want to make that one picture that would end all war,

says Storm. "Now I want to produce media content that is so powerful that it will go viral (and end all war) because going viral isn't just for funny shit." This model is the future, says Storm and his ultimate goal is for "MediaStorm not to be the only place taking this approach."[3]

PhotoVoice

www.photovoice.org

PhotoVoice is a British charity that uses innovative participatory photography and digital storytelling methods to give a voice to disadvantaged and marginalized communities. Since 1999, PhotoVoice has initiated more than 21 projects in 12 countries with more than 1,000 beneficiaries. A recent and typical project, *See It Our Way*, in partnership with World Vision seeks to use photography workshops to empower at-risk youths in countries particularly vulnerable to human trafficking, including Albania, Armenia, Lebanon, Romania, and Pakistan. "We use single images a lot in our publications," says Program Manager Jane Martin. "The single image alone can be very powerful."

Portfolio Magazine

www.portfoliocatalogue.com/51/index.php

Portfolio Magazine, an online magazine devoted to contemporary photography in Britain, devoted Issue 51 to contemporary documentary photographers and an essay from David Bate discussing the broad range of styles and strategies in documentary photography today.

Socialdocumentary.net

Socialdocumentary.net, founded by Glenn Ruga, currently the executive director of the Photographic Recourse Center in Boston, is one of the most comprehensive websites for documentary photography. It's free to members, and it hosts hundreds of online photographic exhibits by photographers from around the world. Each exhibit is vetted for aesthetic quality, documentary integrity, and technical quality. SD also sponsors occasional competitions with themes relating to the human condition.

Verve Photo

Vervephoto.wordpress.com

Founded by photographer Geoff Hiller, Verve Photo features photographs and interviews with "the new breed of documentary photographers" to remind us of the power of the still image. It also features the latest news on new photo agencies, publications, and multimedia projects.

Festivals and events

Fotopub: documentary photography festival, Novo Mesto, Slovenia

www.fotopub.com

Fotopub is an annual photography festival that hosts about 50 participants every year. It features a workshop involving Slovene and international tutors, exhibitions, guest lectures, a photography course for young people (from 10 to 20 years old) called the "Photography Experience," and a thematic competition.

LOOK3: festival of the photograph, Charlottesville, Virginia

www.look3.org

LOOK3 is a three-day festival created by photographers to celebrate documentary photography through exhibitions, presentations, interviews, workshops, and outdoor projections.

Visa pour l'Image, Perpignan, France

www.visapourlimage.com

Visa is the premier international festival of photojournalism where, in the last week of August (professional week), the who's who of the documentary world and thousands of other photographers gather for a few days to talk about work, debate issues about the profession, and look at great work in exhibits scattered throughout the city and projected nightly in an open-air medieval enclosure, Campo Santo.

Nonprofits and NGOs

Charity: Water

www.charitywater.org

Founder Scott Harrison left a lucrative career as an events promoter in New York City, living "selfishly and arrogantly." He worked on a floating hospital ship called Mercy Ships that offers free medical care to the most impoverished nations. He went as the ship photojournalist. The experience was transformative, and when he returned, he founded Charity: Water to bring safe and clean drinking water to people in developing nations. He knows that images tell his story, so he sends photographers into the field to document the projects the charity funds.

Environmental Justice Foundation

www.ejfoundation.org

EJF makes a "direct link between the need for environmental security and the defense of basic human rights." Since 2001, it has featured campaigns on climate, cotton production abuses, illegal fishing, and shrimp farming.

Global Witness

www.globalwitness.org

Global Witness exposes the corrupt exploitation of natural resources and international trade systems, through campaigns that strive to end impunity, resource-linked conflict, and human rights and environmental abuses. It partnered with Human Rights Watch to fund a report on abuses in Congo related to gold mining, making extensive use of photography.

Human Rights Watch

www.hrw.org

HRW, one of the world's leading independent organizations dedicated to defending and protecting human rights, is a photographer favorite because it funds and sponsors projects, and then smartly uses the photographs in reports it publishes to advocate for change. It also administers the Hellman–Hammet Grant for writers around the world who have been victims of political persecution.

Médecins Sans Frontières (Doctors Without borders)

www.doctorswithoutborders.com

MSF is an international medical humanitarian organization working in more than 60 countries to provide aid to people whose survival is threatened. It is known for its partnerships with photographers who consider it one of the best groups to work with. It publishes a list of the Top Ten most underreported Humanitarian Stories.

Oxfam

www.oxfam.org

Oxfam is an international confederation of 14 organizations. It works directly with communities to fight poverty, injustice, and intolerance, highlighting these issues with photography taken by some of the leading documentary photographers today.

Save the Children (STC)

www.savethechildren.net/alliance/index.html

Save the Children's mission is self-explanatory: It wants to create a world in which every child attains the right to survival, protection, development, and participation. Under direction of photo editor Jessica Crombie, STC makes effective use of photography.

United Nations Refugee Agency (UNHRC)

www.unhcr.org/cgi-bin/texis/vtx/home

UNHRC leads and coordinates international action to protect refugees and resolve refugee problems worldwide. It understands the value of photographs, partners regularly with photographers, and maintains an extensive photographic archive.

War on Want

www.waronwant.org

War on Want is a British charity that fights poverty in developing countries in partnership with people affected by globalization. It sponsors major campaigns on effects of war, sweatshops, trade justice, and the impact of the corporate food business. These campaigns use photography extensively, including in broad sheet formats, such as one featuring photographer Paul Weinberg, titled *Trading Place: Life in the Markets of Zambia.*

WaterAid

www.wateraid.org

WaterAid is an NGO that works on transforming lives by improving access to safe water, hygiene, and sanitation in the world's poorest communities and regularly hires leading photographers to photograph its international projects.

Miscellaneous projects

Billboardliberation

www.billboardliberation.com/partners.html

Billboardliberation is Eclectic site with activist groups such as the Guerilla Girls, a group of anonymous women devoted to actions and projects that expose sexism and racism in politics.

How We See It

Howweseeit.org

A project in collaboration with PhotoVoice in London, How We See It is working with inner-city children to empower them to improve their own lives. They participate in a battery of programs to improve their literacy and communication skills. They are also given the chance to work with professional photographers who encourage them to express themselves creatively.

Loca

www.loca-lab.org/background.html

Loca is a Locative Art project on mobile phones and grass roots, pervasive surveillance. Loca aims to inform people about the many ways they are under surveillance, equipping them to make informed decisions about the networks that they populate by using an interactive platform to examine and detect the many types, ways, and places that they are under surveillance today. The *New York Times* called it a surveillance project that talks back.

Nuru Project

Nuruproject.org

Founded by photographer JB Reed and financial consultant Omri Block, the Nuru Project leverages photography as an agent for social change in the developing world by hosting photographic auctions centered on a particular issue affecting the developing world. Photographers who have worked on these issues donate prints, and 100 percent of the auction proceeds are distributed to an existing charity working on that show's theme.

The Rights Exposure Project

Therightsexposureproject.com

An eclectic project started in 2009, the Rights Exposure Project looks to explore the use of visual media, primarily photography and video in social activism.

Through the Eyes of the Children (The Rwanda Project)

www.rwandaproject.org

Through the Eyes of the Children began as a photographic workshop in 2000, where Rwanda orphans were given disposable cameras to help them explore their community and find beauty as the country struggled to rebuild. Now, with support of photographers such as American Kristen Ashburn, the project continues although the children also use donated digital cameras.

Foundations and grants

The Aftermath Project

www.theaftermathproject.org

The Aftermath Project is a nonprofit organization committed to telling the other half of the story of conflict: what happens after the conflict ends and the story of individuals learning to live again, to rebuild destroyed lives and homes, to restore civil societies, to address the lingering wounds of war while struggling to create peace. Through partnerships with universities, photography institutions, and nonprofit organizations, the Aftermath Project seeks to help broaden the public's understanding of the true cost of war and the real price of peace through international traveling exhibitions and educational outreach in communities and schools. It holds a yearly grant competition open to working photographers worldwide covering the aftermath of conflict.

Alexia Foundation

www.alexiafoundation.org

The Alexia Foundation's mission is to promote "the power of photojournalism to give voice to social injustice, to respect history lest we forget it and to understand cultural difference as our strength—not our weakness." It supports photographers as agents for change through scholarships and the Alexia Grant, a $15,000 award, established to honor Alexia Tsairis, a promising photojournalism student and peace activist killed in the terrorist bombing of Pan Am flight 103 over Lockerbie, Scotland. Previous winners include Walter Astrada, Stephanie Sinclair, and Marcus Bleasdale.

Alicia Patterson Foundation

aliciapatterson.org

The Alicia Patterson Foundation fosters, promotes, sustains, and improves the best traditions of American journalism and photojournalism. The Foundation provides support for journalists and photographers engaged in rigorous, probing, spirited, independent, and skeptical work that will benefit the public.

Burn Magazine: The Emerging Photographer Fund

www.burnmagazine.org/emerging-photographer-grant-2011

Awarded by the Magnum Foundation, *Burn*'s Emerging Photographer Fund gives $15,000 for the continuation of a photographer's personal project. The submission process is open, and it is intended for "emerging photographers who will become the icons of tomorrow."

Getty Images Grants for Editorial Photography

imagery.gettyimages.com/getty_images_grants/overview.aspx

To further creation of compelling images that tell social, cultural, and political stories, Getty Images awards five $20,000 grants annually to fund documentary projects of personal or journalist significance.

Getty Images Grants for Good

imagery.gettyimages.com/getty_images_grants/overview.aspx

The Grants for Good fund supports the collaboration between photographers and nonprofit organizations with two $15,000 grants to support creation of new imagery to aid a nonprofit issue.

Marty Forscher Fellowship Fund (MFFF)

www.pdnphotoannual.com

Established to honor legendary camera repairman Marty Forscher, the MFFF is given annually to an emerging professional photographer and student working in a humanistic tradition. The fund is administered by Parsons The New School for Design in partnership with the PDN annual contest.

Open Society Institute (OSI) Documentary Photography Project

www.soros.org/initiatives/photography

OSI's documentary photography project supports photographers whose "work addresses social justice and human rights issues that coincide with OSI's mission of promoting and expanding open society." The project's

longest running event is *Moving Walls*, a group photography exhibition series that features "in-depth and nuanced explorations of human rights and social issues," shown at OSI's offices in Washington, D.C., and New York City.

Prix Pictet

www.prixpictet.com

The Prix Pictet, a leading prize in photography and sustainability, was established in 2008 to "use the power of photography to communicate vital messages to a global audience" about the pressing social and environmental challenges of the new millennium. Winners receive the equivalent of about $108,000 for work that speaks powerfully to a specific theme such as water, earth, and currently growth. The exhibitions produced by Prix Pictet winners tour the world in places as diverse as Dubai, New Delhi, and Dresden.

W. Eugene Smith Grant in Humanistic Photography

www.smithfund.org

Established as a memorial to W. Eugene Smith, the grant was established in 1979 to seek out and encourage independent photographic voices. It is presented annually to a photographer whose past work and current project follows in Smith's tradition of concerned photography.

Photographers and artists

Lynsey Addario is a self-taught, award-winning American photojournalist based in New Delhi, India. Since 2000, she has photographed conflict and humanitarian issues, often specifically the role of women in traditional male-dominated societies in Afghanistan, Iraq, Lebanon, Darfur, and Congo. She has produced essays on maternal mortality in Sierre Leone, self-immolation in Afghanistan, women at war, refugee camps in Darfur, and transsexual prostitutes in New York City. She has won many awards, including the prestigious MacArthur Fellowship in 2010.

www.lynseyaddario.com

Kristen Ashburn (Contact Press Images) is a documentary photographer with deep activist roots. "Often photographers want to do more than document a situation so they extend their abilities into the grey area of making tangible change," says Ashburn.[4] "I think that's okay. We can do that and not break the rule of journalistic objectivity." While still in college, Ashburn made five trips to Romania to work as a volunteer with neurologically impaired orphans. She was so affected by that experience she established The Romanian Challenge Appeal and organized a photographic auction that raised more than $30,000 for the charity. Her more recent project, *Bloodline*, produced as a multimedia piece by MediaStorm, focuses on the AIDS epidemic in Africa. "Sometimes when you are deeply involved in a project you want to do more than just publish the images," says Ashburn. "I felt that my photographs on HIV/AIDS could inspire people to donate to organizations working on the forefront of the pandemic." Ashburn has also worked on stories about the spread of tuberculosis in the Russian penal system, Palestinian suicide bombers, and the aftermath of the 2004 tsunami on Sri Lanka.

www.kristenashburn.com

James Balog, a former geologist, is an award-winning environmental photographer involved with both the *Nova* PBS program and *National Geographic*, which have featured his work on disappearing glaciers and receding ice levels around the world. Balog is involved in a program called the Extreme Ice Survey where geologists, glaciologists, and image makers have gotten together to create an approachable and scientifically sound body of evidence to show the impact of Climate Change.

www.jamesbalog.com/pages/home.php

Sammy Baloji, an internationally exhibited Congolese photographer currently living in Lubumbashi, DRC, was short listed for the Prix Pictet in 2009, for work that combines photography, video, film, and collage. He often mixes historical and contemporary photographs in large-scale photomontages because to understand the present, one must read traces of the past. "To superimpose past onto present reveals the will to denounce past and present abuses," he says.

www.prixpictet.com/2009/statement/384

Brendan Bannon, a photojournalist based in Nairobi, Kenya, wants to reinvigorate an interest in global news and issues because he believes that curiosity is a thread that links humanity.[5] To spark curiosity, he has launched Daily Dispatches, an unmediated documentary exploration of Nairobi, Kenya, unfolding day by day in real time. He is working with journalist Mike Pflanz to create a daily story from Nairobi. The stories are digitally "dispatched" to participating universities that will hang the images in a unique exhibition that will grow during the month-long project. Previously, Bannon produced long-term projects in Romania and Russia, as well as essays on gold mining in Congo, HIV/AIDS in Kenya and Uganda, piracy in Somalia, and refugees from the Lord's Resistance Army (LRA) in South Sudan. "Different types of photographs have different impacts," says Bannon. "Some are metaphors, some are evidence and some expand the human experience. That's what I'm most interested in. I look at people's lives as being full of meaningful relationships, striving against the odds and achieving small victories."

www.brendanbannon.com/wp

Mari Bastashevski is a Russian-born photographer currently in "exile" in Paris.[6] An activist photographer, she is working on a project that combines documentary photography with a "collaborative social-web." *File 126 (Disappearing in the Caucasus)*, shown as a Moving Walls exhibition in 2010, depicts the violence inherent in the sudden middle-of-the-night abductions of people (usually young men) for political reasons in the Southern Russian provinces of Chechnya, Dagestan, and Ingushetia. "This project serves as both history and an acknowledgement of the atrocities," says Bastashevski, who personally has been detained and questioned by Russian authorities dozens of times while working on this project. "It attempts to create a bridge between the victims of abductions, their families and the rest of the world and necessarily confronts the issue of censorship and information flow surrounding the cases of abductions."

Maribastashevski.com

Daniel Beltrá is a Spanish photographer who works closely with Greenpeace in remote places in Patagonia, the Amazon, and Indonesia. He is also a participant and winner of the Prince's Rainforest Project, a European-based project to protect and eliminate the deforestation of Rainforest Nations.

Danielbeltra.photoshelter.com

Philip Blinkensop (Noor Images) has been photographing environmental issues and forgotten conflicts since arriving in Asia in 1989, such as his project *Secret War in Laos* about the Hmong, abandoned by the Americans they'd fought for during the Vietnam War. "Photographers are both witnesses and messengers," he says. "Our responsibility must always lie with the people we focus on, and with the accurate depiction of their plight, regardless of how unpalatable this might be for magazine readers."

www.noorimages.com

Antonio Bolfo, a featured photographer for Reportage by Getty Images, quickly won acclaim for his project, Operation IMPACT (Figure A.1), which he started while studying photography at the International Center of Photography.[7] Bolfo, who is both a former game designer and a former member of the New York Police Department (NYPD), spent two years documenting one NYPD rookie unit assigned to housing projects in the South Bronx, one of the poorest, most dangerous, and most notorious neighborhoods in America. Bolfo, who sees this project as a statement about the "universal problems in the other ghettos of New York City," says, "I was very honest and upfront about my intentions, and that helped me gain their trust. That's true in most situations. If you are truly honest, people can read that. If you are dishonest, people can read that too." Bolfo has also created extensive bodies of work on the aftermath of the Haitian earthquake and is working on a personal project about the supernatural and paranormal in America.

www.antoniobolfo.com

Zana Briski is a documentary photographer who often focuses on women's issues. She is most well known for her project *Kids With Cameras*, which empowered marginalized children around the world through learning photography, and her film *Born into Brothels*, about prostitutes in India and the children born to those prostitutes who grow up in the brothels. The film has garnered many awards, including a 2005 Academy Award for Best Documentary Feature.

www.zanabriski.com

FIGURE A.1 Antonio Bolfo, *NYPD IMPACT Unit*. Officers Weadock, Olivero, and Suarino (left to right) helplessly listen to a colleague cry for help over the radio July 7, 2009, in Mott Haven neighborhood located in South Bronx, New York City. Because IMPACT cops patrol on foot and have no access to police vehicles, they are unable to respond to the officer in need of assistance. Mott Haven neighborhood is a low-income residential neighborhood geographically located in the southwest Bronx between West 138th Street to East 149th Street. East 138th Street is the primary thoroughfare through Mott Haven. ©Antonio Bolfo/ Getty Images

Vincent Cianni, a documentary photographer whose work explores community, memory, and the human condition, took on the issue of the rampant homophobia in the military in his project *Gays in the Military: How America Thanked Me.*[8] "The role of an activist photographer is to search out new subjects that everyone else isn't photographing," says Cianni, who started this project after hearing a radio interview with the mother of a dishonorably discharged gay soldier. He has interviewed and photographed more than 100 service members discharged under DADT (Figure A.2). "The idea of having to hide and be secretive about your sexuality goes against the oath of honor that soldiers take when they go into the military," says Cianni. "That was a big deal for many of the people I photographed and interviewed." Eventually, Cianni wants this work to be exhibited in alternative spaces that can force confrontations.

www.vincentcianni.com

Natan Dvir, an Israeli photographer with both an MBA and an MFA, merges his eclectic background in images that have an underlying political or social message.[9] His project, *Eighteen*, portraits of Arab teenagers living in Israel (Figure A.3), has been recognized by the New York Photo Festival and Photo District News annual. In these images, Dvir confronts the animosity toward the "other," people in his own country he grew up considering more "foes than as allies." Dvir who thinks that the distinction between "fine art" and "documentary" is an arbitrary distinction says, "For me being a documentary photographer is interacting with the world with a degree of integrity. I am trying to understand different cultures and people and show how conflicts impact the human experience."

natandvir.com

Alixandra Fazzina is a British photographer living in Islamabad, Pakistan, who focuses on underreported conflicts, women's issues, and the often forgotten humanitarian consequences of war. She is widely published and works regularly with UN agencies and NGOs. Her book, *A Million Shillings: Escape from Somalia* (Trolley Books), chronicles the exodus of migrants and refugees along people-smuggling routes from Somalia to the Arabian Peninsula.

Alixandrafazzina.photoshelter.com/gallery-list

FIGURE A.2 Vincent Cianni, *Katie Miller, New Haven, CT*, 2010 (cadet who resigned her appointment at West Point because of Don't Ask, Don't Tell). ©Vincent Cianni

Lauren Greenfield (INSTITUTE), named by American Photo as one of the 25 most influential photographers working today, is an award-winning activist photographer known for her work on youth culture, gender, and women's issues through her projects *Girl Culture; Fast Forward: Growing Up in the Shadow of Hollywood; THIN*, both a book and a feature-length documentary about eating disorders that premiered at the

FIGURE A.3 Natan Dvir, *Aseel, Umm Al-Fahm*, 2009. I love living in Umm Al-Fahm. This is a Muslim city considered noble for its hospitality and respect for others, yet sometimes we must defend ourselves against our enemies. A few months ago, we had to prevent Baruch Marzel, an ultra–right wing Jewish nationalist, from entering the city to stir up trouble. Ten years ago, three young men were killed here during the October 2000 clashes. I was very young at the time yet remember how horrible it was then. In the past I used to go with my father to Jewish cities, but after what happened, we hardly have time anymore.

I prefer being in a family with sisters, since a brother might have imposed increased restrictions. My mother taught me well how to follow Islam, how to dress properly, and how to be respectful of others. I am not allowed to have a relationship with a man before we are engaged. I loved somebody once but never told him. It is better to avoid all the mess of falling in love before getting married.

My dream is to become an English teacher and help the people of my city. I currently work at a local grocery shop, study sociology in a college near Tel Aviv, and improve my English by reading books. I am very optimistic and believe that if you have positive thoughts, good things will happen to you. **©Natan Dvir**

Sundance Film Festival in 2006 and aired on HBO, and kids+money, where Greenfield takes "the cultural temperature of a generation in Los Angeles imprinted by commercial values."

www.laurengreenfield.com

Tim Hetherington, in his most recent project, *Restrepo*, created a feature-length documentary film about a single deployment of American troops in one of the most dangerous postings in Afghanistan: Korengal Valley.[10] For this project, he partnered with Sebastian Junger (author of *The Perfect Storm*). Restrepo won the Best Documentary Film in 2010 at the Sundance Film Festival. He was also the winner of the 2007 World Press Photo Award.

www.timhetherington.com

JR is an anonymous French activist artist who considers the whole world his gallery. He creates "pervasive art" that he installs in places that artwork is seldom seen such as in the slums of Paris or on the broken bridges in Africa or in the favelas in Brazil. He often involves local people as models or collaborative artists. He was awarded the coveted TED prize in 2011. His project is called *Inside Out* (www.insideoutproject.net). He asks people to upload a portrait that he will return as a billboard-sized poster, which they then paste somewhere in their community. As of June 20, 2011 at 2:59 p.m. EST, participants uploaded 7,126 photographs and posted 150 posters.

www.jr-art.net

Brenda Ann Kenneally is an award-winning, independent documentary photographer and interdisciplinary artist living in Brooklyn, New York, who works on long-term projects focusing on the emotional and psychological cycle of poverty as seen by women. Her projects include *Money Power Respect*, *Upstate Girls*, and *Women of Troy*. She's won the coveted W. Eugene Smith Award for Humanistic Photography.

www.brendakenneally.com

Geert van Kesteren is an award-winning Dutch photojournalist known for two recent projects. *Baghdad Calling* is about the thousands of Iraqi refugees and everyday life in Iraq in 2007; it includes both his photos and hundreds of photos from Iraqi people's mobile phones and digital cameras. His project *Why Mister Why?* is an innovative website divided into "chapters" that tell the story of the Iraqi people during and after the Iraq invasion.

Whymisterwhy.com

www.baghadcalling.com

www.geertvankesteren.com

Robert Glenn Ketchum, a founding fellow of the International League of Conservation, is a landscape photographer who for 45 years has been using his images to address critical national environmental issues. He has a long string of advocacy successes, but his most visible success is his work on the Tongass National Forest, the largest temperate rainforest in the world, published in 1986 by Aperture, *The Tongass: Alaska's Vanishing Rain Forest*. His photographs, exhibits, and personal advocacy, including testifying before Congress, are credited with helping to pass the Tongass Timber Reform Act of 1990, which established five major wilderness areas and protected more than one million acres of old-growth trees.

www.robertglennketchum.com

Shai Kremer is an Israeli photographer whose *Infected Landscape* images show the imprint that has been left on the landscape of Israel after the war and the military have moved through. The images show a world that has been burned, trampled, wasted, and violently disassembled.

www.shaikremer.com

Jens Olof Lasthein is a Swedish freelance photographer known for self-directed projects such as *Moments in Between*, for which he photographed before, during, and after the wars in the former Yugoslavia, attempting to understand life in the shadow of war; and *White Sea Black Sea,* where he traveled along the eastern border of the European Union, exploring the transition of the borderland between Eastern and Western Europe. He looks at what happened to a town, Stolnitsy, which was split down the middle when the Yalta Agreement gave the easternmost part of Czechoslovakia to the Soviet Union. Although minefields and guard towers are gone, the cruel wire fence remains.

www.lasthein.se

Benjamin Lowy, a New York–based photographer represented by Reportage by Getty Images, has been shooting professionally only since 2003, but in that short time he's acquired a string of awards, including the World

Press Photo, POY, and the 2011 Marty Forscher Fellowship for Humanitarian Photography. In addition, he was named in PDN's 30 and was a finalist both for the Oskar Barnak Award and Critical Mass. Lowy's work from Darfur appeared in the Save Darfur media campaign. Although he shoots in the typical conflict places (Iraq, Darfur, Afghanistan, Haiti), he doesn't shoot typical conflict photographs. Lowy's reason for covering stories is often just to see and understand and that, combined with his background in the arts (he received a BFA from Washington University in St. Louis in 2002), yields surprising choices. Like most photojournalists, Lowy covered the oil spill in Louisiana, but his images, titled *Oil on Water,* are stunning aerial images, abstract patterns of color and texture that look like paintings. He eliminates any signifiers that root the viewer in place. We see no horizons, no shorelines, and without the title might not realize that the beauty we see is a destructive force. In his *Iraq Perspectives,* Lowy chose to shoot from a soldier's point of view through the thick bulletproof window of an Army Humvee. The window represents "a barrier that impedes dialogue," he writes on his website. "The decision to include the actual window in the images serves a literal as well as a metaphorical purpose. . . . The images are not intimate—they often show a distant and detached perspective of a country so empty, so desolate of a situation so dire," and so representative of how so many soldiers experience Iraq.

www.benlowy.com

Tim Matsui is a multimedia journalist who focuses on human trafficking, alternative energy, and the environment. He created a nonprofit to foster dialogue about sexual violence and has worked with the Cambodian Acid Survivor Charity on a story of portraits of survivors of acid attacks.

www.a timmatsui.com

Mary Mattingly is an American-born artist who experiments with the idea of Wearable Homes, looking at problems or future conditions that large populations can and may face, most specifically water scarcity. She was shortlisted for the Prix Pictet 2008 theme of water. Her project, *Waterpod™ Project*, was a sustainable floating sculptural eco-habitat built out of old water towers and disused billboards that floated between June and October 2009.

www.marymattingly.com

Heather McClintock is a freelance photographer whose project *The Innocent: Casualties of the Civil War in Northern Uganda* focuses on the effect that Uganda's civil war has had on the Acholi tribe in Northern Uganda (Figure A.4), decimated by this barbaric civil war, many displaced by the government to squalid camps with no access to basic resources.

www.heathermcclintock.com

Justyna Mielnikiewicz, based in the Republic of Georgia, focuses her work on the countries from the former Soviet Union.[11] She completed a long-term project about the conflict and daily life of the people in the South Caucasus who are both united and divided by their ethnic diversity. The project, *Shared Sorrows, Divided Lines,* garnered her the Canon Female Photojournalist Award at the Visa pour l'Image 2009. Mielnikiewicz, a self-taught photographer, says, "I want people to look at my photographs and feel something because at the end of the day your photographs talk for you.

www.justmiel.com

Simon Norfolk (INSTITUTE) is a British photographer born in Lagos, Nigeria, who uses the landscape genre, not traditional documentary for his

FIGURE A.4 Heather McClintock, *Okot Simpol, Recovery Room Lacor Hospital,* Gulu, 2007. **Image courtesy of Heather McClintock**

projects, such as *Afghanistan: Chronotopia*, which shows the aftermath of the conflict in Afghanistan as layers and layers of devastation lying on top of each other; *Scenes from a Liberated Baghdad,* photographs taken 10 days after American soldiers pulled out; and *For the Most of It I Have No Words: Genocide, Landscape, Memory,* a project on the places that have witnessed genocide.

www.simonnorfolk.com

Darcy Padilla is a documentary photographer specializing in long-term projects. The longest of those has been The Julie Project, which Padilla started in 1993. It is an in-depth look at the complex story of one AIDS-afflicted woman named Julie Baird. Padilla has received grants from the Alexia Foundation, the Open Society Institute, and the John Simon Guggenheim Fellowship.

www.darcypadilla.com

Louie Palu is an award-winning documentary photographer who spent 15 years collaborating with writer Charlie Angus examining Canada's hard rock mining belt, some of the world's richest and largest underground mines and smelters. The finished project, *Cage Call: Life and Death in the Hard Rock Mining Belt*, focused on the miners, the land, and the work involved in underground mining and smelting. The 64-page book of the same title, published by Blue Sky Gallery in Portland, Oregon, produced from these images won a Critical Mass Award.

www.louiepalu.photoshelter.com

Paolo Pellegrin, an award-winning Italian photographer and full member of Magnum since 2005, focuses on the social, humanistic side of photography. A recent project, *As I Was Dying,* focuses on images of human suffering within areas of conflict and war to create a record for our collective memory. He says, "I am more interested in a photography that is 'unfinished' and can be suggestive" and can "trigger a conversation or dialogue."

www.magnumphotos.com

Dana Popa is a Romanian-born photographer whose interests lie in contemporary social issues that emphasize human rights, including a project titled *Not Natasha* on young women trafficked from poor Eastern European countries to become prostitutes in richer Western Europe.

www.danapopa.com

Fazal Sheikh is an award-winning and widely exhibited activist artist who uses photography to document people living in displaced and marginalized communities in East Africa, Pakistan, Afghanistan, Brazil, Cuba, and India. His projects include portraits, text, found photographs, and sound. In 2005, he was named a MacArthur Fellow. To more widely disseminate his work, in 2001 he produced a series of projects and books about international human rights issues that he published and distributed free of charge and made available online.

www.fazalsheikh.org

Stephanie Sinclair (VII Network) is an award-winning American photojournalist known for gaining unique access to the most sensitive gender and human rights issues around the world.[12] Her work, most of which is self-generated, focuses on women's issues, including difficult topics such as female circumcision and self-immolation. "I definitely think of myself as an activist," says Sinclair, who helped raise money to build a burn clinic for Afghani women. She has won coveted awards including the Alexia Foundation Professional Grant and UNICEF's Photo of the Year, and the 2010 Visa d'Or for her long-term project on the international issue of child marriage, including a section on polygamy in America. "My goal is to make images that can make a difference, because photographs can open doors and create dialogue," she says. Sinclair's work has been exhibited in venues aimed at policy makers, including a one-day exhibit in Washington, D.C., on Capitol Hill, sponsored by the International Center for Research on Women.

www.stephaniesinclair.com

Toby Smith (Reportage by Getty Images) is a contemporary photographer who focuses on issues involving energy and sustainability using genres of landscape and architectural photography.[13] "I choose projects because I think the issue absolutely matters," says Smith. "It has to be something that is more important than just me." He worked with the Environmental Investigation Agency in an international investigation, photographing the illegal logging industry in Madagascar, which led to an international lawsuit. He's recently completed a project, *The Renewables,* for which he photographed every fossil fuel power plant in Britain. "I am definitely offering a point of view for this project," he says.

www.shootunit.com

Stephen Vaughan focuses on places where "the landscape itself is a system of memory." In his project *Ultima Thule,* Vaughan is engaged with spaces that hold a physical embodiment of the events, either geological or human, that happened there. His project *Opened Landscape: Lindow, Tollund, Grauballe* is an extension of the *Ultima* works. In this series, he focuses more directly on bog land and the discoveries found in these lands. These three sites were the locations of the three oldest sacrificial bog burial sites, and have yielded some of the oldest preserved human remains ever found. In one exhibition of these works, the images were shown along side the Lindow Man.

www.stephenvaughan.co.uk

Christian Vium is a Danish photographer and anthropologist working on long-term projects with recurring themes of migration, nomadism, human rights, youth, and conflict, including *Clandestine*, an ongoing documentary project about clandestine migration from West Africa to Europe. The multilayered project covers the actual migratory journey and the physical and psychological trauma and transformation.

www.christianvium.com

Musim Wasif (Vu) focuses on people displaced because of climate changes in the project *Tales of Lost Paradise: Climate Refugees, Bangladesh—2007.*

www.agencevu.com

Endnotes

1. Selected author interviews in 2010.

2. All quotes from interviews conducted by the author in London, England, 2009 and 2010.

3. All quotes from interviews conducted by the author in New York, New York, 2010.

4. All quotes come from interviews conducted by the author in New York in January, 2011.

5. All quotes come from interviews conducted by the author in New York in 2009 and 2010.

6. All quotes come from interviews conducted by the author in Paris, November, 2010.

7. All quotes come from interviews conducted by the author in 2010 in New York and Perpignan, France.

8. All quotes come from an interview conducted by the author in New York in 2011.

9. All quotes come from interviews conducted by the author in New York City in 2010.

10. In Memorium. Tim Hetherington died in Misrata, Libya on April 20, 2011 from injuries suffered during an R.P.G. attack. Fellow photographer Chris Hondros was also killed in the same attack.

11. All quotes from interview with author in Perpignan, France, August 2010.

12. All quotes from interviews conducted by the author in Perpignan, France, September, 2010.

13. All quotes from an interview conducted by the author in New York City, 2010.

Bibliography

Abbott, B. (2010). *Engaged Observers: Documentary Photography since the Sixties*. Los Angeles: J Paul Getty Museum.

Adams, A. (1985). *Ansel Adams, an Autobiography*. Boston: Little, Brown and Company.

Adams, R. (1981). *Beauty in Photography: Essays in Defense of Traditional Values*. New York: Aperture.

Azoulay, A. (2008). *The Civil Contract of Photography*. Cambridge, MA: MIT Press.

Berger, J., Strauss, D. L., & Stoll, D. (Eds.). (2005). *Between the Eyes: Essays on Photography and Politics*. New York: Aperture.

Berkeley Art Center (Ed.). (2001). *The Whole World's Watching: Peace and Social Justice Movements of the 1960s & 1970s*. Berkeley, CA: Berkeley Art Center Association.

Brown, K. B. (1992). From Travel to Tourism: The Relation of Photography to Social Change in Nineteenth-Century America. Ph.D. Thesis, New York University.

Buckland, G. (1974). *Reality Recorded: Early Documentary Photography*. Greenwich, CT: New York Graphic Society.

Bull, S. (2010). *Photography*. New York: Routledge.

Cantril, H. (1941). *The Psychology of Social Movements*. Hoboken, NJ: John Wiley & Sons.

Cohen, S., & Hales, P. B. (Eds.). (2008). *The Likes of Us: Photography and the Farm Security Administration*. Boston: David R. Godine.

Coles, R. (1997). *Doing Documentary Work*. New York: Oxford University Press.

Eno, H. L. (1920). *Activism*. Princeton, NJ: Princeton University Press.

Esche, C., & Bradley, W. (Eds.). (2008). *Art and Social Change: A Critical Reader*. London: Tate Publishing.

Ferrato, D. (2005). *Love and Lust*. New York: Aperture.

Ferrato, D., & Jones, A. (2005). *Living with the Enemy*. New York: Aperture.

Fox, W. L. (2001). *View Finder: Mark Klett, Photography, and the Reinvention of Landscape*. Albuquerque: University of New Mexico Press.

Freedman, R. (1994). *Kids at Work: Lewis Hine and the Crusade against Child Labor*. New York: Clarion Books.

Garner, G. (2003). *Disappearing Witness: Change in Twentieth-Century American Photography*. Baltimore: The Johns Hopkins University Press.

Gernsheim, H., & Gernsheim, A. (1954). *Roger Fenton: Photographer of the Crimean War: His Photographs and Letters from Crimea*. London: Ayer Co. Pub.

Gernsheim, H., & Gernsheim, A. (1969). *The History of Photography from the Camera Obscura to the Beginning of the Modern Era*. New York: McGraw-Hill.

Gierstberg, F., Heuvel, M., Scholten, H., & Verhoeven, M. (Eds.). (2005). *Documentary Now!: Contemporary Strategies in Photography, Film and the Visual Arts*. Rotterdam, Netherlands: NAi Publishers.

Govigon, B. (Ed.). (2004). *Abrams Encyclopedia of Photography*. New York: Henry N. Abrams.

Great Themes: Life Library of Photography. (1987). Alexandria, VA: Time-Life Books.

Gross, M. L. (1997). *Ethics and Activism: The Theory and Practice of Political Morality*. Cambridge, England: Cambridge University Press.

Harriman, R., & Lucaites, J. L. (2007). *No Caption Needed: Iconic Photographs, Public Culture and Liberal Democracy*. Chicago: University of Chicago Press.

Herzog, W. (2002). *Herzog on Herzog*. London: Faber & Faber.

Hirsch, R. (2009). *Seizing the Light: A Social History of Photography*. New York: McGraw-Hill.

James, A., Evans, W., & Hersey, J. (1989). *Let Us Now Praise Famous Men.* New York: Mariner Books. Intro.

Jussim, E., & Lindquist-Cock, E. (1985). *Landscape as Photograph.* New Haven, CT: Yale University Press.

Katz, L. (1971). Interview with Walker Evans. *Art in America*, March/April.

Kidd, S. (2004). *Farm Security Administration Photography, the Rural South, and the Dynamics of Image-Making, 1935–1943.* Lewiston, NY: Edwin Mellen Press.

Lemagny, J. C., & Rouille, A. (1987). *A History of Photography.* Cambridge, England: Cambridge University Press.

Light, K. (2000). *Witness in Our Time.* Washington and New York: Smithsonian Books.

Lister, M. (1995). *The Photographic Image in Digital Culture.* New York: Routledge.

Macdonald, G. (1980). *Camera: Victorian Eyewitness: A History of Photography, 1826–1913.* New York: Viking Press.

Mann, M. (1972). *Documentary Photography: Time-Life Library of Photography.* New York: Time-Life Books.

Marien, M. W. (2011). *Photography: A Cultural History.* Upper Saddle River, NJ: Pearson Prentice Hall.

Martin, P. (1973). *Victorian Snapshots.* New York: Arno Press.

Mauro, A. (Ed.). (2007). *My Brother's Keeper: Documentary Photographers and Human Rights.* Rome: Contrasto.

Meiselas, S. (2008). *Nicaragua.* New York: Aperture.

Meltzer, M. (1999). *Dorothea Lange: A Photographer's Life.* Syracuse, NY: Syracuse University Press.

Moeller, S. D. (1989). *Shooting War: Photography and the American Experience of Combat.* New York: Basic Books, Inc., citing W. Eugene Smith, quoted in George Santayana, "The Photograph and the Mental Image," in Vickie Goldberg (Ed.), *Photography in Print: Writings from 1816 to the Present* (New York: Simon & Schuster, 1981).

Newhall, B. (1964). *The History of Photography.* Albuquerque: KNME-TV, ©2003.

Pogue, A. (2007). *Witness for Justice: The Documentary Photographs of Alan Pogue.* Austin: University of Texas Press.

Richards, E. (2010). *War Is Personal.* Brooklyn, NY: Many Voices Press.

Ritchen, F. (2006). *In Our Own Image: The Coming Revolution in Photography.* New York: Aperture.

Rosenblum, N. (1997). Documentation: Landscape and Architecture. In W. Rawls & N. Grubb (Eds.), *A World History of Photography* (3rd ed.). New York: Abbeville Press Publishers.

Rosler, M. (1992). In, Around and Afterthoughts (on Documentary Photography), originally published in R. Bolton (Ed.), *The Contest of Meaning.* Boston: The MIT Press.

Salgado, S. (1993). *Workers: An Archaeology of the Industrial Age.* New York: Aperture.

Salgado, S., Orville, S., Fred, R., & Eduardo, G. (2004). *Sahel: The End of the Road.* Berkeley: University of California Press.

Simpson, J. (1974). *The Way Life Was: A Photographic Treasury from the American Past.* New York: Praeger Publishers.

Squires, C. (Ed.). (1999). *Over Exposed: Essays on Contemporary Photography.* New York: The New Press.

Stange, M. (1989). *Symbols of Ideal Life: Social Documentary Photography in America, 1890–1950.* Cambridge, England: Cambridge University Press.

Stoddart, T., Geldof, B., & Leroy, J. F. (2004). *iWITNESS.* London: Trolley.

Stott, W. (1986). *Documentary Expression and Thirties America.* Chicago: University of Chicago Press.

Szarkowski, J. (2007). *The Photographer's Eye.* New York: Museum of Modern Art.

Tagg, J. (2009). *The Disciplinary Frame: Photographic Truths and the Capture of Meaning.* Minneapolis: The University of Minnesota Press.

Trachtenberg, A. (1989). *Reading American Photographs: Images as History, Mathew Brady to Walker Evans.* New York: Hill and Wang.

Vanderbilt, P. (1993). *Between the Landscape and Its Other.* Baltimore: Johns Hopkins University Press.

Index

Note: Page numbers followed by *b* indicate boxes and *f* indicate figures.

Check us out at
masteringphoto.com

MasteringPhoto, powered by bestselling Focal Press authors and industry experts, features tips, advice, articles, video tutorials, interviews, and other resources for hobbyist photographers through pro image makers. No matter what your passion is—from people and landscapes to postproduction and business practices—MasteringPhoto offers advice and images that will inform and inspire you. You'll learn from professionals at the forefront of photography, allowing you to take your skills to the next level.